A DAVID & CHARLES BOOK

First published in the UK in 2004
First published in the US as Pencil Magic by F&W Publications

Printed in the US by Maple-Vail Book Mfg. Group
for David & Charles
Brunel House Newton Abbot Devon

Visit our website at www.davidandcharles.co.uk

David & Charles books are available from all good bookshops; alternatively you can contact our Orderline on (0)1626 334555 or write to us at FREEPOST EX2110, David & Charles Direct, Newton Abbot, TQ12 4ZZ (no stamp required UK mainland).

Drawing Landscapes
in 10 *Easy Lessons*

Phil Metzger

David & Charles

Dedicated to Shirley and Charlie

and

To my kids, who are my role models

Three accomplished artists gave me an enormous amount of help in cleaning up the manuscript. They corrected my English, fixed my punctuation, organized things better and critiqued the illustrations. They also helped me get rid of the cornball things I sometimes write—well, most of them. Sincere thanks to:

Marah Heidebrecht
Leah Henrici
Shirley Porter

And thanks to good buddy Michael David Brown, renowned illustrator and painter, who years ago introduced me to hatching, which is now my favorite drawing technique.

CONTENTS: PART I: GETTING STARTED

CONTENTS: PART II: DEMONSTRATIONS

DETAILED CONTENTS

You can draw with anything—pen and ink, brush, charcoal, crayon, colored pencil, pastel, silverpoint, whatever makes a mark on paper—but probably the simplest medium is the pencil. It's a magical tool. Using just pencil and paper and very little else, you can render any subject imaginable. Although in this book we'll deal mostly with landscape drawing, there is no subject you can't render with the pencil.

In Part I, we explore the mechanics of drawing—everything from choosing paper and pencils to designing a picture. Part II demonstrates in detail the evolution of several drawings. I encourage you to copy them; to help you get started I've included an outline, or template, for each.

Thanks for buying this book. I hope you'll enjoy using it.

Phil Metzger

OTHER BOOKS BY PHIL METZGER

Perspective Without Pain

Enliven Your Paintings with Light

The North Light Artist's Guide to Materials and Techniques

Realistic Collage Art (with Michael Brown)

Perspective Secrets

How to Master Pencil Drawing

How You Can Sell Your Art or Craft For More Than You Ever Dreamed Possible

The Artist's Illustrated Encyclopedia: techniques, materials and terms

Managing a Programming Project

Managing Programming People

PART I

GETTING STARTED

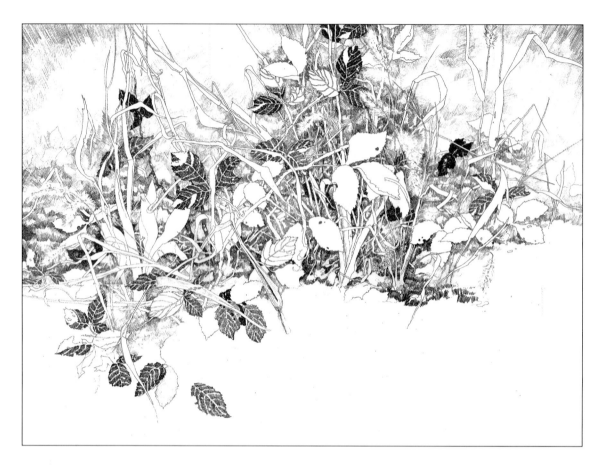

Weeds
Pencil on Strathmore illustration board,
regular finish, 18" x 24"

CHAPTER ONE
TOOLS & MATERIALS

All you *really* need for drawing is a pencil and some paper, but there are additional tools you can use to make drawing a whole lot easier. Happily, everything you need is simple and inexpensive.

PENCILS

Drawing pencils, often called graphite pencils, are a stick of "lead" encased in wood. The lead is not lead at all, but a combination of graphite (a form of pure carbon) and clay. The word "lead" is a holdover from centuries ago, when marks were made by scratching a surface with a rod of metal such as lead. The proportions of graphite and clay in a pencil determine how hard the lead is and how dark a mark it will make. The more graphite, the softer the lead and the darker the mark.

 The brand of drawing pencil I use is called Staedtler Mars Lumograph, currently available in nineteen different degrees of hardness/softness. The range is from 9H (the **H**ardest) to 8B (the softest, or **B**lackest). The complete list of designations is:

 9H, 8H, 7H, 6H, 5H, 4H, 3H, 2H, H, F, HB, B, 2B, 3B, 4B, 5B, 6B, 7B, 8B.

 The F pencil ("firm") is a little softer than H and a little harder than HB. You may find pencils marked EB or EE; EB is the old designation for 7B and EE is the old designation for 8B.

 It's a good idea to decide on a brand and stick with it so you get to know exactly what to expect from a given pencil. You'll find that one brand's HB, for example, may be the same as another brand's B.

 You don't need to buy nineteen grades of pencil. I suggest buying several HBs and a sampling of harder and softer leads, such as 4H, H, 2B, 4B, and 6B. As you experiment, you'll find which leads are your favorites. In my case, I use many more HBs and 2Bs than others. You can do entire pictures with a single grade of pencil, such as HB.

 Throughout this book we'll stick with wood-clad drawing pencils, but there are other types you may want to try. Mechanical pencils are metal or plastic holders that may be filled with individual leads of your choice. These are

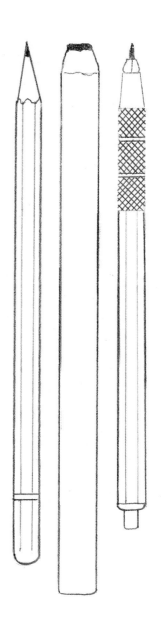

From left, a graphite drawing pencil, a sketching (carpenter's) pencil and a mechanical pencil.

 The pencil on the left is the type we'll use throughout this book.

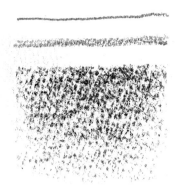

*2B strokes on
smooth paper.*

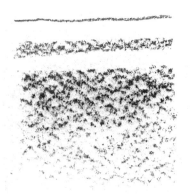

*2B strokes on medium
(cold-press) paper*

*2B strokes on
rough paper.*

PENCILS

popular among some artists because they minimize the need for sharpening. You don't cut away the part of the pencil that holds the lead—all you sharpen is the lead itself. Leads for these pencils are not available in as wide a range as the wood-clad pencils. Another popular pencil is a sketch pencil, also called a carpenter's pencil. It has a broad lead that many find useful for rough sketching. There are also colored pencils, carbon pencils, charcoal pencils and so on. For much more on these and hundreds of other products, see *The North Light Artist's Guide to Materials & Techniques.*

DRAWING PAPERS

There are dozens of different papers on which you can draw, and it's important to try as many as possible to find those that best suit you. Some papers are made for use with a specific medium—for example, pencil, ink, charcoal, or watercolor—but, of course, you may draw on any paper (or even nonpaper) surface that suits you. Here are the important things to consider when choosing a paper:

Use. If you want paper on which to practice strokes or for throwaway sketches, then any kind will do. But don't forget that a stroke on one paper may look quite different from a stroke on another paper, so if you practice on newsprint and switch to good drawing paper for your serious stuff, you'll find a world of difference between the two. My own usual practice is this: I use white bond writing paper or computer inkjet paper for preliminary work and acid-free, 100% rag Bristol paper for finished work. Bristol is strong paper made by gluing together under pressure two or more layers, or "plies," of thinner paper.

Surface texture. Art papers range from silky-smooth to coarse, and they all have their place. There are three common groups of textures: (1) Smooth, also called *hot-press*, *high*, and *plate*; (2) slightly textured, also called *cold-press*, *vellum* and *medium-textured*; and (3) strongly textured, usually called *rough*. For most of my drawings I use either a smooth paper or one with a faint texture, such as vellum. I prefer to simulate texture in a drawing by using appropriate pencil marks instead of relying on the texture of the paper. In PART II of the book I spell out exactly what paper I used for each drawing.

DRAWING PAPERS

Permanence. Most papers are made from either wood pulp or cotton fibers (and sometimes a combination of the two). Wood pulp products are by nature acidic and unless they are factory-treated to neutralize their acidity, they will turn yellow and become brittle (an old newspaper is an example). Wood pulp papers are also generally not as strong as other papers. Your best choice is to use the more expensive, but much more permanent, papers that are called "100% rag" (which means the papers are made from cotton or sometimes other fibers, such as linen) *and* "acid-free" (they are naturally nonacidic or have been treated to make them so). A drawing on 100% rag, acid-free paper may be expected to outlast you and your grandchildren with no appreciable yellowing or brittling, provided it's framed correctly using acid-free materials.

Stiffness. Most papers are sold as flexible sheets, but others are glued to a stiff cardboard backing. Those mounted on cardboard are called either "illustration boards" or, if intended primarily for painting, "watercolor boards." Boards are handy to use, but they have two drawbacks: (1) Most do not have acid-free cardboard backings, even though their surfaces may be acid-free. Over many years, acidic backings will become brittle and weak and, if they are *very* acidic, may even stain the surface paper. There are a few boards that are completely acid-free—e.g., Crescent Premium Watercolor Board and Whatman Water Media Board. (2) If you are making drawings for publication, publishers may copy your work by mounting it on a round drum that's scanned by laser beams as it rotates— obviously impossible to do if the picture is mounted on stiff cardboard or very heavy paper.

SKETCHBOOKS

Get in the habit of keeping a sketchbook, maybe several in different sizes. Choose sketchbooks that lie flat when opened—spiral-bound books are good. Use a sketchbook as you might a diary, recording quick sketches, detailed studies, color information, thoughts, doodles, picture ideas— anything that might help you later on to develop a drawing or painting.

TIP

White papers are most commonly used, but you can use colored papers for special effects. Graphite on gray or buff paper, for example, can be quite beautiful.

Another drawing surface popular among some artists is coated paper—a paper with a thin surface layer of clay or other material, usually tinted. Scratching through the layer to expose white underneath is a way of providing sharp accents and highlights.

Your sketchbooks are like a visual diary. Record in them color notes, quick sketches, finished studies, sights, sounds, smells— whatever you wish.

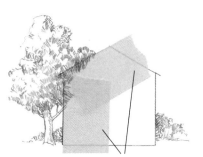

*tracing paper taped over
part of drawing to be traced*

TRACING PAPER

Tracing paper is thin and translucent. It's handy for at least three purposes: (1) Tracing a drawing or portion of a drawing for transfer to a new piece of drawing paper for a fresh start; (2) placing over the lower part of your drawing so you don't smudge the drawing while working on an upper section; and (3) improving the symmetry of an object by tracing one half of it and flopping the tracing paper over to establish the other side of the object (as illustrated in Chapter Four).

MASKS

To preserve a clean edge you may mask the drawing paper where you don't want pencil marks. A simple way to mask is to cover an area with tape; another is to hold a piece of paper or an index card over the area to be masked. In both cases, you can tear or cut the masking material to whatever shape you wish.

It's better to use either drafting tape or Scotch Removable Magic Tape, rather than masking tape, because drafting tape and removable tape are both less sticky and therefore less likely to tear the drawing paper's surface when removed.

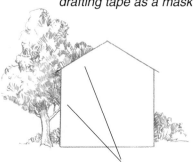

drafting tape as a mask

*clean edges after tape is
removed*

*Above, masking with drafting tape; below,
masking with an index card.*

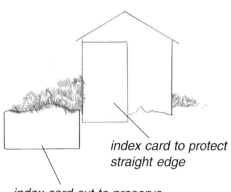

*index card to protect
straight edge*

*index card cut to preserve
clean curved edge*

TIP

Even drafting tape and removable tapes may tear the fragile surface of some drawing papers. Test first by pressing a piece of tape firmly onto a scrap of drawing paper and see if the tape lifts cleanly without doing damage. To make the tape less adhesive, try sticking it to another surface, such as your table top, before using it on your paper.

ERASERS AND SHIELDS

For most erasing I use either a *kneaded* eraser, a soft material that may be stretched into whatever shape you want, or a Pink Pearl eraser. To use the kneaded eraser without damaging your drawing paper, *dab* rather than *rub*. As the eraser becomes "dirty," stretch and fold it several times to expose cleaner eraser material. To erase a thin line, either squeeze the eraser into a thin-edged shape or use an erasing shield.

For tougher erasing jobs, try Pink Pearl erasers. They come in two forms, a beveled block or a rod protruding from a plastic sleeve. Try them first on scrap paper to be sure they don't leave a pink smudge or stain and to be sure they don't damage your paper. There are other good choices, including white plastic erasers and ArtGum rubber erasers. Try them all.

An erasing shield is a thin sheet of metal, plastic, or other material with slots and holes in a variety of sizes and shapes. Place an appropriate opening over the area to be erased and you can erase without disturbing the surrounding part of the drawing. An index card is useful as a shield. Hold the card down over an area to be protected and then erase along the edge of the card. Cut the card into any shape you need.

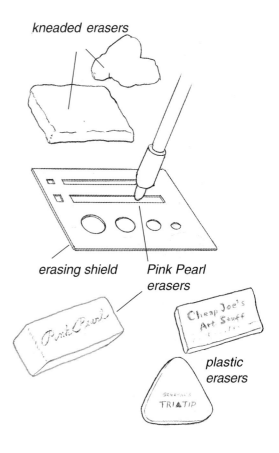

kneaded erasers

erasing shield Pink Pearl erasers

plastic erasers

STUMPS AND TORTILLIONS

A stump (also called stomp) is a tightly-wound cylinder of paper or similar material with two blunt points. It's used for smearing pencil, charcoal, pastel and other marks. A tortillion (also tortillon) is a similar tool with a sharper point at only one end, used similarly to a stump.

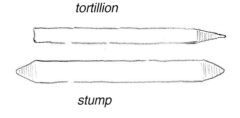

tortillion

stump

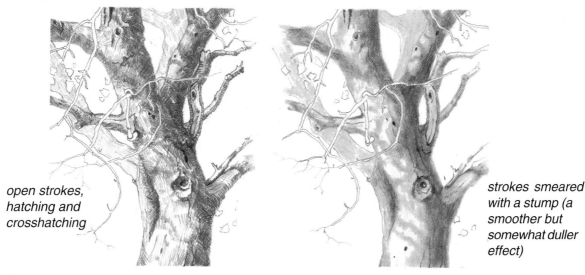

open strokes, hatching and crosshatching

strokes smeared with a stump (a smoother but somewhat duller effect)

SHARPENERS

For wood-clad pencils, use either an ordinary rotary pencil sharpener, a razor blade, or an electric sharpener. I use a battery-operated sharpener that's slim enough to fit in a pocket. Given such handy gadgets, I don't know why anyone would resort to razor blades, pen knives, or other blades unless the idea is not only to cut away wood but to shape the point, as well. But if you use an electric sharpener (which saves lots of time and is easier on the fingers), you can shape the lead by simply rubbing it a few times against a piece of fine sandpaper or any slightly abrasive surface.

Another type of sharpener is a small gadget containing a blade at an angle, illustrated at bottom left. You stick the pencil into the opening and twist carefully until sharpened—and hope the point doesn't break off inside the sharpener! Models are available for both wood-clad and mechanical pencils. In either case, carry a blade or wire with you to unclog the opening when necessary. Users of mechanical pencils can also buy a special sharpener like the Koh-I-Noor Lead Pointer shown at left.

No matter what type of sharpener you use, keep a small piece of fine sandpaper handy for shaping the actual *point* of the lead. You can buy or make a sandpaper block, a small piece of wood or cardboard with strips of sandpaper fastened to it.

Some of the many types of sharpeners available. Above left, a battery-operated Panasonic KP-4A model for wood-clad pencils; left center, a Koh-I-Noor mechanical lead pointer; lower left, a small sharpener for wood-clad pencils. Above, a razor blade and a sandpaper block.

BRIDGES

A bridge is a strip of material that spans your drawing and serves as a handrest, keeping your hand from smudging the drawing. It makes sense to use a strip of Plexiglas so you can see the drawing underneath as you work. If you work top-down on a drawing, you may not need a handrest, but if, as is usual, you end up working all over the picture, this gadget will save you a lot of grief. The illustration shows one way to make a bridge; you may want to make one for each width drawing board you use. Some art catalogs, such as Daniel Smith, offer clear acrylic bridges in a number of sizes.

Plexiglas strip

screw

guide strip (wood or cardboard) *drawing board* *drawing paper* *spacer (wood or cardboard)*

TRANSFER PAPER

A form of "carbon paper" used to copy a drawing from one sheet to another. One brand is Saral Transfer Paper. You can make your own by thoroughly covering one side of a sheet of paper, such as bond or heavy newsprint, with flat strokes from a soft (e.g., 2B) pencil or better, a black Conté crayon. Fill the paper densely and it will last a long time.

MAHLSTICK (or MAULSTICK)

This is a rod that allows you to bridge your drawing and keep your hand off the drawing surface. It can be made of any rigid, lightweight material. It helps to have a rubber or other nonskid cap on the upper end to keep the rod from slipping.

　　　If you're up the creek without a mahlstick, use a slender tree branch.

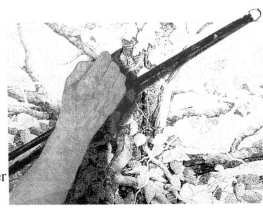

drawing paper

drafting tape

drawing board

DRAWING BOARDS

For firm support, place your drawing paper on a board made of wood, hardboard, Plexiglas or other stiff material. Either tape or tack the paper in place. I usually use one-inch-wide drafting tape that not only holds the paper down, but serves as a border around the drawing, as well. When the drawing is finished and the tape is removed, there is a fresh white edge around the drawing. You may find it helpful to have more than one drawing board so that when working on a smaller drawing you don't need to lug around an oversize board.

I've recently begun using an excellent lightweight board called Pickett Aero/Core Drawing Board. It has smooth wood surfaces and a honeycombed core that makes it rigid, but light. It's sold in several sizes, including 16" x 21" and 18" x 24."

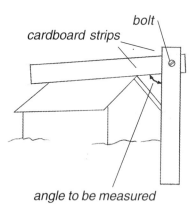

bolt

cardboard strips

angle to be measured

PERSPECTIVE JAWS

This homemade gadget makes it easy to draw the angle between two lines. It consists of two pieces of cardboard fastened together so they may be spread to any angle. To use it, line up one of the strips along one edge of an object and swivel the other strip to match the slope of the second edge. Lay the jaws on your paper and copy the angle. It's important to fasten the strips snugly—they must be movable, but not loose and floppy.

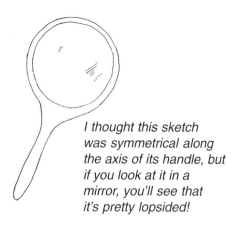

I thought this sketch was symmetrical along the axis of its handle, but if you look at it in a mirror, you'll see that it's pretty lopsided!

MIRROR

Whether painting or drawing, I can't think of a more valuable tool than an ordinary hand-held mirror. Each of us is biased in how we see things and our built-in biases find their way into our pictures as lopsided shapes, asymmetries and so on. Look at your picture in a mirror (or hold it up to a strong light and view it from the rear) and design flaws will pop out at you because the mirror reverses everything and forces you to see the picture the way someone else (without your biases) might see it.

tightening collar split sleeve

PENCIL EXTENDER

When your wood pencil is too short to hold comfortably, either chuck it or get that last bit of life from it by inserting it into an extender, or lengthener—a handy gadget.

VIEWFINDER

Let's say you're gazing at a beautiful panoramic scene—stuff to draw or paint everywhere you look! You can't squeeze it all onto your little piece of paper or canvas, so what to do? Use a viewfinder to narrow the field and zero in on some possibilities. A viewfinder is a piece of cardboard with a small rectangular hole. The cardboard eliminates from your view everything except what you see through the hole—it's a simple tool, but effective. A hole an inch or two in each dimension works well. Some people use a cardboard 35mm slide mount, but a larger piece of cardboard is better because it blocks out everything except what you see through the hole.

Shifting the viewfinder right, left, up, down gives you an isolated view of different parts of the landscape. It's important that the hole be at least roughly the same shape as the drawing paper.

BRUSH

Don't wipe erasing crumbs from your picture with your hand because the oil and moisture on your skin will smear the drawing. Instead, use any soft, clean brush.

CARRYING CASE

If you travel light, with only pencils, a sharpener and a sketchbook, you won't need a carrying case—everything except the sketchbook will fit in your pockets. But if you want to carry along all the other paraphernalia we've discussed, you gotta get organized! Any lightweight container will do. I use a wooden painter's box big enough to hold the size papers and sketchbooks I use and roomy enough for little extras such as Handi-Wipes, bug repellant and a sandwich.

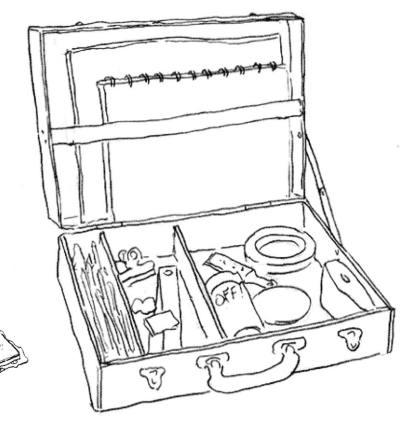

SHOPPING LISTS

Here are two lists, one for basic items I think you should have
and one for extras to make your drawing life easier.

BASICS	✔
drawing pencils 1 4H 1 H 6 HB 2 2B 2 4B 1 6B	
paper 1 pad of acid-free Bristol, plate (smooth) 1 pad of acid-free Bristol, vellum (slightly textured) several sheets of inexpensive paper, such as bond	
sharpener battery-operated model such as Panasonic KP-4A (requires 4 AA batteries)	
piece of fine sandpaper	
erasers kneaded Pink Pearl or white plastic	
drawing board a lightweight board a couple inches larger than the papers you choose	
drafting tape 1 roll of one-inch tape	
mirror small cosmetic type	

EXTRAS	✔
sketchbooks	
3" x 5" index cards	
erasing shield	
bridge	
mahlstick	
viewfinder	
paper towels	
Handi-Wipes	
bug repellant	
large paper clamps	
soft brush for dusting away eraser crumbs	
pencil extender	
carrying case	

CHAPTER TWO
BASIC STROKES

Like everyone who uses a pencil, you'll eventually develop your own distinctive strokes, or marks. But if you're just getting started, or if you're looking for ways to add to your artistic toolbox, here are some basic strokes to practice.

SHARP STROKES

These are strokes made with a sharpened pencil point. Use them wherever you want a crisp edge or clear, engraving-like hatching and crosshatching. To keep sharp strokes consistent, sharpen the lead frequently because the fine tip wears down quickly.

CHISEL STROKES

These strokes are made with a lead blunted at an angle, so the lead resembles a chisel blade. Chisel strokes are broader and fuzzier than sharp strokes, so you use them when you want a softer effect. As the lead wears down, sharpen to expose more lead and then rub the lead at an angle against a piece of paper, sandpaper, or other abrasive surface.

FLAT STROKES

Hold the pencil with the side of the lead pressed against the paper for a flat stroke. The paper's texture, the softness of the lead and the amount of pressure you apply will all affect the look of the stroke. After sharpening a point, there is often a loose grain or two stuck at the tip. For a smoother stroke, gently rub the tip against a piece of paper to get rid of any grains.

H sharp 2B sharp

H chisel 2B chisel

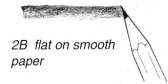

2B flat on smooth paper

H flat on smooth paper

2B flat on textured paper

H flat on textured paper

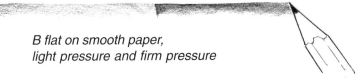

B flat on smooth paper, light pressure and firm pressure

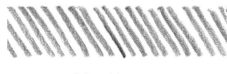

4B hatching

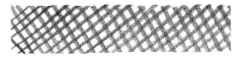

4B crosshatching

HATCHING AND CROSSHATCHING

Hatching is the use of parallel strokes, either curved or straight; crosshatching is the overlaying of one set of hatched strokes with another (or several others) at an angle to the original hatched strokes. Hatching and crosshatching are used to suggest mass, textures, shadows, depth, roundness and so on. The individual marks may be either sharp or broad and in any combination that suits your subject.

TIP

Hold the pencil any way that feels comfortable. Most people hold the drawing pencil the same way they hold a writing pencil, as shown below. An exception is when you make "scribble" strokes (see next section).

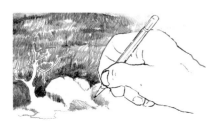

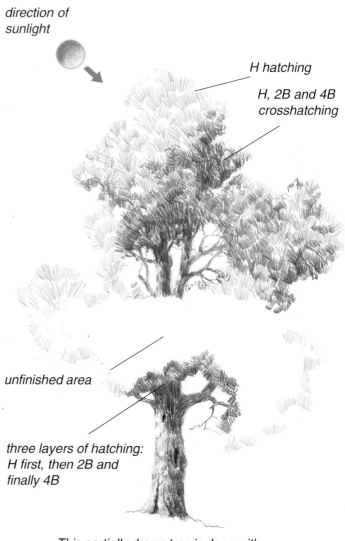

direction of sunlight

H hatching

H, 2B and 4B crosshatching

unfinished area

three layers of hatching: H first, then 2B and finally 4B

This partially drawn tree is done with hatched and crosshatched strokes. Later I'll finish with more hatching and crosshatching and some scribbled lines, as well.

HATCHING AND CROSSHATCHING

When using these strokes to suggest *shadows*, keep in mind the nature of the surface over which the shadows fall. If the surface is smooth, it's usually best to use more delicate hatching rather than coarse crosshatching. On a textured surface, such as tree bark, either dense hatching (as in the tree illustration) or vigorous crosshatching will work.

To show *roundness*, try hatching and letting the spaces between strokes diminish as they go farther around the curve of the object. If the rounded object is cylindrical, straight strokes are best; if spherical, use curved strokes. The same method—diminishing spaces between strokes—may be used to show a receding *flat* surface, such as a wall or the side of a box (see the chapter on perspective).

Simple hatching on a cylinder.

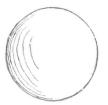

Simple hatching on a sphere.

CONTINUOUS HATCHING AND CROSSHATCHING

Hatching and crosshatching imply the laying down of many individual strokes. Often it's more effective (and easier) to use *continuous* strokes whose effect is pretty much like hatching and crosshatching, but continuous strokes are made without constantly lifting the pencil from the paper. Think of these strokes as a sort of dense scribbling. You start anywhere and, using varying pressures, quickly fill in an area.

Aside from speed, the advantage in using this technique is a freer, looser final effect. This is a more relaxed way of hatching/crosshatching and, for many, a more enjoyable kind of stroke.

Continuous hatching strokes—the pencil was not lifted from the paper from beginning to end (like one of the penmanship exercises once taught in school).

A tree done with continuous hatching/crosshatching strokes. The pencil was lifted from the paper only about eight or ten times.

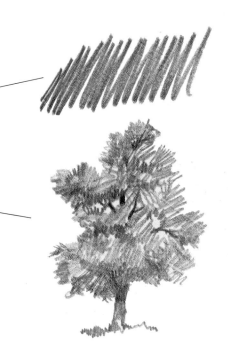

SCRIBBLES

Scribbles are any lines made in a jerky, usually curved, manner. They may be used to suggest all kinds of materials or objects, such as hair, turbulent water, clouds and foliage. They're best done quickly so they look loose and spontaneous rather than labored. Often it's helpful to hold the pencil not in the usual way, as in writing a letter, but more vertically with your grip near the far end of the pencil—that way, you are freer with your strokes.

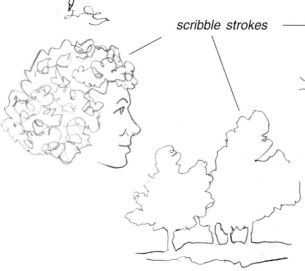

scribble strokes

In this picture there are many scribble strokes in tree foliage and in grasses. The scribbled grass strokes are quicker, more "nervous," while the rounded strokes forming the big tree's foliage are more deliberate.

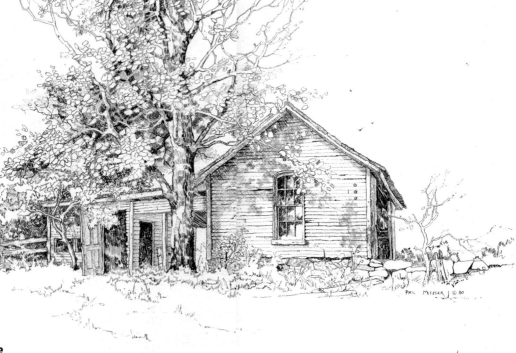

Old Carriage House
Pencil on illustration board,
smooth finish, 11" x 15"

VARIED PRESSURE AND EDGES

No matter which individual stroke you happen to be using, you can change the amount of pressure you use and, in so doing, change the appearance of the stroke.

Varied pressure using a flat stroke.

You can vary the pressure with any stroke to introduce changes in value. You can also twirl the pencil as you draw so that sometimes you get a broad, soft-edged stroke and at other times, a finer, sharper stroke. As you become comfortable with the pencil, such variations will become natural and you won't have to think about them.

This stroke is made with a chisel-shaped lead. I began at the left with the sharp part of the chisel and gradually twirled the pencil so that at the right end, the broad part of the lead is doing the marking.

This is a chisel stroke during which I varied the pressure of the lead against the paper.

DIRECTIONAL STROKES

Always consider whether the direction of a stroke—any stroke—is appropriate to the object you're drawing. Sometimes, as in stippling, scribbling and some crosshatching, direction is not important. But in other cases, drawing strokes in the proper direction can make a world of difference. Consider these examples:

The horizontal strokes on the birch bark help identify the kind of tree this is.

The curved strokes clearly indicate the roundness of the onion.

Although the stroke directions in the trees take many directions, the strokes in the water and the reflections are horizontal to help suggest the flatness of the water.

STIPPLING

Stippling is the placement of small dots (of paint, graphite, pastel, etc.) to simulate tone, texture, mass, or any other pictorial element. One kind of stippling uses dots that are all the same size but at varying distances from each other. Another uses dots of varying sizes. Some artists create entire pictures using only stippling, which requires uncommon patience! Some combine stippling with other kinds of strokes.

Stippling usually implies the use of fairly uniform individual dots, but a variation I call "stabbing" makes more ragged marks.

SUMMARY

This chapter explored a few basic kinds of pencil strokes, but the list of *possible* strokes is truly endless because the marks each person makes are at least a tiny bit different from strokes made by others. Such differences help to distinguish people's individual styles.

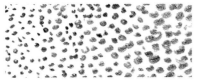

Stippling: same size dots, varying distance between dots.

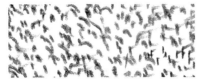

Stippling: varying size of dots.

Stippling: aggressive stabbing strokes.

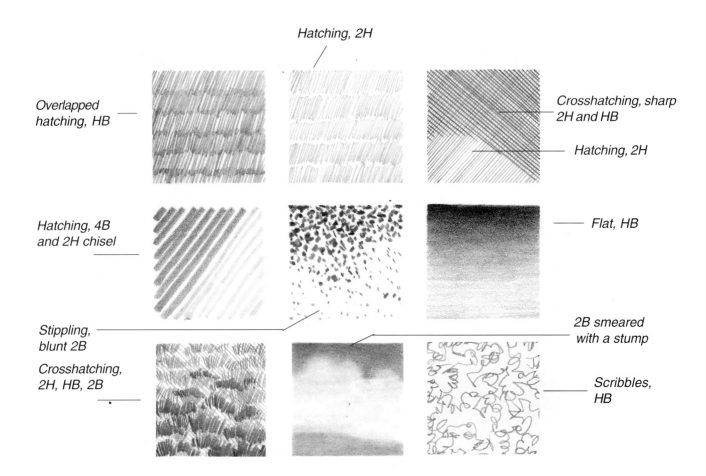

Hatching, 2H

Overlapped hatching, HB

Crosshatching, sharp 2H and HB

Hatching, 2H

Hatching, 4B and 2H chisel

Flat, HB

Stippling, blunt 2B

2B smeared with a stump

Crosshatching, 2H, HB, 2B

Scribbles, HB

CHAPTER THREE
DRAWING STYLES

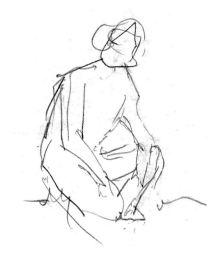

As your drawings evolve, not only will they look different from everyone else's (and that's a good thing), but they'll look different from each other, as well. One day you'll do quick sketches that have a loose, spontaneous quality; another time you may do a finished, completely rendered drawing. It all depends on your objective for that day. Let's look at a few of the approaches, or styles, you might use at different times.

QUICK SKETCHES

Probably the fastest way to improve your art is to sketch constantly. You don't always have time for a detailed drawing, but you can almost always spare five minutes for a quickie. The idea is to use a few rapid strokes to capture the essence of something, especially a gesture or a shape—an old man's posture, a tree's raggedy outline, a road disappearing over a hill, your shoe, a farm scene, a bird on the feeder. Sketchbooks full of such insights are a rich reservoir of ideas that will eventually find their way into your more studied drawings or paintings, but the greatest payoff is that constant sketching sharpens your ability to look at any object and accurately get it down on paper.

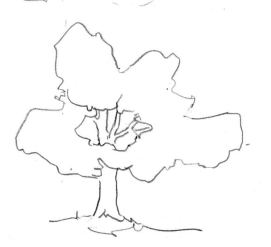

A few examples of quick (less than a minute) sketches that help me learn to SEE better!

DRAWING THROUGH

Drawings sometimes look as flat as the paper they're drawn on, with no convincing illusion of depth. One of the ways around this is to draw hidden edges, ones you can't actually see. Draw them lightly and they'll help you feel your way around the thickness of the object.

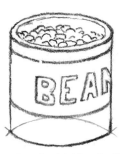

The bottom of this can looks wrong. But why?

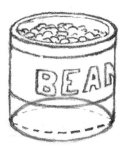

Drawing the hidden half of the bottom shows that, rather than a smooth, elliptical curve, we have an almond shape with pointy ends.

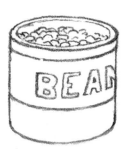

The fix is to draw the complete ellipse using smooth curves with no points or corners.

hidden edges

TIP

To help draw smooth curves, draw a part that's comfortable for you and then rotate the drawing paper to draw some more—do this as many times as necessary until you complete the curve.

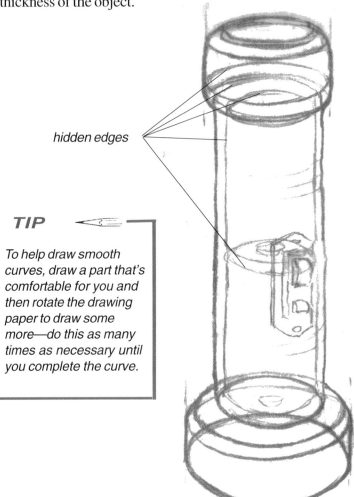

Drawing hidden edges helps you to "feel" the volume of an object. The technique is particularly helpful when the hidden edges are curved, since many of us tend to draw curves (such as circles and ellipses) as though they had sharp points. Drawing through usually makes these "points" obvious, as in the example at left.

Then you can erase the hidden edge.

VISIBLE CORRECTIONS

Some painters, especially watercolorists, worry about leaving pencil lines that show through the paint. My usual approach is to allow, maybe even welcome, such lines. They are simply part of the picture. (If your aim is to paint photorealistically, you'll probably never tolerate visible pencil or other lines in the finished work.)

You think cleanliness is next to godliness? Don't be too sure. In a drawing, you may not like visible corrections and may carefully erase them, but too much cleanliness may rob a picture of its spontaneity. There are plenty of excellent artists who love the scribbly, lively effect of corrections and feel it's exciting to leave every line on a drawing, including "corrections." Such pictures have the charming quality of showing a sort of work-in-progress. They're a little like a toy store transparent anatomical figure that exhibits everything, guts and all!

It's up to you. I think you'll find certain drawings benefit from letting everything show, but others demand some cleanup.

TIP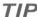

Not sure you want correction lines to remain in your drawing? Try doing the drawing rapidly, leaving all lines, including corrections, and only at the end decide whether to "clean up" or not. Stopping to clean up as you go along may divert your creative energy.

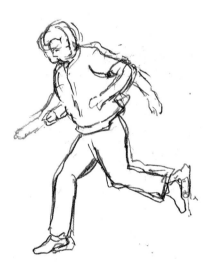

A couple of examples. Which do you prefer? (There's no right answer.)

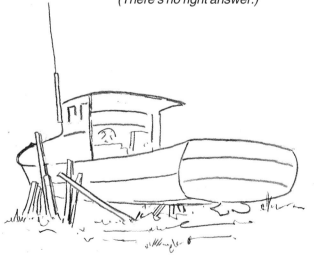

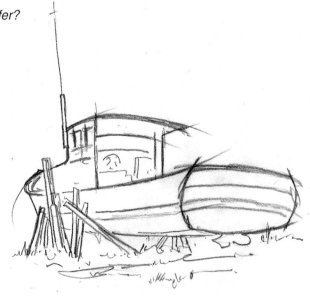

OUTLINE DRAWING

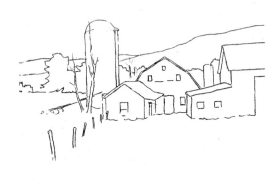

There are many places where outline, or contour, drawings are appropriate—for example, in some stylized advertisements. A common use of outline drawing is in teaching—the student is asked to copy the shapes before him or her by drawing a single continuous shape without lifting pen or pencil from the paper, sometimes without even looking at the paper. Such exercises can be useful in improving hand-eye coordination and they are worth practicing.

In the case of finished, three-dimensional drawings, an outline drawing is usually only a first step, intended to place shapes appropriately on the paper. An outline drawing appears in each chapter in PART II of this book. At upper left is one example from PART II.

BLENDED-STROKE DRAWING

An example of blended strokes.

Many artists try for a smooth photo-like quality, either by using broad, overlapping strokes without spaces between them or by smearing strokes with a soft tool, such as a finger or a stump. In my drawings I use blended strokes sparingly—I prefer open strokes (hatching and crosshatching) because I feel they yield a livelier result. Still, blended strokes are useful in certain circumstances. For example, you might use light blended strokes to depict a large sky area that you don't want to be too active.

Blended strokes made with the flat of the lead or by placing many strokes close together, as shown below, are more lively than those that are smeared with a finger or a stump. As in charcoal drawing and pastel painting, too much smearing may rob your picture of life. When you use any kind of blended strokes, try out your intentions first on scrap paper to be sure you'll like the result.

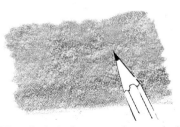

Blended strokes may be made by holding the lead flat against the paper . . .

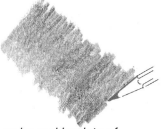

. . . or by making lots of individual strokes adjacent to one another . . .

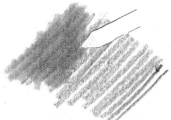

. . . or by smearing with a stump.

OPEN-STROKE DRAWING

For a fresher (but less photographic) look, place many small strokes parallel to one another (hatching) or crossing one another (crosshatching), leaving tiny bits of white (the paper) showing through. This method is roughly analogous to the traditional technique used by painters in egg tempera. It's the dominant approach used in the drawings in PART II.

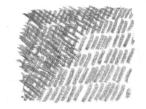

Open strokes (hatching and crosshatching).

COMBINING STROKES

Many drawings are made up of more than one type of stroke. The picture below, for example, uses mostly open strokes, but many outline, or contour, strokes as well—primarily in the leaves and in some of the branches. This combination provides a nice contrast between the stark, often undetailed, leaves and the heavily textured trunk and branches. In some of the dark areas there are also some blended strokes made with the flat of the pencil lead. To maintain a crisp appearance, I used no smearing.

On the next page are two examples contrasting the use of blended and open strokes.

TIP

When combining strokes, it's a good idea to let one type be dominant. Psychologically, conflict (in colors, shapes, strokes, etc.) is good in a picture, but it can be distracting if a clear dominance is not apparent.

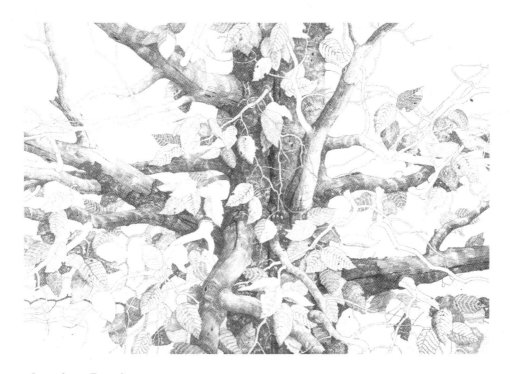

American Beech
Pencil on 100% rag
Strathmore illustration board,
smooth finish, 30" x 40"

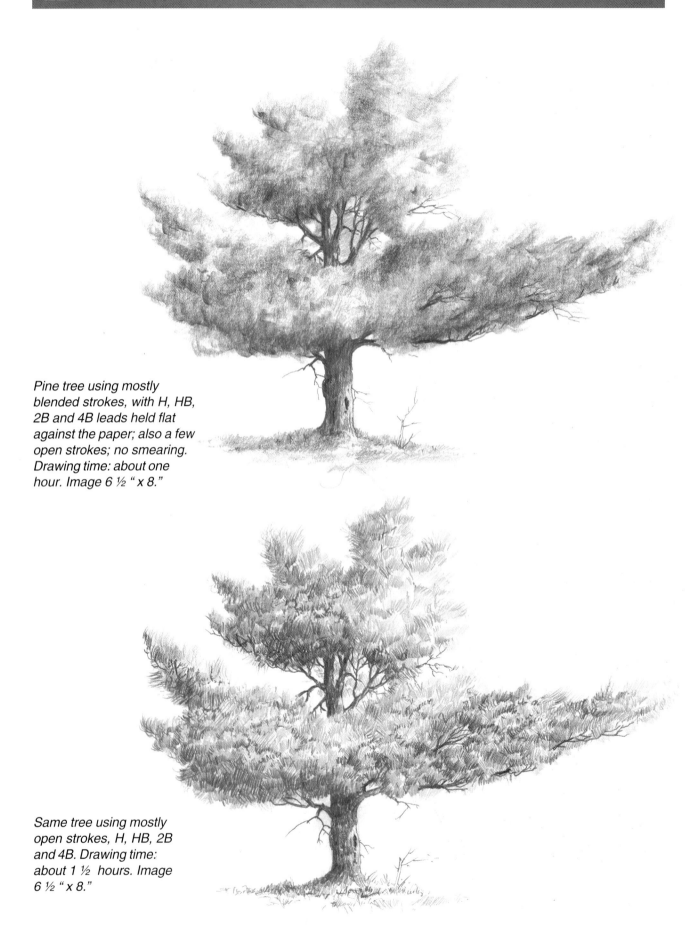

Pine tree using mostly blended strokes, with H, HB, 2B and 4B leads held flat against the paper; also a few open strokes; no smearing. Drawing time: about one hour. Image 6 ½ " x 8."

Same tree using mostly open strokes, H, HB, 2B and 4B. Drawing time: about 1 ½ hours. Image 6 ½ " x 8."

CHAPTER FOUR
MEASURING

When you draw or paint any realistic scene, you're constantly making judgments, comparing sizes and shapes of things, estimating distances, and so on. Whether you realize it or not, you're doing a lot of measuring. Here are some ideas and tools to help you get it right.

DIVIDING YOUR PAPER

viewfinder

You've looked at the scene through a cardboard viewfinder and you've picked out what you want to include in the drawing (also, what you're going to exclude). Let's say you're going to draw a barn, a silo and a tree. Before you draw a single line for any of those objects, make sure you can fit them on your paper. If you begin drawing right away, chances are good you'll make your first object so big that later, to your dismay, you'll find your paper is too little! You need to establish *boundaries* for your drawing.

 Try it this way: Place light pencil marks that represent the top and bottom of the tallest main object. Now all you have to do is draw within those boundaries and you won't run off the paper. You could also mark left and right boundaries, but I think you'll find the top and bottom boundaries are all you'll need. If your drawing is to be quite large, setting the top and bottom boundaries may not be enough—you may start drawing at the top boundary and by the time you reach the bottom one—bingo! You're out of space. The solution is to make more marks *within* the object to further restrain your tendency to draw too big.

top of silo

ground (bottom of silo)

taped-off drawing paper

EYEBALLS AND THUMBS

Having marked boundaries to keep you from running off the paper, quickly sketch a main object, such as the silo. First eyeball it and draw (lightly) the size, shape and position you think feels right on your paper. If you have a great eye and the object looks just right, that's fine. But let's say it doesn't look quite right—it looks too fat. Assuming you're happy with the height, let's see about fixing the width so the silo doesn't feel fat.

 Hold your pencil (or a stick or a ruler or whatever) at

first attempt at drawing silo

(too fat)

EYEBALLS AND THUMBS

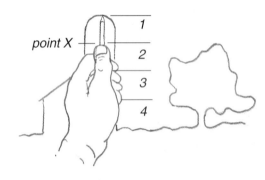

Measure the silo's width . . .

point X

. . . and then compare the width to the height.

arm's length, elbow locked, with the pencil horizontal. Close one eye (not your good eye!) and line up the tip of the pencil with one side of the distant silo. Slide your thumb along the pencil until your thumbnail marks the opposite side of the silo. The distance between your thumbnail and the tip of the pencil represents the width of the silo.

Now turn your wrist ninety degrees so the pencil is vertical. One eye still closed, arm still extended and elbow locked, align the tip of the pencil with the top of the silo. Notice how far down the silo your thumbnail is and mentally call that point X. Move the pencil down so the tip is at point X. Repeat this to see roughly how many times the width of the silo (pencil tip to thumbnail) fits within the height of the silo. Let's say the answer is four. Now you know the silo is four times as high as it is wide.

Look at the silo you've drawn. Does your drawn silo's width fit four times into its height? If not, adjust until it does.

You can use this measuring method for every object in your picture and of course, you can use it to compare dimensions of one object with those of another. For example, in the barn-silo-tree scene, you can measure the width of the barn compared with the width of the silo, or the height of the tree with the height of the silo, or anything with anything. You can also use it for every *space* in your picture—the space between the barn and the tree, for example, compared with the width of the tree.

What you're dealing with when you do these measurements is proportions—that is, the *relative* sizes of things. You don't care about the *actual* dimensions of the barn and silo; all you care about is that when you draw them, their relative sizes are proper. That is, if the real silo is twice as high as the real barn, then the drawn silo should be twice as high as the drawn barn.

TIP

If you want to get really fussy about your measurements, use a ruler instead of a pencil or stick. That way, if the silo measures, say, 2.5 inches wide and 10 inches high, you know to draw it exactly four times as high as wide. Of course, you won't look nearly so arty holding up a ruler!

MEASURING ANGLES

Most scenes have horizontal, vertical and sloping edges and where any two of those edges meet they form an angle. If you get the angles right, you have a good chance of making a convincing drawing. The job is easy if you use *perspective jaws*, mentioned in Chapter One—two strips of cardboard hinged at one end. There are many ways you can use the jaws, but they all boil down to this: (1) Align one strip with some edge in the scene you're drawing; (2) swivel the other strip so it aligns with another edge in the scene; (3) copy on your paper the angle between the two strips.

USING PLUMB LINES

Portrait artists use a variety of techniques to get facial features in the right positions relative to one another. One technique is to use calipers to get accurate measurements—height and width of head, distance from eyes to mouth, and so on. Another is to "see" imaginary vertical lines on the model from one feature to another—for example, from the inside corner of an eye to the outer corner of the mouth—and then draw or imagine vertical lines on the portrait to see if those features line up the same as on the model. The vertical lines, imagined or drawn, are called plumb lines, or sometimes, drop lines.

Plumb lines are just as helpful in landscape drawing as in portraiture. Hold a pencil or a ruler vertically at arm's length, squint, and note how certain features, such as windows, line up. Then place the ruler vertically on your drawing and see if the features you've drawn line up the same as the features on the subject.

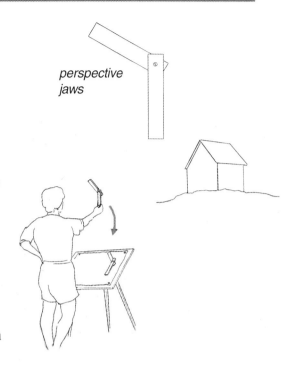

perspective jaws

Hold your perspective jaws tool at arm's length, elbow locked. Align one leg of the tool with an edge (here, the vertical edge of the building); then swivel the other leg to align with another edge (here, the sloping front edge of the roof). Without twisting your arm or wrist, lower the jaws to your paper and draw the angle.

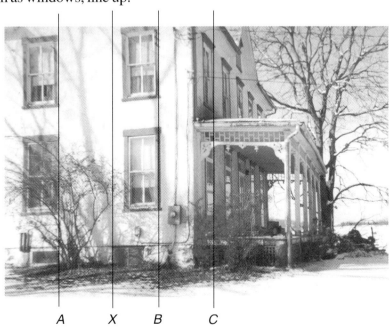

Plumb lines A, B and C show that upper and lower windows line up. Plumb line X shows that the little basement window does not line up with the others. So, plumb lines can show both alignments and offsets.

A X B C

"HORIZONTAL" PLUMB LINES

Plumb lines are vertical and they help align things east-west. Equally useful are *horizontal* lines that help you to align things north-south.

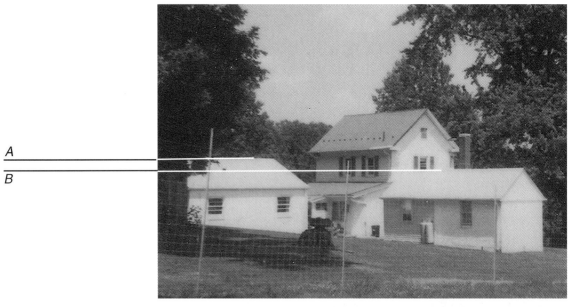

I've drawn horizontal lines representing just two roof levels, A and B, in the subject. The lines show clearly the distance from level A to level B. I could also have drawn many other horizontals to check up on the relative heights of other roof edges, windows and so on.

In the drawing below, I've again drawn in levels A and B, but the lines coincide, which means I messed up! I need to lower the right-hand part of the building. I could, of course, ignore accuracy and let A and B remain on the same level, but the drawing has more variety if the levels are not the same.

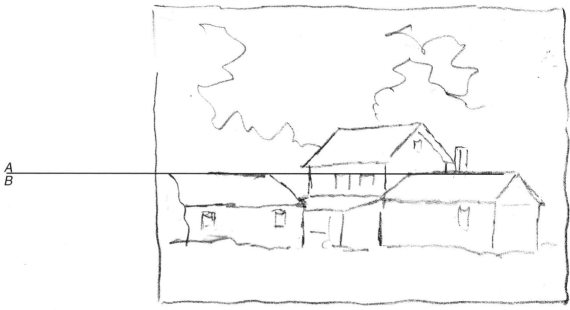

GRIDDING

Suppose you have a small drawing or photograph you want to either draw or paint in a larger size. One way to blow up the picture is by enlarging it on a copy machine, provided you find a machine that can handle the size you want. Another method, good for any size, is gridding.

Gridding means dividing your small image into a number of equal-sized rectangles, dividing your larger paper into the same number of equal-sized rectangles and then copying by hand the contents of each small rectangle onto each corresponding large rectangle. What you're doing is breaking a complex picture down into smaller, simpler pieces that are easy to copy. Of course, you can reverse the process and grid a larger picture in order to reproduce it smaller.

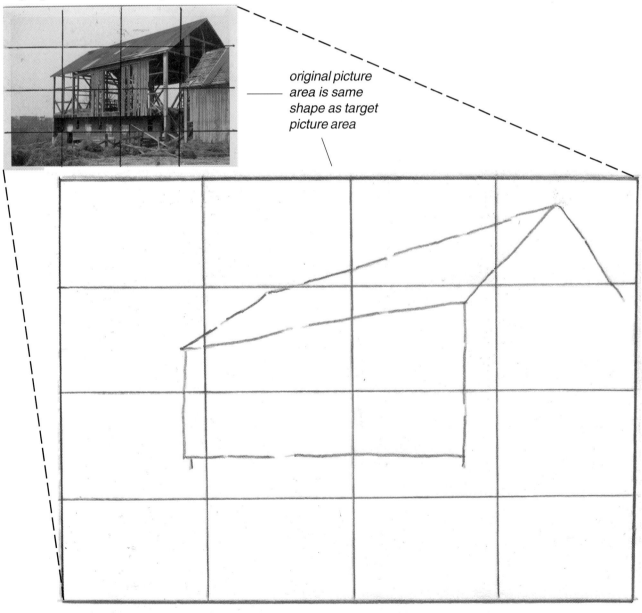

*original picture
area is same
shape as target
picture area*

GRIDDING

Gridding only works if the original picture and the target picture are of similar shapes and the number of rectangles in the original picture equals the number of rectangles in the target picture. Here is one way to get the shape of the target drawing exactly the same as the shape of the source drawing.

source picture
(e.g., a photo)

drawing paper

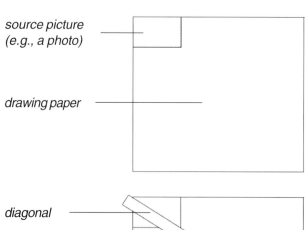

1 Place the source picture (such as a photo) in the upper left corner of the drawing paper.

diagonal

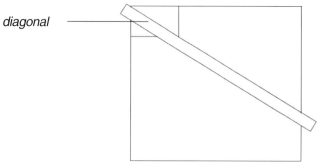

2 Lay a straightedge along the diagonal of the source picture.

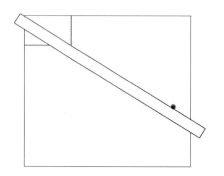

3 Decide how big you want the target picture to be. Place a dot to represent the lower right corner of the target picture.

source picture

target picture

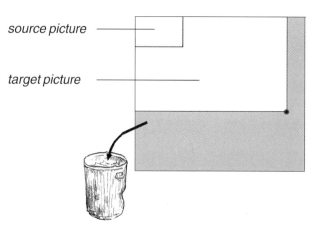

4 Draw a vertical line and a horizontal line through the dot. Discard the portion of drawing paper shown in gray—the remaining white area is your target drawing area and it's in exact proportion to the photo.

CHECKING SYMMETRY

Sometimes you'll draw an object asymmetrically on purpose, but often it's a goof you'd like to fix. Here's a good way to restore lost symmetry. It'll work with any object and with either horizontal, vertical, or oblique symmetry.

This bowl is out of whack. The right "half" looks a little more present-able than the left, so let's try to make a new left to match the right.

Tape a piece of tracing paper over the good part. Draw the good part on the tracing paper using a soft pencil.

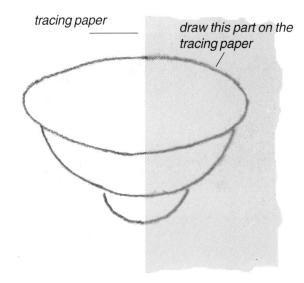

tracing paper

draw this part on the tracing paper

Flip the tracing paper over onto the sick side of the bowl. Trace over the new lines with a pencil—the soft-pencil marks that are now facedown will transfer to the drawing paper. The dotted lines show the new and im-proved bowl shape. The remainder goes to the dump!

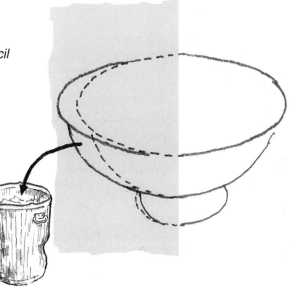

STAYING PUT

A surefire way to keep from wandering.

Lots of times, especially when drawing something up close, moving around while you draw can significantly affect what you see and, therefore, what you draw. In a later chapter on perspective, you'll see that whether you sit or stand can affect the way you see a scene because you're radically changing your eye level. But *lateral* movement can also disrupt things. If you begin a drawing standing at spot A and finish it an hour later standing at spot B, feet or yards away from A, you may have introduced lots of errors into your picture. So . . . unless you're perfectly aware of the effects of your movement and are happy with the results, it's a good idea to pick a spot and stick with it.

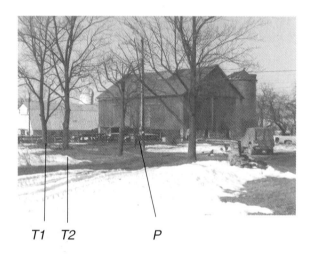

T1 T2 P

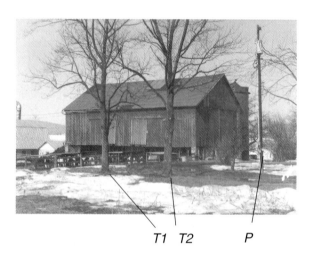

T1 T2 P

If you were at this scene making thumb-and-pencil measurements, you'd see significant differences between these two views from spots only twenty or thirty yards apart. In the left scene, the barn is considerably foreshortened—if you compare measurements, the long side of the barn at left is relatively much shorter than the long side of the barn at right.

There are many other differences: The power pole (P) has shifted more than you might expect; the little white building in the right picture is hidden in the left picture; the two trees (T1 and T2) are shifted and the other two trees visible in the left picture don't even show in the right picture. These differences are the result of shifting your viewpoint both left-right and far-near—the left photo was shot from farther away than the right.

CHAPTER FIVE
LANDSCAPE ELEMENTS

Let's look at some of the more common objects you might find in a landscape drawing. I'll show you some ways you might draw each of these elements, but keep in mind there are many other approaches, as well. Consider these examples, like everything else in this book, as starting places and allow yourself the freedom and pleasure of taking off in your own unique direction.

TREES

You might gather, after browsing through this book, that I like trees! Indeed, they are one of my favorite subjects. They offer a variety of shapes, textures, colors, sizes—and, to my mind, lots of grace and dignity.

Each species of tree has a fairly predictable shape, or contour, and it's worthwhile to learn to recognize those in your area. It's more important, though, to study the shape of the particular tree or trees you're about to draw. Any individual tree may diverge in interesting ways from its textbook outline. Do a few quick sketches to capture the shape of your tree, modify the shape to suit you and then begin filling in its details. As in drawing any subject, choose what you want to include and throw out anything that doesn't suit you.

Suppose your starting place is the pine tree in the photo, above right. I circled the tree and looked at it from several sides before deciding on this view, which I chose for both the raggedy shapes of the outer branches and the calligraphic tangle of bare limbs and trunks toward the center. The second photo zooms in on those branches and trunks.

On the following page are steps you might take in drawing this tree.

TREES

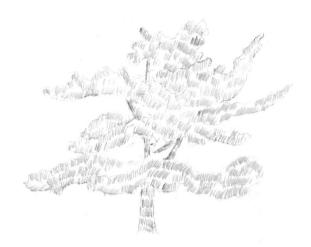

First I outline the tree, getting rid of the background clutter that makes the tree a little hard to find in the photo. I look for the big foliage masses and ignore the small. Then I decide where the light source (sun) will be. (For illustration purposes, the outline shown here is much darker than I actually drew it,)

Next, I lay in hatching strokes with a slightly chiseled H pencil. These strokes will be the lightest in the finished drawing. This rough stage can be done quickly.

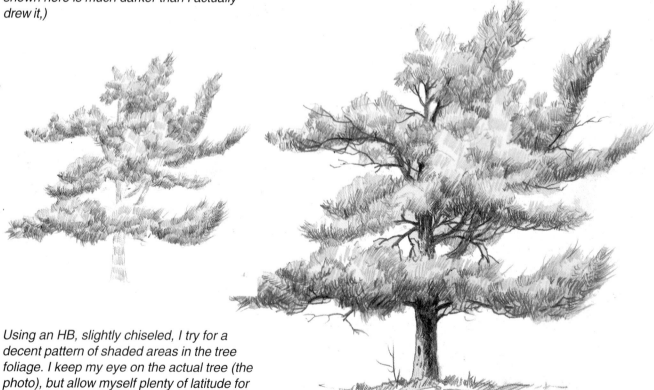

Using an HB, slightly chiseled, I try for a decent pattern of shaded areas in the tree foliage. I keep my eye on the actual tree (the photo), but allow myself plenty of latitude for changing things the way I want.

I finish up (this is the fun part!) with 2B crosshatching and finally, some 4B crosshatching. This is another view of the tree you saw at the end of Chapter Three, drawn here entirely with open strokes.

ROCKS

Rocks are occasionally the focus of a scene but are more often bit players. In either case they need to be rendered convincingly. The first thing to notice about a rock, aside from its shape, is its texture—that is, is it smooth or rough. For smooth rocks, either blended or open strokes can be effective; for rough rocks, open strokes would be my choice.

Notice whether the rocks you're drawing are cracked, moss-covered, shiny, dull, dark, light, and so on. Which sides are sunlit, which are in shadow. If cracked, which way do the cracks run—horizontally, vertically, obliquely, or a combination of directions.

On this page and the next are photos and translations of the photos into pencil drawings. Keep in mind that the amount of detail you draw depends a lot on the role of the rocks in your picture. If they're not the focus of the picture, take it easy and play them down.

Above, initial lay-in of rough rocks with H pencil, slightly chiseled. Below right, more rendering with HB and 2B, sharp.

Below, final stage using HB, 2B and 4B, slightly chiseled. I've taken some liberties with the original photo to form a more interesting, less symmetrical shape. Because the picture is unfinished, the rocks stand out too starkly; if the trees were rendered, the picture would hang together better. Try finishing the trees yourself.

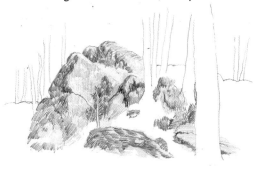

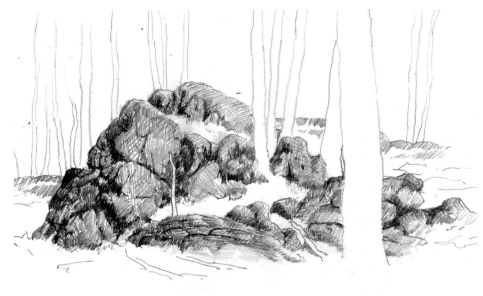

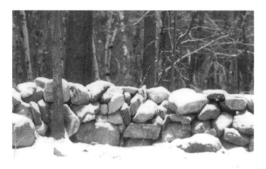

Photo courtesy of Jeffrey Metzger

ROCKS

In this example the rocks are relatively smooth, so they require a more gentle rendering than those in the preceding example. You can achieve this either by using blended strokes or fine open strokes or, as here, a combination of blended and open strokes.

I use a few open strokes, but mostly light blended strokes (HB), to shape the individual rocks and to suggest the woodsy background.

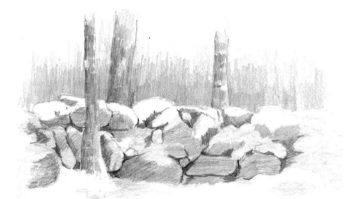

Still using an HB, I carry the drawing further . . .

. . . and finish with strengthening touches using 2B and 4B pencils. I use mostly blended strokes—that is, strokes with the lead held flat against the paper OR with chisel-shaped leads not held flat but used in continuous fashion, not lifting the pencil from the paper.

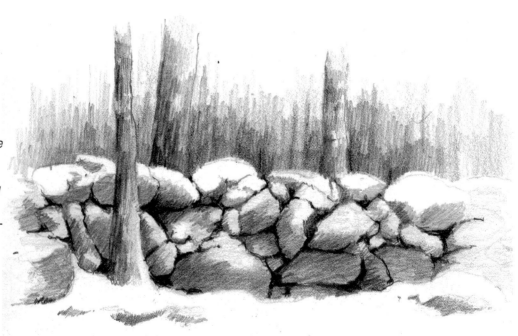

WATER

In many scenes, water is flat and uneventful; in others, it's full of action. For flat water, use horizontal strokes; for turbulent water, use oblique and vertical ones. In either case, you should use the fewest strokes possible—usually pale strokes—to represent water. Too strong a treatment will destroy the inherent "softness" of the subject.

In the sketch at right, the few light strokes representing the falling water are vertical, or nearly so. Where the water forms a pool at the bottom of the picture, the strokes are horizontal to suggest flatness, but they are gathered into shapes that suggest a little movement in the flat water.

The long horizontal strokes for the water in the scene below show that the water is flat and relatively calm. Note that I have not shown reflections of the distant treeline; I chose to omit reflections because the foreground is pretty busy and I felt the other areas of the picture should stay quiet. The combination of bright sun glare and slight rippling in the water can easily explain the absence of reflections.

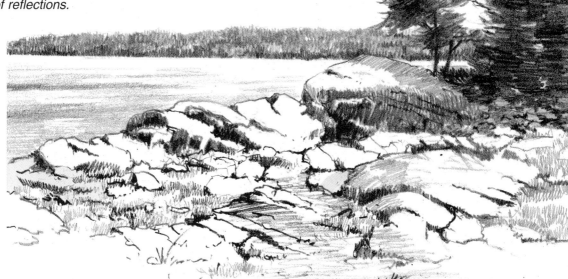

Drawing based on a photograph, courtesy of Jeffrey Metzger

BUILDINGS

TIP

You can save yourself a lot of wasted work if you do quickie value sketches before committing yourself to a value scheme. I drew the lower left scene first and then decided I preferred the values reversed, as at the right. Since the pictures are fairly large and involved a lot of work, I would have been smart to settle the direction of my light source early!

Probably the most important characteristic of a building in a landscape is its *shape*. Select buildings, or groups of them, that have interesting, un-boxlike shapes. If necessary, change a shape to give it more pizzazz.

When you include a building in a landscape, be sure you decide why it's there—is it the center of interest or only a supporting element. If the former, give it plenty of size and attention and if the latter, keep its size small enough that it doesn't take over the picture.

How you draw a building depends on many factors: Is it old, suggesting a lot of pencil texture? Is it smooth, suggesting a minimum of strokes? Is the surrounding landscape very busy, so maybe the building should be less busy? Are there strong shadows cast on its surfaces? Is the light source in the right place to give you the best shadows? Are you doing a close-up and zeroing in on details? Here are a few of the many ways you might treat buildings.

Country House
Pencil on Strathmore 500 series illustration board, regular surface, 17" x 19" Collection of Lori and Doug Kraus, Mt. Sinai, NY

Here are two versions of the same scene with some minor differences and one major difference—the location of the light source. Simply reversing the light direction causes a dramatic change in the picture.

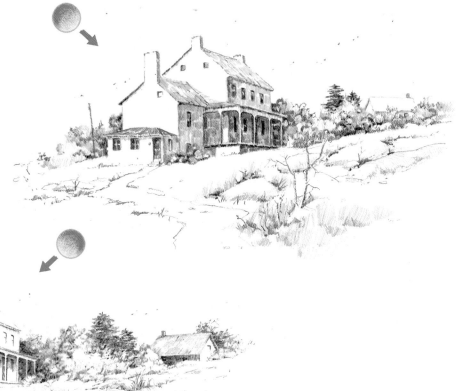

BUILDINGS

Often, the view you choose is critical. A plain front or side view, for instance, might give you a bland, boxy shape, but a three-quarter view (so you see both the side and the front) might dramatically improve your design. An added benefit of a three-quarter view is that converging linear perspective lines come into play and help add depth to the picture.

How much detail should you include? If you're doing a close-up, plenty of detail may be appropriate. But if your building is at some distance, you have a choice: You can include lots of detail and take the chance all that detail will not break up the building shape too much, or you can simplify detail to help keep the focus on the main shapes. The large section of the building shown on the preceding page is stone and the front section is wood siding, both involving plenty of detail. But I preferred to play up the large white shapes of the sunlit sides of the building—putting too much detail into those shapes would have brought a knock on my door from the clutter police.

Here are three views of a basic house. The first two are not very exciting, but turning the house to a three-quarter view gives us a better shape.

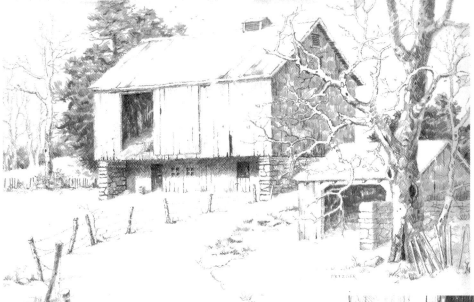

Barn and Shed
Pencil on Canson Bristol, plate finish, 8" x 12"

Barn Overhang
Pencil on Strathmore 500 series Bristol, plate finish, 3" x 5"

In the picture above, the area of the overhang is not detailed because that's not the focus of the picture. In the drawing at the right, the area of the overhang is the focus of the picture, so more detail makes sense.

TIP

Shadows may be drawn with either open or blended strokes. Blended strokes, as in the ball below, can be used to achieve a smooth finish; open strokes, as on the opposite page, create a rougher look. Use whichever style best complements the rest of the picture. It's okay to mix styles, provided one style is dominant.

SHADOWS

Shadows aren't *things*, of course, but they're important landscape elements. Shadows are areas darker than surrounding areas because something is blocking the light. In painting it's important to accept that shadows are almost never black. On the contrary, almost every shadow has within it a rich play of color, including the colors of the area over which the shadow falls and color reflected into the shadow from surrounding objects.

In a black-and-white picture you obviously don't have a chance to include other colors, but there are nuances you can observe and include in your drawing. Relatively small gradations among the grays that make up a shadow will enliven the picture considerably. The illustration below shows the play of light and shadow on a simple object, a ball.

TIP

If you're drawing from memory or imagination and you're not sure about how a shadow might fall over an object, make a simple model of the object (e.g., a cardboard house). Shine a flashlight on the object and see how the shadows fall. Five or ten minutes doing this may save you from drawing or painting shadows that look wrong.

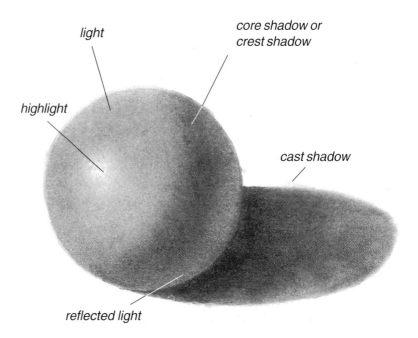

This drawing is an example of *chiaroscuro, the use of a range of values (light through dark) to create an illusion of form, or solidity. In this example, where there is a single light source, the cast shadow is fairly sharp. In situations where there are two or more light sources (such as lamps) cast shadows are less sharp—in fact, there may be two or more distinct, overlapping cast shadows.*

A cast shadow is usually darkest near the object that's blocking the light and lighter at the edges farthest from the object. That's because light reflected from surrounding objects invades and lightens the parts of the shadow that are most out in the open.

SHADOWS

Shadows can serve many purposes in a drawing: (1) They offer value contrasts; (2) they may help knit together parts of the drawing; (3) they help describe the shapes over which they fall; (4) they help to anchor other objects in place; (5) they may signal the time of day; (6) they may set the mood for a picture; (7) they may increase the illusion of depth.

School Stuff
Pencil on Strathmore 400 series Bristol paper, smooth finish, 10" x 8"

Shadows help create depth (e.g. looking down into the sneakers); they help tie all the objects together; they suggest form (e.g., the roundness of the ball).

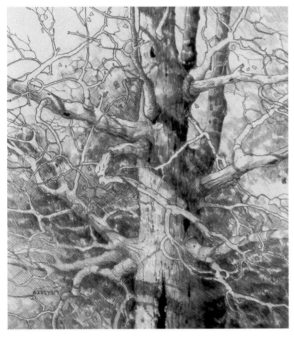

Woods Textures
Pencil on Canson Bristol, plate finish, 7" x 6 ½"
Collection, Barbara Weiss, Chevy Chase, MD

Shadows in the background help set the mood and at the same time provide important value contrasts; cast shadows help define the curve of the trunk; small shadows in crevices and holes contribute to the illusion of texture; light-shadow contrasts show that the light source is at the left.

Apples and Brandy
Pencil on Bristol paper, vellum finish, 4 ½" x 7"

Shadows help define the forms of objects, but mostly, in this picture, they add spark by providing strong value contrasts, especially at the far right and far left.

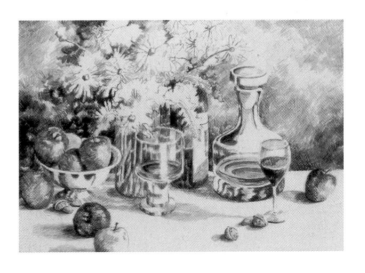

REFLECTIONS

Since you're working in black-and-white and can't take advantage of the colors presented by most reflections, you have to pay attention to *values*. Effective reflections can be drawn using appropriate shades of white, gray and black.

There are basically two breeds of reflections: smooth and broken. Smooth reflections occur on surfaces such as glass, metal and still water; light bounces from such surfaces in an orderly way. Broken reflections happen on rough surfaces such as rippled water; light bounces from those surfaces in a scattered manner.

The sensible way to draw or paint reflections is to observe them closely and draw or paint what you see—no amount of bookish theory can compete with your powers of observation. But sometimes, when you're inventing a scene and therefore not observing, you may wonder if a reflection you've dreamed up makes sense. If you'll learn and apply one simple rule, you'll be able to figure out whether a made-up reflection is reasonable.

angle of incidence = angle of reflection

Well, what on earth does that mean? It means that when a beam of light strikes a smooth reflecting surface at an angle it bounces away at that same angle, like this:

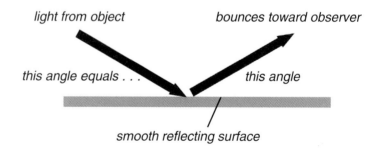

light from object bounces toward observer

this angle equals . . . this angle

smooth reflecting surface

Armed with just that much knowledge, you can make reasonable judgments about reflections. For much more on this subject, see one of the perspective books listed in the Bibliography.

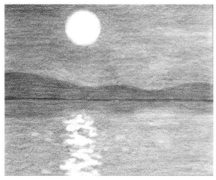

The moon reflects from very still water in this manner . . .

. . . and from choppy water in this manner. The still water behaves like an ordinary flat mirror, while the choppy water acts like zillions of tiny, individual mirrors tilted in lots of directions so they scatter the light.

TIP

LEAH'S LAW

Artist Leah Henrici argues that dark objects have lighter reflections and lighter objects have darker reflections. This appears to be generally true, at least in outdoor settings. Further, objects that have medium value have reflections that are also of medium value. You may find special situations that argue against Leah's Law, but, from my observations, the Law holds true.

REFLECTIONS

Reflections are tricky—you can sometimes see details in a reflection that you can't see in the object. For example, if you see a house at the edge of a pond, you'll be able to see the underside of the roof overhang in the reflection even though you don't see that underside in the actual house. There are two ways to get things right: (1) Observe an actual scene, rather than make something up; (2) build a simple model of the object you're trying to draw and look at its reflection after placing it on a flat mirror.

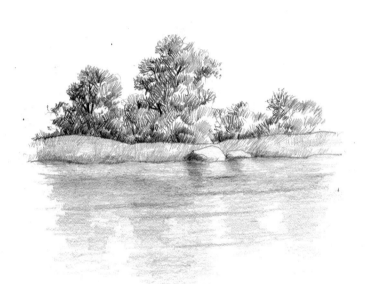

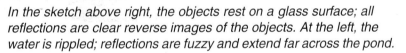

In the sketch above right, the objects rest on a glass surface; all reflections are clear reverse images of the objects. At the left, the water is rippled; reflections are fuzzy and extend far across the pond.

A vertical object has a vertical reflection; a leaning object has a reflection that leans in the same direction as the object.

SKIES

In many drawings, skies are left white to serve as a plain backdrop for a landscape. But sometimes the sky is a more important element in the picture and must be addressed directly. If the sky is of paramount importance, it may be rendered using plenty of deep values and vigorous pencil strokes. If the sky is only a supporting element, it should be treated delicately so that it doesn't look too aggressive in the finished picture. Here are just a few possible sky treatments.

Light horizontal hatching.

Horizontal blended strokes in sky; circular blended strokes in clouds.

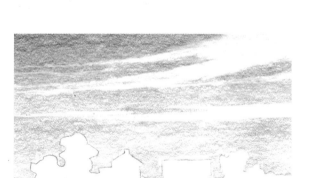

Blended strokes; clouds erased with Pink Pearl eraser.

Oblique blended strokes.

Blended strokes; moon erased with Pink Pearl eraser using circular erasing shield.

Oblique hatched strokes in sky; blended strokes in clouds, smeared with a stump.

ROADS AND PATHS

Roads (and streets and paths) often are a unifying element in a picture. They tie together other elements, such as buildings. At other times they help aim the eye at the center of interest and in still other cases they show the contour of the land by the way they rise or dip or wander. To make roads effective, it's important to follow the rules of linear perspective discussed in Chapter Six.

The addition of a road ties together the scattered buildings; it also helps emphasize perspective depth.

Showing the dip in this road automatically tells the viewer the land is rolling, not flat.

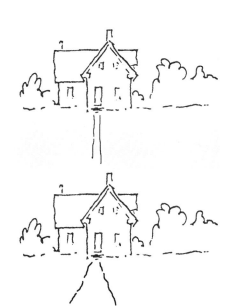

Here are just a few ways to add a path to a house. The path at left center is clearly too narrow, showing no perspective. Below left is better. The path at upper right is too broad to be realistic. At right center is a believable curved path. At bottom right, the path turns and then lies parallel to the front of the house.

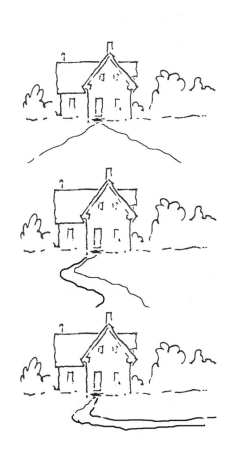

HILLS AND FIELDS

TIP

When drawing hills (or mountains), use a harder lead or gentler strokes to make the distant hills paler than the closer ones.
Also, don't forget where the sun is—hills have light sides and shadowed sides just like any other object.

Often a field is an incidental element in a drawing, expressed with little detail other than some sort of boundaries, such as fences or hedgerows. But sometimes a field may be more important, especially if it's in the foreground (as in *Country House* under BUILDINGS earlier in this chapter). In *Country House,* the rocks and weeds are there to balance the weight of the buildings and trees running across the upper part of the picture.

Hills, too, are often only a backdrop for some other part of the picture, and they usually call for simple treatment. The sketches here show just a few ways hills and fields might be handled.

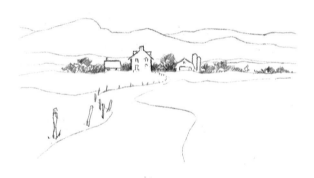

Simple contour sketch emphasizing the buildings and trees.

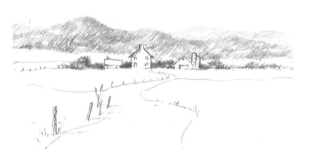

Added emphasis on hills, but fields left plain.

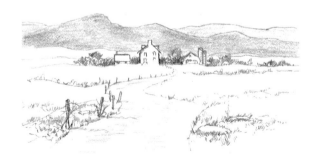

Blended treatment in the hills, more detail in the foreground.

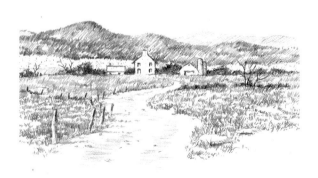

Fully textured version.

ODDS AND ENDS

All around us are objects that can be used as interesting details in a landscape drawing or, in many cases, as subjects of drawings. You may tend to look past objects such as power poles, trash cans, peeling paint, broken-down doors, abandoned vehicles and so on—in fact, they may seem ugly to you. But many a fine painting or drawing has as its center the worn or the common or the discarded.

Consider worm's-eye or bird's-eye views rather than normal, straight-on views.

These bricks have recessed mortar joints, so the edges of each brick cast thin shadows onto the mortar. In this case, the sun is at the upper left, so the shadows are cast to the right and downward. Little details such as these shadows help give a feeling of depth and reality.

The posts get smaller and the spaces between them get smaller as they recede (see the chapter on perspective).

Some posts may be braced by a second post.

Be a careful observer. Notice that the spacing of the horizontal wires gets smaller near the ground— that's to screen out small animals.

Look for odd things, such as holes in the fence.

ODDS AND ENDS

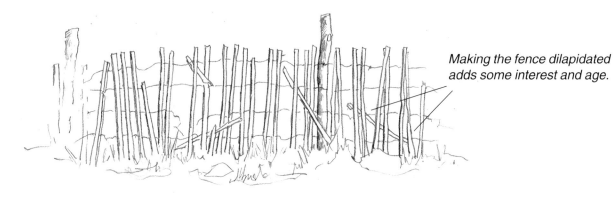

Making the fence dilapidated adds some interest and age.

Another type of fence is a snow fence. I often use them as a bit of calligraphy or, sometimes, to help tie together other elements in a picture. One of my students, as she watched me paint yet another snow fence, grumped: "So, what's with the snow fences already?"

Dormers provide good shapes for breaking up an otherwise boring roof. Look at them from a variety of positions to get the best shapes. Don't forget linear perspective—I've drawn in a few sloping perspective lines.

In this type of window (called "double-hung") the bottom window is farther back than the top so the two sections can slide past one another.

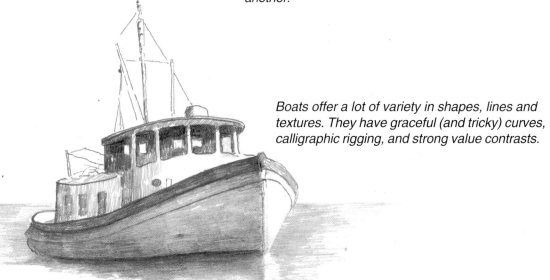

Boats offer a lot of variety in shapes, lines and textures. They have graceful (and tricky) curves, calligraphic rigging, and strong value contrasts.

ODDS AND ENDS

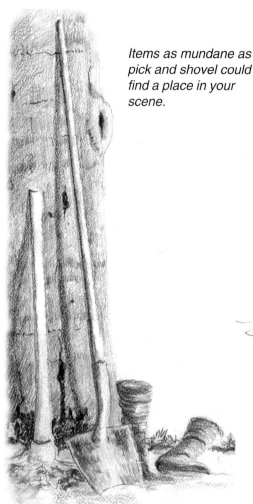

Items as mundane as a pick and shovel could find a place in your scene.

An old truck might make a good center of interest or at least an interesting bit player.

Farm objects like this rusted hinge make good subjects for close-up drawings. And even if you don't care for such items as drawing subjects, looking at them carefully enough to draw them in detail is an excellent way to sharpen your powers of observation.

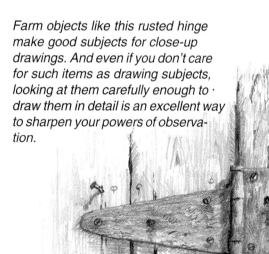

I often use items such as barrels and buckets to introduce a bit of curvature into an otherwise linear drawing.

ODDS AND ENDS

There may be places in your landscapes for a bit of wildlife—or animals could even be the center of interest.

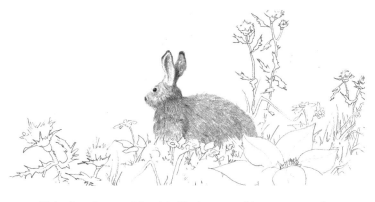

This drawing and the bird below combine open and contour strokes.

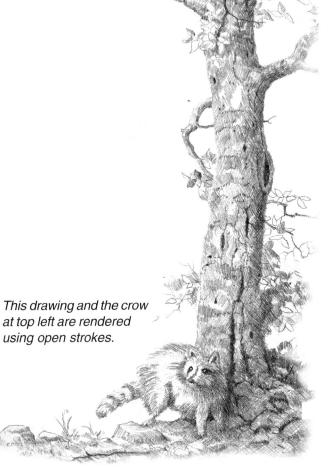

This drawing and the crow at top left are rendered using open strokes.

The illustrations on this page are from my children's book, *Friendship Farm*.

CHAPTER SIX
PERSPECTIVE

I don't know why people run for cover at the mention of the word perspective. It's really a pretty straightforward subject. *Perspective is any technique that makes an image on a two-dimensional piece of paper look as if it has three dimensions.* I'll cover each of the more useful techniques briefly, ending with the one called *linear* perspective—we'll spend extra time and space on that one because it's more involved than the others and often more critical to the success of a drawing. For much more on all the perspective techniques, see the books listed in the Bibliography.

From cover of book, *Perspective Without Pain* (see Bibliography).

ATMOSPHERIC PERSPECTIVE

A distant hill, mountain, or city skyline looks pale, indistinct and bluish because you're seeing it through a veil of impure air. All the bits of impurities in the air—soot, dust, water—help to change the appearance of distant objects in two ways: First, the impure air blocks some of the light from the object so that it never reaches your eye; that makes the object indistinct or pale. Second, the impure air filters out some of the reddish wavelengths of light and allows mostly the bluish wavelengths to get through, so the object appears cooler (bluer) than it actually is.

Since we *see* things that way, it's reasonable to draw or paint them that way. Make a distant hill or mountain pale and indistinct in your drawing and you're mimicking the way we see things in nature. Atmospheric perspective (also called *aerial perspective*) is easier to represent in a colored picture, since you can show the blueness of a distant object as well as its paleness. In a drawing you're limited to showing the paleness.

Be on the lookout for scenes in nature that don't follow the rules. If you were standing on some high perch and looking out over a series of hills and mountains, you might easily spot some hills far away that seem much darker than the closer ones—an apparent departure from the way atmospheric perspective works. That can happen for a number of reasons—for example, a particular hill might be thick with dark evergreens, or clouds may be casting strong shadows on some of the hills.

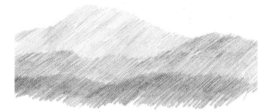

Three ranges of hills distant from the viewer and looking pale because of atmospheric perspective.

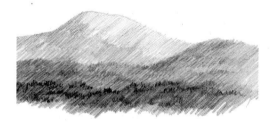

The same three hills on a clearer day, less affected by atmospheric perspective.

OVERLAP

One of the simplest techniques for suggesting depth, or distance, is to place one object in front of another. This always clearly signals that one object is farther back than the other. On the preceding page, the middle hill overlaps the most distant hill and leaves no doubt which hill is closer and which is farther back.

At left, you have no clue whether the house or the tree (or neither) is closer to you until you overlap the two. Overlapping them instantly introduces some depth. In the sketch below, overlapping one branch with another or overlapping a branch with the trunk changes the picture from a flat silhouette to one with considerable depth.

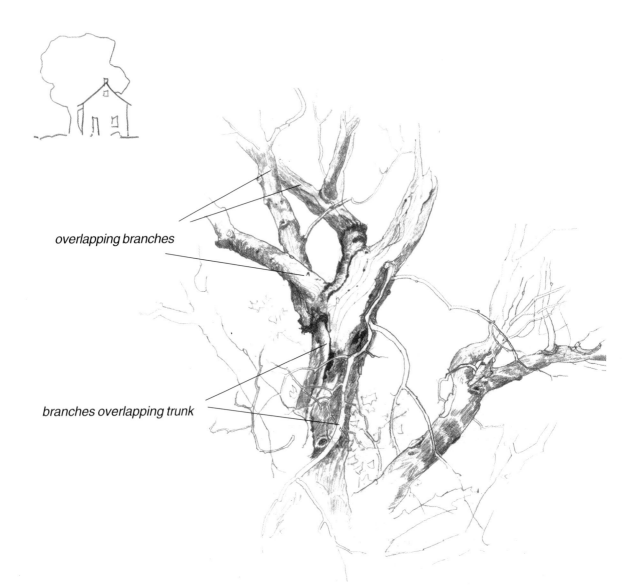

overlapping branches

branches overlapping trunk

DETAIL AND EDGES

By drawing distant objects with less detail and softer edges than nearer objects, you increase the feeling of distance. To soften distant edges, outline them just faintly enough that you can see where they are and then fill in with either blended or open strokes using light leads. Avoid dark, definite edges that automatically suggest the objects are nearer than you want them to be.

The sketches at the right show how objects can be made to seem more distant by softening edges and minimizing details. Making the distant house smaller, of course, helps emphasize distance.

A house at some distance . . .

. . . and the same house closer.

SIZE AND SPACE

Look at a row of fence posts and usually you'll find the posts all about the same size and spaced the same distances apart. But look at that same fence at an angle—that is, with the fence receding from you—and the posts no longer look the same size, nor does their spacing seem uniform. What you're observing is an important form of perspective and you can make good use of this type of perspective to significantly deepen your pictures.

Receding power poles.

Receding picket fence.

Horizontal objects, such as these railroad ties, recede in the same manner as vertical objects.

MODELING

To make a convincing "three-dimensional" picture, we need to consider not only the miles that may separate a foreground from a distant mountain, but also the inches or feet that measure the thickness of an apple or a tree trunk. If you want to show depth in your picture, you have to do so in little ways as well as big. A flat apple in a still life will not give the still life any depth. A flat tree in a landscape will not help suggest distance at all.

An important way to give objects depth is to *model* them well. Modeling is the use of shadow, and sometimes curved lines, to suggest thickness.

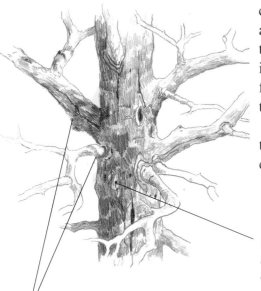

Curved lines help show the thickness of branches.

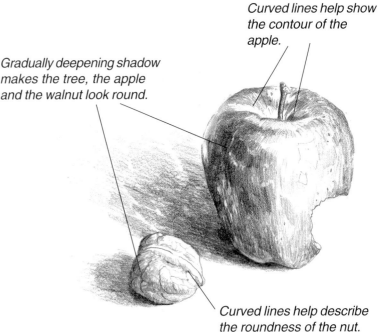

Curved lines help show the contour of the apple.

Gradually deepening shadow makes the tree, the apple and the walnut look round.

Curved lines help describe the roundness of the nut.

Modeling occurs on all shapes, not only round ones. The shadow cast on the spines of these books helps to describe their shapes, much like a stack of bricks with recessed mortar. The shadowed ends of the books also help give them depth.

To model an object effectively, you must first settle on the location of the light source and keep its location consistent throughout the drawing—don't put the light source in one position for one object and in a different position for another object in the same drawing. Next, it's important to understand the nuances of light and shadow. The apple above, for instance, isn't all light on the lighted side and all dark on the side away from the light. Look at the "dark" side and see that, far from being solid black, it has bits of invading light reflected from surrounding surfaces. Seeing such variations is especially helpful in drawing or painting a still life, but they occur in open landscape as well. Learning to see these lovely bouncing lights will greatly improve your drawing and painting.

MODELING

Any object may be modeled using shading, sometimes combined with curved lines. You can often make modeling easier by combining it with other techniques, such as "drawing through," discussed in an earlier chapter, or by visualizing an object as a set of geometric solids such as cylinders, cones, spheres and so on. If you consider the tree on the opposite page, for instance, as a collection of cylinders (or cans or plumbing pipes), you may find it easier to visualize it and draw it as a three-dimensional object. You can do the same with practically any object.

TIP

To help get a handle on the roundness or thickness or general shape of an object, use the technique called "drawing through" discussed in an earlier chapter. It's a great way to force yourself to see all sides of an object, even the hidden ones.

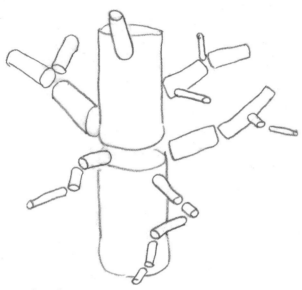

No matter what its shape, any three-dimensional object can be modeled. This tower has both flat and curved surfaces, making it an interesting subject for modeling.

Pretend you're a plumber and look at the tree on the opposite page as a series of pipes. This will help you see the tree's dimensions and draw it more realistically. This sort of diagramming helps especially in drawing the curved joints where branches attach to the trunk or to other branches.

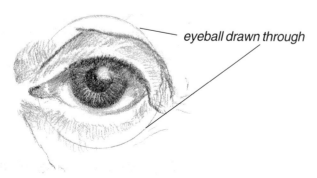

eyeball drawn through

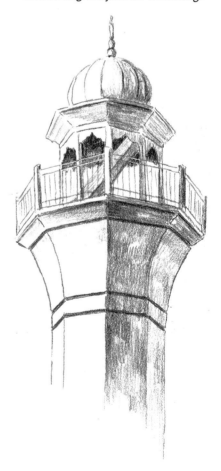

As small an object as an eyeball needs modeling to make it look right. Here you can see the ball curve away into shadow on both sides and there is cast shadow from the upper lid. The entire eyeball is shown by drawing through.

FORESHORTENING

Foreshortening is the technique of suggesting depth by shortening receding lines. A common example is drawing an arm or a leg shorter than it really is because it's aiming at you or away from you. Also common is the drawing of tree limbs shorter as they advance or recede. Even the receding wall of a house seen in perspective is an example of foreshortening.

Drawing foreshortened objects is often difficult because we get hung up on what we *know* and ignore what we *see*. For example, we know the arm in the illustration at left is a certain length (a) and that knowledge makes it difficult to draw it as we see it (b). The only reasonable way around the problem is to measure—and trust your measurements.

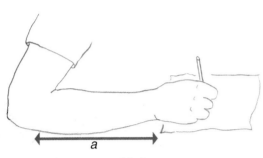

Here's how long this forearm actually is . . .

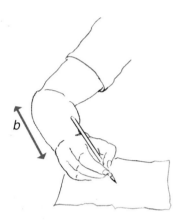

. . . but in this view the forearm is foreshortened (and so is the hand).

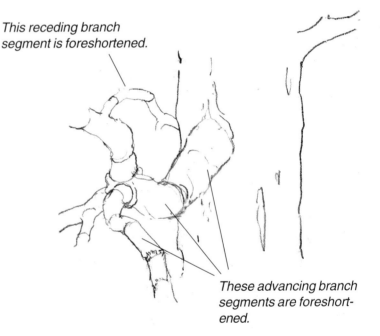

This receding branch segment is foreshortened.

These advancing branch segments are foreshortened.

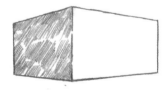

Both sides of this box are foreshortened. This is an example of two-point linear perspective (see following section).

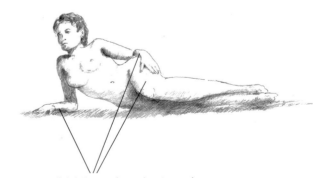

Forearms and thigh are foreshortened.

LINEAR PERSPECTIVE

This is the perspective technique that drives people nuts. Too complicated, they shriek. Too mathematical. Too this, too that. But that's all hogwash. Linear perspective is basically simple—in fact, it's quite intuitive.

 Linear perspective is the technique of drawing parallel lines so they converge, thus giving an illusion of distance. Whoa! Parallel lines don't ever meet, do they? Well, in high school geometry they don't, but to our *eyes* they do. Here's a simple example: Look down a long straight road and what do you see? The edges of the road seem to come together in the distance, don't they? That's the way we *see*, even though we know the edges of the road are parallel and in reality never meet. All of linear perspective is based on this idea:

vanishing point

If you extend the parallel sides of this dock, they'll meet. Where they meet is called a vanishing point.

 Parallel lines that recede from the observer "meet" in the distance at a point we call the vanishing point.

Here are some examples of parallel lines that meet at a vanishing point.

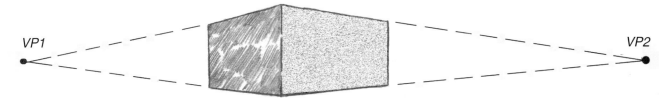

VP1 VP2

This box is turned so you see two of its sides. The parallel edges of each side meet at a vanishing point. In this case there are two vanishing points, VP1 and VP2. This is called two-point perspective.

The only parallel lines that don't meet are those that are not receding from you—e.g., lines that travel left to right or top to bottom across the picture surface, as in the example below. Since there is only one vanishing point in this example, this is called one-point perspective.

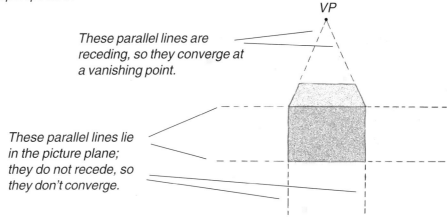

VP

These parallel lines are receding, so they converge at a vanishing point.

These parallel lines lie in the picture plane; they do not recede, so they don't converge.

LINEAR PERSPECTIVE: EYE LEVEL

To get at the workings of linear perspective, it's absolutely necessary to understand the concept of eye level because everything that happens in linear perspective is related to eye level.

Imagine yourself standing or sitting and looking straight ahead, with your head neither tilted up nor down. Now imagine a humongous sheet of glass parallel to the ground, passing right through your eyes, and extending everywhere as far as you can see. That sheet of glass represents your *eye level*. All the things you see are either right on that eye level or above it or below it.

Here is a still life setup as seen from a standing position . . .

. . . and here is the same still life seen from a sitting position. The difference between the two scenes is the location of the eye level. In the top photo, the eye level is high; in the bottom photo, the eye level is lower.

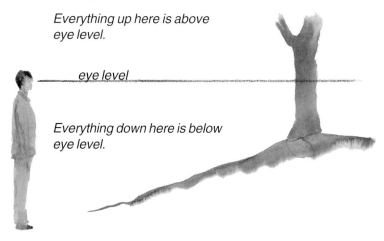

Everything up here is above eye level.

eye level

Everything down here is below eye level.

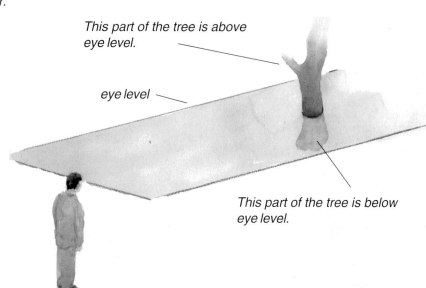

This part of the tree is above eye level.

eye level

This part of the tree is below eye level.

LINEAR PERSPECTIVE: EYE LEVEL

What we're really dealing with when we talk about eye level is the horizon—the imaginary line where the sky meets the ocean or where the sky meets a flat field. Eye level and horizon are synonymous. The reason we stick with the term "eye level" instead of "horizon" is that we can't always *see* the horizon because it's blocked by mountains, buildings, and so on.

As you begin any realistic drawing, the first thing to do is to choose an eye level. Look at the still life on the preceding page—as you see, your choice of eye level is critical. If you stand, you see one scene, but if you sit you see another. Changing your eye level changes *everything*. Once you choose an eye level, stick with it. If you change your eye level midway through a picture, you'll have to go back and redraw what you've already done so everything corresponds to the new eye level.

Once you've settled on an eye level (I usually draw a light horizontal line to remind myself where the eye level is), now you relate everything to that eye level. Suppose you're drawing two boxes, one above eye level and one below, like this:

TIP

Each realistic picture is allowed only one eye level. Only if you're from the planet Zecton where critters have three eyes, one above the other, do you have more than one eye level. Here on earth, each of us has a single eye level.

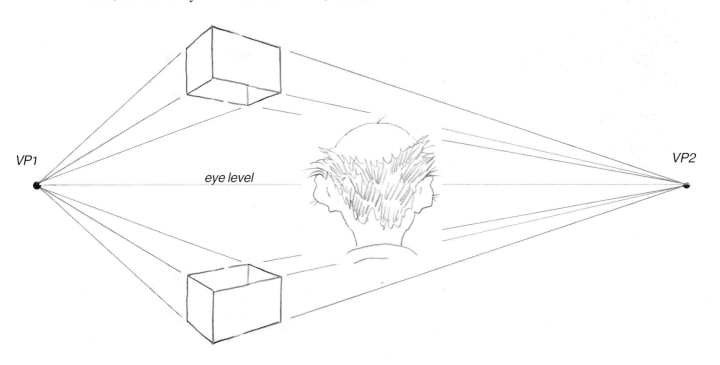

VP1

eye level

VP2

There are several important things to notice about this drawing: First, both vanishing points are on the eye level; second all receding parallel lines below eye level slant UP; third, all receding parallel lines above eye level slant DOWN.

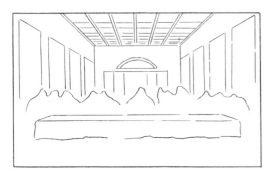

A house in one-point perspective, above eye level (up on a hill). If you could see through the hill, the large shaded area would represent the underside (floor) of the house. The other shaded areas are the undersides of the roof overhang.

LINEAR PERSPECTIVE: EYE LEVEL

What we've talked about so far is at the core of any understanding of linear perspective, so let's review:

1. Parallel lines that recede from the observer "meet" in the distance at a point we call the vanishing point.

2. Vanishing points fall on an imaginary horizontal line called the eye level.

3. Receding parallel lines below eye level slant UP toward the eye level; receding parallel lines above eye level slant DOWN toward the eye level.

All the parallel lines we've considered so far are *horizontal* parallel lines. Later we'll discuss what happens to *vertical* or *oblique* parallel lines.

There may be lots of vanishing points, depending on the shape of the object we're drawing, but mostly we'll be concerned with either a single vanishing point or two vanishing points. Later we'll look at situations where there are three or more.

LINEAR PERSPECTIVE: ONE-POINT

One-point perspective occurs when dealing with an object or objects whose receding lines all converge at a single vanishing point (on the eye level, of course), as in the examples on this page. Pictures using one-point perspective are usually fairly symmetrical, a situation more common to formal or religious motifs than to landscapes. Probably the most famous picture in one-point perspective is *The Last Supper*, by Leonardo da Vinci.

Above is the layout for Leonardo's Last Supper. *The sketch below shows some of the receding parallel lines, all meeting at a single vanishing point.*

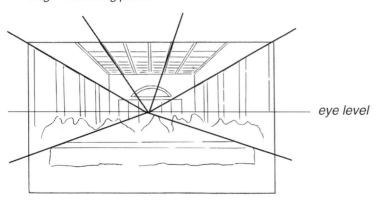

LINEAR PERSPECTIVE: TWO-POINT

One-point perspective involves a head-on view of an object, so you don't see much or any of the sides of the object. Two-point perspective deals with objects turned at an angle so you see two sides and each side has its own receding parallel edges meeting at two separate vanishing points, both on the eye level line.

 Most drawings involving rectangular objects use two-point perspective. Often an object shown in two-point offers a better shape and more design possibilities than that same object shown in one-point. There are three common ways objects may be situated: above eye level, below eye level and sitting at eye level. Here are three houses, one on a hill, one at eye level and one down in a valley below eye level.

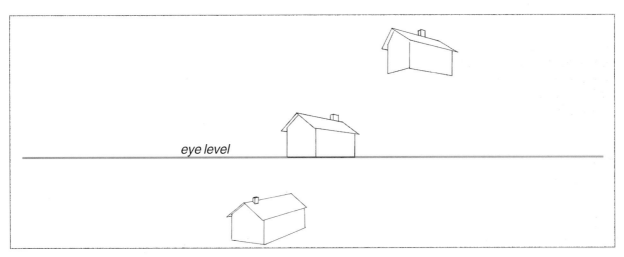

Each house is in two-point perspective and each has its own pair of vanishing points, some of which are off the page to the right or left. ALL the vanishing points lie on the eye level line.

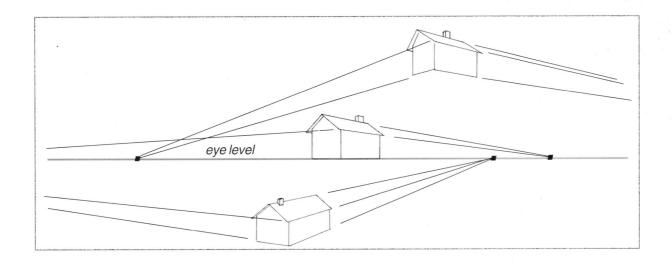

LINEAR PERSPECTIVE: VANISHING POINTS

Where do we stick those pesky vanishing points? Is there some deep math involved? Magic? Actually, we don't *put* the VPs anywhere. They end up where they end up only because we've drawn some proper sloping lines and where a sloping line crosses the eye level—presto! A vanishing point!

Let's consider one way you might go about drawing, say, a barn. You wander around until you find both a suitable view of the barn and a comfortable spot to set up your easel. You decide roughly what parts of the scene you want to include in your drawing. You draw a faint line across your paper representing your eye level; let's say the bulk of the barn is above your eye level. You scribble a few lines (faint) showing the barn's placement. You step back to admire your layout and glance around to make sure there's not a bull eyeing you.

No bull, so you take a look at a main sloping line of the barn, perhaps the roof line. It slants left so you draw a (light!) line slanting left. You draw other lines that slant left. When these guidelines are done, you eyeball the left-slanting lines and mentally (or even physically, with light lines on your paper) extend them so they intersect the eye level line. You do the same with the right-slanting lines. If all the left-slanting lines meet the eye level at about the same point, and if all the right-slanting lines meet at a second point on the eye level line, you've probably got a masterpiece in the works.

And guess what! You never drew a single vanishing point! So what's the big deal about vanishing points? They're really only a way to help you check the accuracy of what you've drawn—if the lines that are supposed to meet at a vanishing point do in fact meet there, you've probably drawn well.

But suppose things *don't* look right. On the next page we'll try a different approach, one more likely to get you off to a better start.

LINEAR PERSPECTIVE: VANISHING POINTS

Let's revisit the barn drawing and start a little differently. Pick out an important sloping line, such as a roof line, *using your perspective jaws* or at least a pencil held out in front of you mimicking the slant of the roof line. Get that first line drawn on your paper as accurately as you can. Extend that line (tape some scrap paper to the sides of your drawing paper if necessary) until it crosses your eye level line. Now you've located a vanishing point. If you've been careful about it, all you need to do is make each of the other lines that slant in that direction hit that vanishing point—sort of connecting the dots.

 If you feel cheated because you really want to play with those VPs, try moving them left and right along the eye level and see how those moves affect your drawing.

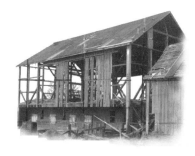

This is your subject. Your eye level is even with the top of the recessed part of the barn.

Draw in the eye level.

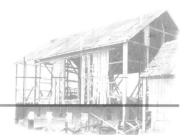

Use your perspective jaws to help draw a line representing the slope of the roof. Where that line intersects the eye level line, that is a vanishing point.

Now you have a point to aim at! Draw the other left-slanting lines from the barn to the VP.

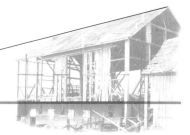

When you're happy with the left-slanting lines, do the same for right-slanting lines. Now, using those slanted lines as guides, go ahead and enjoy rendering the barn freehand. The lines you've established will keep you from going far astray.

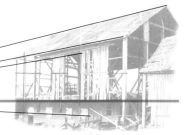

LINEAR PERSPECTIVE: RECTANGLES

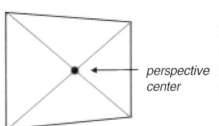

true center

A rectangle, such as the side of a house. Its center is where its diagonals cross.

perspective center

When a rectangle is in perspective, its perspective center is where its diagonals cross.

If you have a house in two-point perspective, the rectangular sides of the house no longer look like true rectangles—in perspective each side gets somewhat distorted. The example at left shows how to find the "center" of a rectangle in perspective. This center is called the perspective center. As you can see, the perspective center is shifted a bit away from true center. The perspective center is important because it's the key to locating such things as doors, windows and roof peaks. The sketches at bottom left show how the perspective center may be used to accurately locate the peak of a roof.

Notice how different the rectangle looks in perspective. It's shorter, left to right, than the original rectangle—that's an example of foreshortening, discussed earlier. Each receding side is shorter than in the original and the right-hand vertical is also shorter.

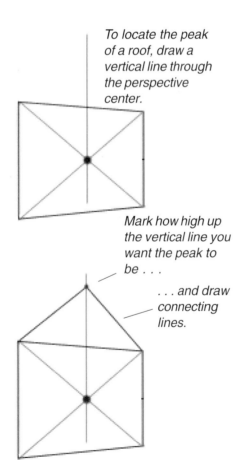

To locate the peak of a roof, draw a vertical line through the perspective center.

Mark how high up the vertical line you want the peak to be . . .

. . . and draw connecting lines.

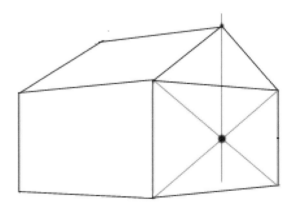

Here's the house with a second side and a roof added. If you need to find the perspective center of the second side, draw its diagonals and see where they cross.

LINEAR PERSPECTIVE: THREE-POINT

You may have noticed we've dealt so far with horizontal lines meeting at vanishing points, but we've said precious little about *vertical* lines. The reason: Most vertical lines don't recede (not much, anyway) from the viewer. So in most cases the vertical sides of buildings or the vertical edges of objects in a still life may be simply treated as vertical lines in your drawing.

Sometimes, however, vertical lines are so long that they stretch far away from the eye and—heaven help us— they appear to converge the same way horizontal lines converge! They aim for a vanishing point—yes, a *third* vanishing point. An example is a skyscraper or a tall tower. Now, it's true that many, if not most, skyscrapers actually are built with a slight taper toward their tops, so naturally their vertical edges "converge." But suppose we have a building with no natural taper and suppose we're looking up at it from the sidewalk—its vertical edges will seem to converge exactly the way the edges of a road on flat ground seem to converge.

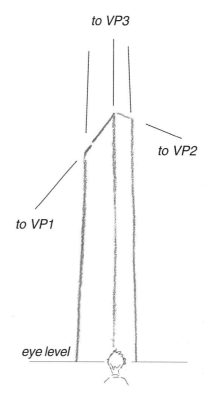

If you're at street level looking up, the sides of the building will seem to converge at a point high in the sky. The horizontal edges recede as usual, converging at vanishing points on the eye level. Even though you might be looking up toward the top of the building, your eye level *is* still where it always is—a horizontal plane passing through your eyes.

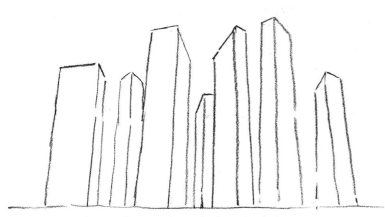

A worm's-eye view of a bunch of sky-scrapers. Eye level is at street level..

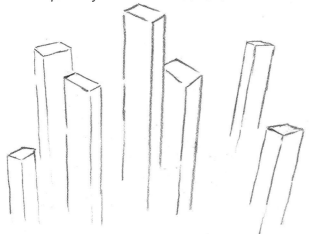

A bird's-eye view of skyscrapers. Eye level is high, as from an airplane.

LINEAR PERSPECTIVE: INCLINES

There is yet another kind of vanishing point that may be important in a drawing involving inclined surfaces. The cheese wedge at lower left has the usual converging lines you'd expect in two-point perspective, but it also has a pair of lines (the sloping edges) that slightly converge as they recede from you. The convergence is barely noticeable in this small object and can easily be ignored. But in other objects, such as a roof, the convergence should be taken into account. Below is a typical slanting roof and on the next page is a warehouse with some complicated perspective, including ramps.

A wedge of cheese in profile . . .

. . . and in perspective.

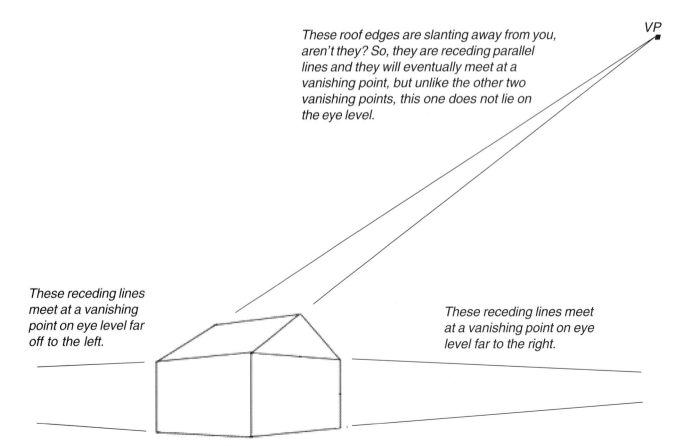

These roof edges are slanting away from you, aren't they? So, they are receding parallel lines and they will eventually meet at a vanishing point, but unlike the other two vanishing points, this one does not lie on the eye level.

VP

These receding lines meet at a vanishing point on eye level far off to the left.

These receding lines meet at a vanishing point on eye level far to the right.

LINEAR PERSPECTIVE: INCLINES

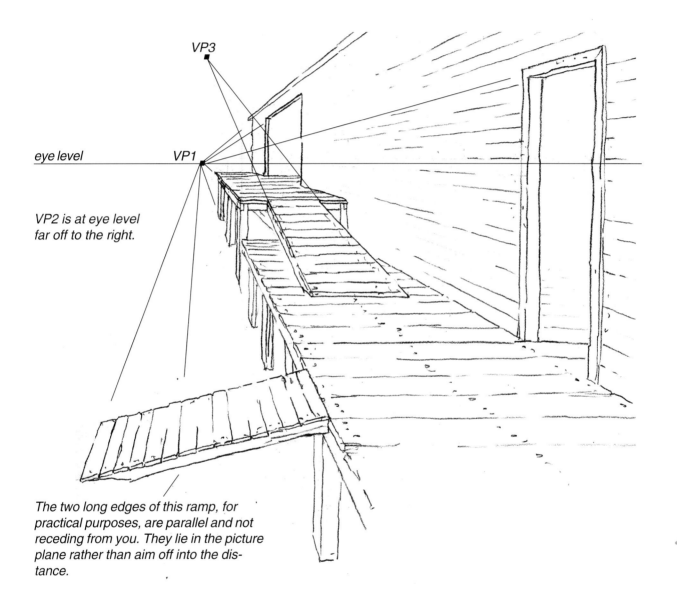

VP3

eye level VP1

VP2 is at eye level
far off to the right.

*The two long edges of this ramp, for
practical purposes, are parallel and not
receding from you. They lie in the picture
plane rather than aim off into the dis-
tance.*

*I drew most of this warehouse using ordinary two-point perspective
One of the two vanishing points is, as you see, at the upper left;
the second is far off to the right. The far ramp, or incline, has a
vanishing point above eye level, just like the roof of the house on
the preceding page.*

LINEAR PERSPECTIVE: CURVES

Let's look at a common type of curve—the circle—and how it behaves in perspective.

A circle is a uniform curve that fits neatly inside a square. To see what a circle looks like in perspective, stick it inside a square that's drawn in perspective, as at left. What you get is an ellipse. Sometimes it's helpful, when you need to draw an ellipse, to first sketch a perspective square and then draw the ellipse within the square.

The most common mistake in drawing ellipses is giving them sharp corners at the narrow ends. I think most "corners" on ellipses happen because we try to make the hand and wrist go around tight curves that don't feel natural. Remember that neither a circle nor its perspective cousin, an ellipse, has *any* corners! To help free up your drawing hand and wrist, try turning the paper as you draw these curves so that at each stage of the curve you feel comfortable.

Another common problem in drawing ellipses is making one end fatter than the other. The best remedy for this is to peek at the ellipse in a mirror and you'll see the error instantly.

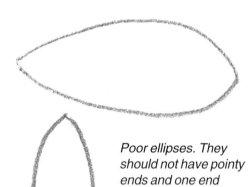

Poor ellipses. They should not have pointy ends and one end should not be fatter than the other. Turning the paper as you draw is a good way to get smoother curves.

TIP

Sometimes it's helpful to draw a circle first and then make your ellipse inside the circle. The presence of the circle helps constrain the dimensions of the ellipse and also helps remind you to keep the ellipse smooth.

Think of an ellipse as a circle squeezed in a vise.

LINEAR PERSPECTIVE: CURVES

You need not look far for examples of curves, especially ellipses—cans and bottles in the pantry, vases, coins, tires, dishes, cups and so on. Here are a few practical applications for ellipses.

To get the ellipses right, picture the cylindrical shaft as though it's inscribed inside a rectangular box in perspective.

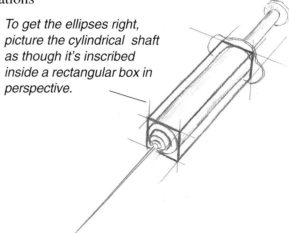

Here's my profit from this book (before taxes!). All the coins are below eye level and all are ellipses, but the coin at the bottom of the stack is a fatter ellipse than the coin at the top. The farther down the stack you go, the closer each coin comes to being a circle.

The body of the camera is a rectangular box in two-point perspective. The lens is a circular cylinder in two-point perspective.

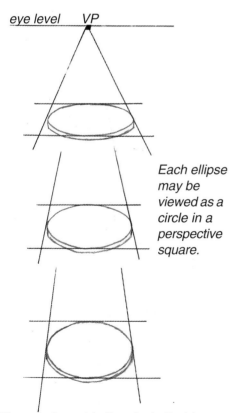

Each ellipse may be viewed as a circle in a perspective square.

The coin lowest in the stack (that is, farthest from eye level) is the fattest (most nearly circular).

Eye level for the camera is high, somewhere above the camera. Eye level for the tire is right smack through its center. The tire is inscribed inside a box in perspective—but in this case, the perspective is slight

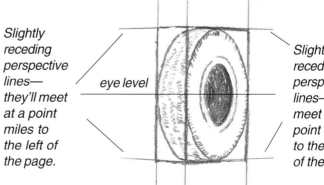

Slightly receding perspective lines— they'll meet at a point miles to the left of the page.

eye level

Slightly receding perspective lines—they'll meet at a point miles to the right of the page.

LINEAR PERSPECTIVE: CURVES

Imagine the cans at right sitting on glass shelves so you can see their ends. The cans farthest above or below eye level show the fattest ellipses at their ends; the can straddling eye level shows a thin ellipse at both ends; the one whose top is smack at eye level looks perfectly straight (un-curved) at its top and has a slight curve at the bottom.

eye level

Here is an exaggerated drawing mistake. The curved mouth of the vase clearly says you're looking down into it—that is, the vase is below eye level. But the bottom—it's flat as a fritter! The picture suggests there are two different eye levels (not allowed), one above the vase and another at the base of the vase. All that's necessary to fix the picture is to curve the bottom of the vase appropriately, something like the sketch at right.

To get the windows reasonably accurate in this tower, it's best to sketch in ellipses to mark off their tops and bottoms. Notice that the higher you go above eye level, the fatter the ellipses become.

eye level

LINEAR PERSPECTIVE EXAMPLES: BUILDINGS

Here are some examples of the use of linear perspective. For a
great deal more on the subject, including detailed constructions,
see *Perspective Without Pain* (Bibliography).

*Learning to "see" the
hidden edges and
other details will help
you to draw any
object more con-
vincingly.*

*Below is a page from a sketchbook, over
which I've drawn some perspective lines. If
you extend them you'll find they come
reasonably close to meeting at left and right
vanishing points (close enough, as they say,
for gov'ment work!).*

*The chimney is the
least accurate part
of the drawing. Its
top needs more
slope and . . .*

*. . . more of the
right side of the
chimney should
be visible.*

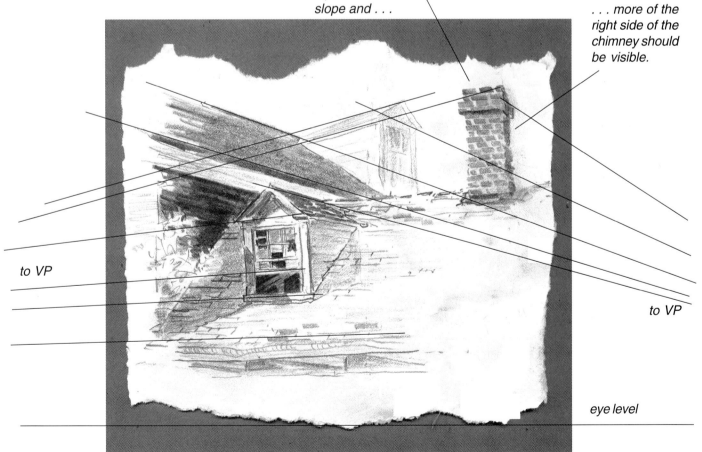

to VP

to VP

eye level

LINEAR PERSPECTIVE EXAMPLES: A BRIDGE

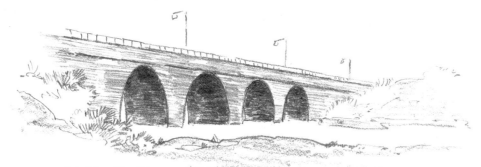

A bridge like this one in two-point perspective can best be seen as a combination of rectangular boxes and curves built inside rectangular boxes.

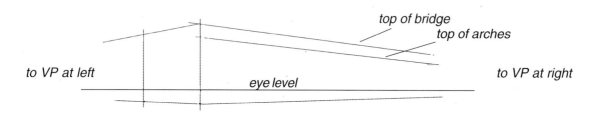

top of bridge

top of arches

to VP at left

eye level

to VP at right

Try to envision a long box that will contain the bridge. Draw the box in perspective

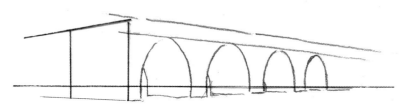

. . . and then sketch in the arches lightly freehand, adjusting till they feel right. There are ways to lay them out mathematically, but why spoil your fun!

"Midpoint" of arch is slightly to right of center—it's aligned with the perspective center of the rectangle in which it's drawn.

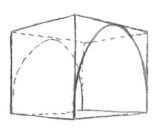

Think of each arch as a half-ellipse (although in this case they're probably parabolic) and put each arch inside a perspective cube.

When you draw an arch in perspective, notice that it's slightly warped toward one side—that is, it's not quite symmetrical.

LINEAR PERSPECTIVE EXAMPLES: TRUCKS

Here's my truck on its way to an art show in Podunk. It's in one-point perspective. In a flat-on view such as this, there are only a few visible perspective clues-e.g., the top edges of bumpers and imaginary receding lines showing how the tires on the two sides of the truck line up. If you could see into the body, you'd see a rectangular block in perspective, something like this:

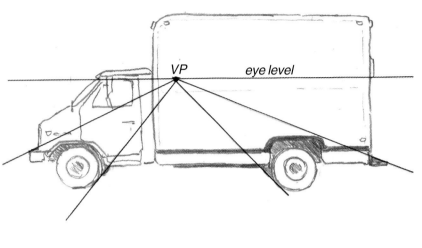

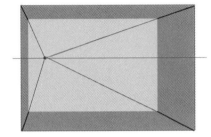

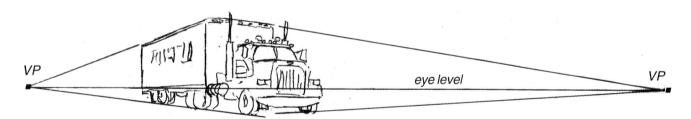

This truck is in two-point perspective.

This one is partly in one-point perspective (the cab) and partly in two-point (the trailer). Look for such combinations to add spice to your drawings.

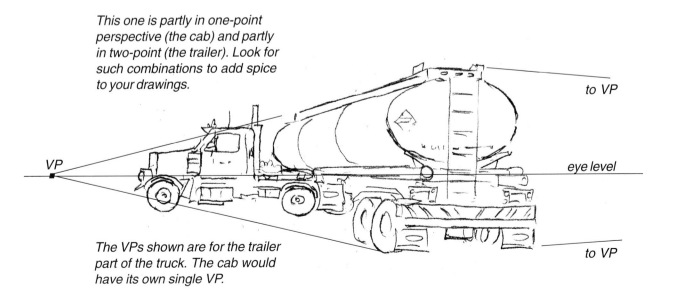

The VPs shown are for the trailer part of the truck. The cab would have its own single VP.

LINEAR PERSPECTIVE EXAMPLES: A ROOM
INTERIOR

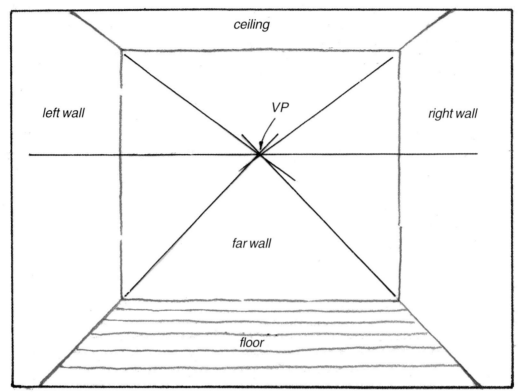

Above is a simple, basic room in one-point perspective. Below, I've added a door, a
window and a table. If you imagine the floor boards running in the other direction,
front to back, each of them would aim at the same single vanishing point.

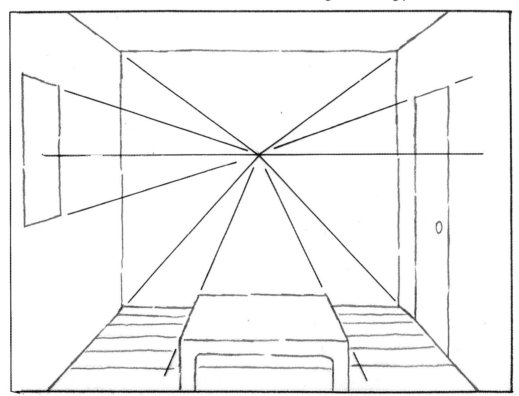

LINEAR PERSPECTIVE EXAMPLES: STAIRS

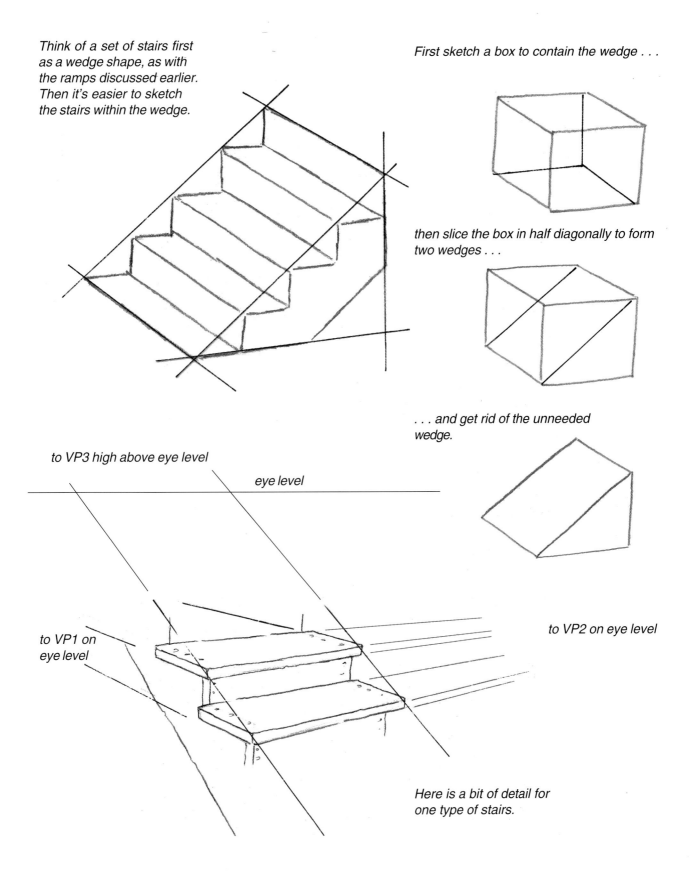

Think of a set of stairs first as a wedge shape, as with the ramps discussed earlier. Then it's easier to sketch the stairs within the wedge.

First sketch a box to contain the wedge . . .

then slice the box in half diagonally to form two wedges . . .

. . . and get rid of the unneeded wedge.

to VP3 high above eye level

eye level

to VP1 on eye level

to VP2 on eye level

Here is a bit of detail for one type of stairs.

LINEAR PERSPECTIVE EXAMPLES: A TABLE

This is my first try at drawing this table. I like it okay, but the critic is not happy!

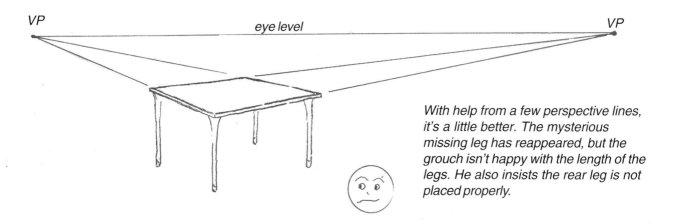

With help from a few perspective lines, it's a little better. The mysterious missing leg has reappeared, but the grouch isn't happy with the length of the legs. He also insists the rear leg is not placed properly.

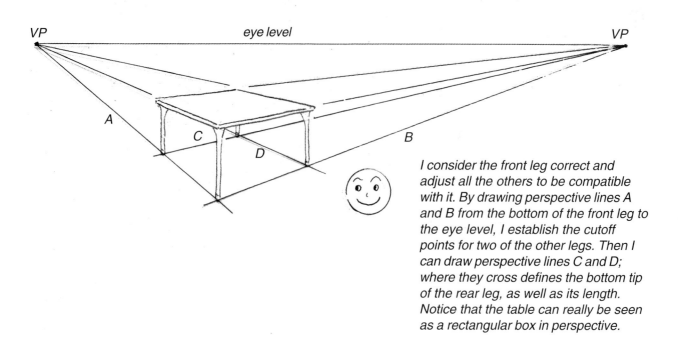

I consider the front leg correct and adjust all the others to be compatible with it. By drawing perspective lines A and B from the bottom of the front leg to the eye level, I establish the cutoff points for two of the other legs. Then I can draw perspective lines C and D; where they cross defines the bottom tip of the rear leg, as well as its length. Notice that the table can really be seen as a rectangular box in perspective.

LINEAR PERSPECTIVE EXAMPLES: BUILDING DETAILS

Since buildings are so often part of a landscape drawing, it's important to get them right. Pay attention to details and, where necessary, draw in some perspective lines to help make the details convincing.

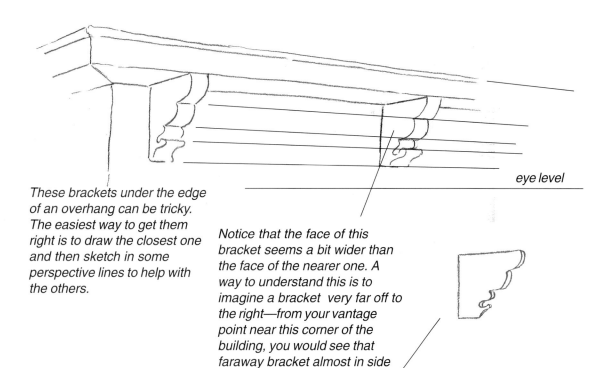

eye level

These brackets under the edge of an overhang can be tricky. The easiest way to get them right is to draw the closest one and then sketch in some perspective lines to help with the others.

Notice that the face of this bracket seems a bit wider than the face of the nearer one. A way to understand this is to imagine a bracket very far off to the right—from your vantage point near this corner of the building, you would see that faraway bracket almost in side silhouette, something like this (but smaller).

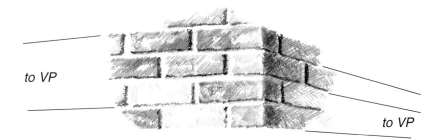

to VP

to VP

To make these bricks turn the corner effectively, make them diminish in size as they recede. A few light perspective lines will help a lot to keep the bricks in line and make them convincing.

TIP

The light on the bricks is from the left, making the right-hand bricks darker. But notice, the dark bricks are darkest near the corner. This is an optical illusion. When there is a plane change and a dark area and a light area adjoin, the strong contrast makes the dark area seem darkest and the light area seem lightest at the place where the two areas join.

LINEAR PERSPECTIVE EXAMPLES: BUILDING DETAILS

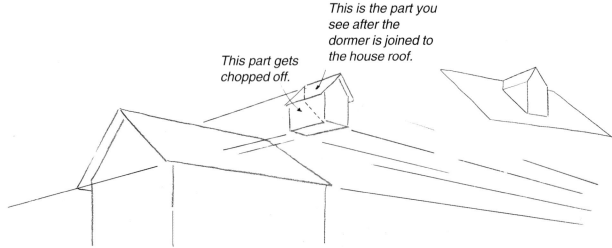

This part gets chopped off.

This is the part you see after the dormer is joined to the house roof.

A dormer is like a little house attached at right angles to a bigger house. The dotted line in the dormer above shows where the dormer and the house roof join.

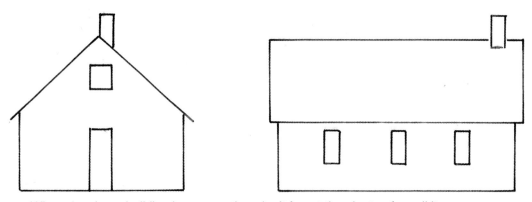

When drawing a building in perspective, don't forget the slants of small items, such as the tops and bottoms of windows, doors and chimneys. Notice the steepest perspective lines belong to the highest (or lowest) features—in this case, the chimney.

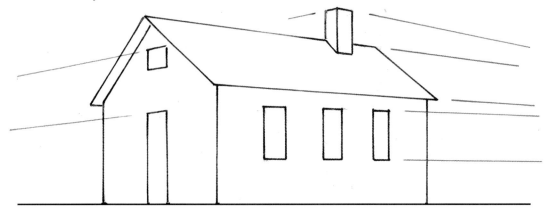

PERSPECTIVE PROBLEMS

The next few pages illustrate some of the more common goofs we make in using perspective. Some of these may seem small, but if your aim is an accurate and believable representation of a scene, details may be crucial. (If your aim is to take liberties with reality, that's fine as long as it's clear you're being arty and not incompetent!)

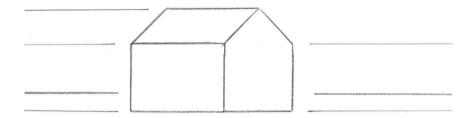

Above, the vanishing points are too far out, making the building look flat. Below, the vanishing points are too close, so the building looks distorted.

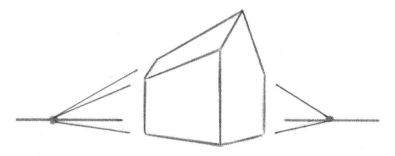

Whoops! The poor shack at far right is sliding into the sea! The problem is that the eye level is perfectly obvious (it's the horizon, *where sky meets water), but the receding horizontal lines from the shack don't meet on the horizon. Instead, they meet somewhere deep in the water! Let's erase the shack and try again.*

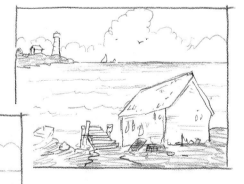

Now the shack is sitting reasonably well. Its receding lines meet at eye level (the horizon). The dock was okay from the start—as you see, its receding lines meet on the eye level line (but at a different vanishing point—don't forget, each object has its own vanishing points).

PERSPECTIVE PROBLEMS

It would be unusual (but not unheard-of) to draw a building with as many ailments as this one, but one or more of the problems shown here crop up in lots of drawings.

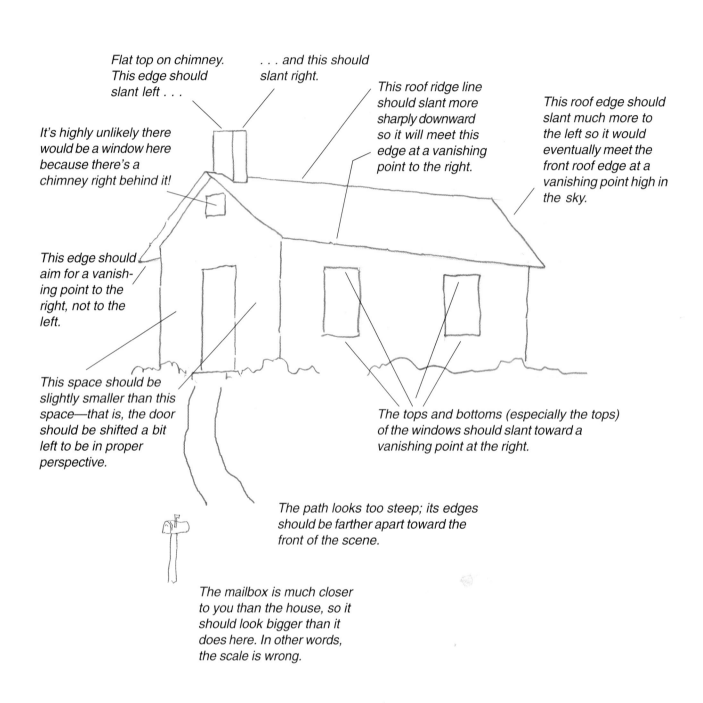

Flat top on chimney. This edge should slant left . . .

. . . and this should slant right.

This roof ridge line should slant more sharply downward so it will meet this edge at a vanishing point to the right.

This roof edge should slant much more to the left so it would eventually meet the front roof edge at a vanishing point high in the sky.

It's highly unlikely there would be a window here because there's a chimney right behind it!

This edge should aim for a vanishing point to the right, not to the left.

This space should be slightly smaller than this space—that is, the door should be shifted a bit left to be in proper perspective.

The tops and bottoms (especially the tops) of the windows should slant toward a vanishing point at the right.

The path looks too steep; its edges should be farther apart toward the front of the scene.

The mailbox is much closer to you than the house, so it should look bigger than it does here. In other words, the scale is wrong.

PERSPECTIVE PROBLEMS

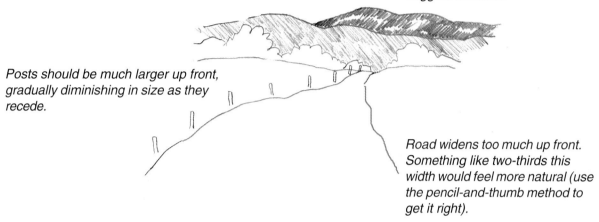

Distant hills should usually (not always) be paler than near hills to suggest distance.

Posts should be much larger up front, gradually diminishing in size as they recede.

Road widens too much up front. Something like two-thirds this width would feel more natural (use the pencil-and-thumb method to get it right).

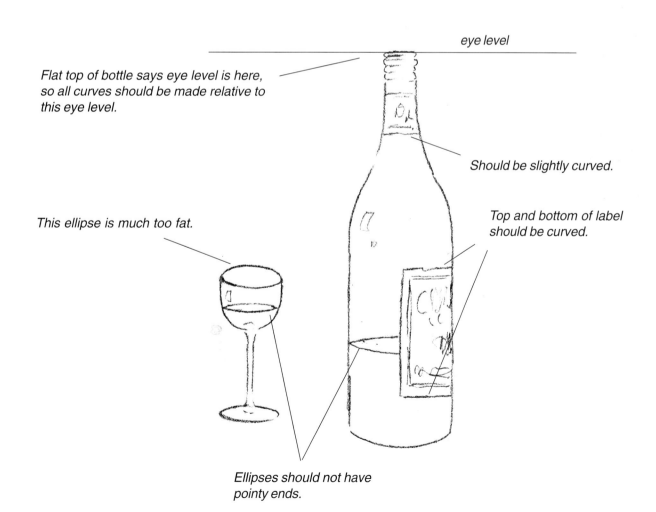

eye level

Flat top of bottle says eye level is here, so all curves should be made relative to this eye level.

Should be slightly curved.

This ellipse is much too fat.

Top and bottom of label should be curved.

Ellipses should not have pointy ends.

SUMMARY

Make distant objects paler and less distinct than nearer objects; draw more distinct edges on nearer objects.

Draw similar-size objects smaller as they recede into the picture.

Draw similar-size spaces smaller as they recede into the picture.

Overlap objects to strengthen the suggestion that one is farther back than another.

Use shading, or modeling, to suggest the depth or roundness of an object.

Shorten the perceived length of an object as it advances or recedes in a picture.

Establish eye level at the outset and then relate all receding lines to that eye level.

Make receding horizontal parallel lines above eye level slant down toward a vanishing point on the eye level; and make receding horizontal parallel lines below eye level slant up toward a vanishing point on the eye level.

Remember that receding parallel lines meet at a vanishing point even if they are not horizontal lines.

Keep all vertical lines vertical unless the object is very tall and three-point perspective is called for.

Make curves fatter the farther they are above or below eye level.

Draw ellipses with smooth "ends," no points.

Don't bother to draw ANY perspective lines unless you need them to solve a problem!

CHAPTER SEVEN
DESIGN

Everybody's a designer. Each time you arrange the furniture or plant a garden or organize your desk, you're designing—putting things together in a way that makes the best sense practically and aesthetically. Every time you draw something, even doodling, you're designing. You're shifting parts around, deciding on sizes of things, making some areas dark and some light. Problem is, not every design is good one. The neighbor who plops plants and rocks indiscriminately all over his yard gets the neighborhood rotten-designer award.

Design is the layout, or arrangement, of all the elements, or parts, that make up a picture. The knack for designing well is not something we're all born with—some have to work harder at it than others, but designing is certainly learnable. In this chapter I'll cover the basic ideas behind good design. There are books that go deeply into the subject (see the Bibliography), but I think design, like linear perspective, is often made much too complicated. I'll try to uncomplicate things.

The major elements , or parts, of a drawing design are *shapes*, *values*, *textures, lines* and *direction*. Let's look at each in turn and see what impact each has on the effectiveness of a picture.

TIP

WOOF!
One sure way to improve your design ability is to study other people's pictures. Most of the pictures you find in galleries, local shows and museums will be reasonably well-designed. But beware! Some pictures made by famous artists are real dogs, and they're hanging somewhere, not necessarily because they're good, but for other reasons—e.g., they may represent first attempts by an artist at a new direction.

SHAPES

Every representational picture is made up of shapes. For each shape we need to obey two reasonably simple rules:

> **Rule 1: Make the shape engaging, interesting, exciting (but appropriate).**

> **Rule 2: Place the shape in a good spot.**

Let's see what these rules mean in a practical sense. On the next pages are suggestions for choosing and improving shapes, and some ideas about how to place one shape relative to another. But in all cases, remember that what must govern your choice of any shape is whether it's *appropriate* for your picture. If your scene is meant to be quiet—let's say, a sunset—then aggressive shapes may be inappropriate. In a quiet scene, you may well choose shapes that are soothing—e.g., long horizontal shapes rather than obliques or verticals, and shapes with smooth rather than jagged edges.

SHAPES: IMPROVING

At left are some basic geometric shapes. By themselves, they're pretty humdrum, but they can be combined in an infinite number of ways to create interest, as in the examples below.

SHAPES: IMPROVING

Sometimes an individual shape can be changed for the better, as in these examples.

There are lots of lollipop-shaped trees like this one, but they don't necessarily make good shapes in a picture. They're too static.

Reshaping the tree like this and whacking it out of symmetry makes it more interesting.

Messing with the edges makes the shape more eye-catching.

Seen from the side, this house is pretty boxy.

From the gable end, the shape is a little better, but not much.

In two-point perspective, the shape is lots more interesting.

A symmetrical hill and an uneventful treeline in front of it.

Hill thrown out of symmetry, but treeline still boring.

Both hill and treeline asymmetrical, much more eye-catching than the first sketch.

SHAPES: COMBINING

Maybe a particular shape isn't so exciting, but there's no end to the number of ways you can combine simple shapes to make new and more interesting ones.

SHAPES: LOCATIONS

Location! Location! Location! What applies to real estate happens to work for shapes in a drawing, too. It's not enough to draw interesting shapes—you've got to place them appropriately for maximum impact. There aren't any hard rules about where to place things, but there are some pretty good guidelines for both what to do and what not to do. Many of these suggestions are the result of studies by art researchers who tried exposing people to different kinds of pictures and recording their reactions (kind of like a modern political poll!).

rules rules rules rules

Beware of "rules" in art. Many of the greatest artists became great because they broke some rules!

When I speak of rules I always mean "rules-of-thumb"—that is, suggestions or pointers or ideas that generally work well, but sometimes don't.

As you learn to make art, begin by obeying the "rules" but be happy to break them when they get in your way.

rules rules rules rules

SHAZAM!!

Because we usually want a picture to hang together as one harmonious whole, avoid putting important shapes right in the center of the picture. Severe centering may visually blast the picture in two.

A good place for an important object is either one-third or two-thirds of the way across the picture (or, in a vertical format, one-third of the way up or down the picture). This placement is called the "rule of thirds."

Resist placing strong objects along the edges of the picture. Such placements direct the viewer's eye toward the edges or even out of the picture; normally it would be nice to make the viewer look into the picture.

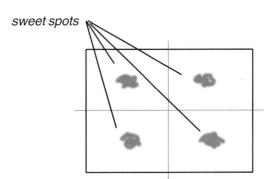

sweet spots

Many artists rely on one of the "sweet spots" as locations for main shapes. A sweet spot is anywhere near the center of one of the four quadrants of a rectangular picture.

SHAPES: DOMINANCE AND VARIETY

Psychologically, we feel good about a picture in which one kind of shape is dominant. For example, in a cluster of buildings, it makes sense to emphasize rectangular, straightedged shapes; in a summer landscape with lots of trees, curved, blobby shapes may predominate. But where one kind of shape is dominant, introduce other kinds of shapes to break the monotony. A picture involving lots of buildings, for instance, needs a break from all that rectangularity, so look for a way to break the monotony by including a curved shape here and there.

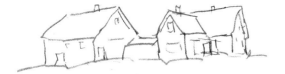

All these boxy shapes . . .

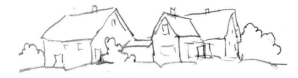

. .. . may be relieved by adding some curved shapes,

If repetitive shapes make you snooze, introduce some variety to wake things up.

SHAPES: BALANCE

Placing a large, important shape at one side of a picture may make the picture feel unbalanced, as if all the picture's "weight" is gathered in that one area. To bring things into balance, consider adding a shape near the opposite edge. The added shape need not be the same size as the first shape—it can do its balancing job by being far enough away, like a skinny kid on the long end of a seesaw balancing a bigger kid on the short end. There are other ways of achieving balance—for example, by placing a small object with a strong value opposite the larger object, (or, in a painting, by placing a small object with intense color opposite the larger object).

The little guy balances the big guy just because of his advantageous position.

SHAPES: REPETITION

A picture having one of each shape—rectangular, round, smooth, irregular and so on—would be unsettling to the eye. Try for repetition of a couple of basic shapes to help make the picture more cohesive. The repeated shapes may be (and usually, should be) of differing sizes.

Too many different kinds of shapes is confusing.

A limited number of kinds of shapes offers enough variety without being confusing.

SHAPES: A PUZZLE

Like a jigsaw puzzle, every drawing has a number of pieces that connect with one another. In quiet scenes, the pieces adjoin one another gently, smoothly; in more active scenes, the pieces interconnect more forcefully. Thinking of your design as a jigsaw puzzle will help you analyze its strengths and weaknesses.

Simply put, if you want your picture to convey a mood of peace and quiet, make the pieces smoother, less jagged; if you want a more active mood, make your pieces intersect more vigorously.

Illustration from children's book, Friendship Farm (detail)

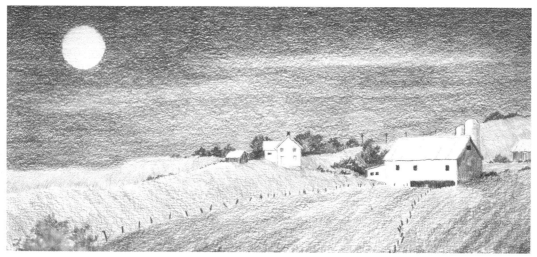

Long horizontal shapes that don't intersect vigorously help make this a quiet scene. The low-key values, of course, also contribute to the quiet mood.

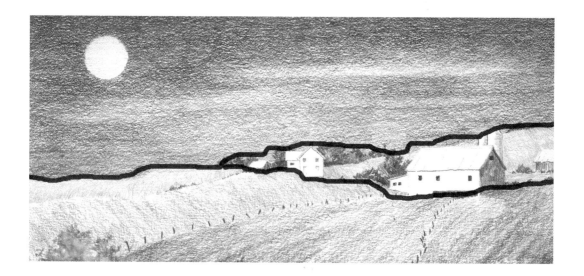

SHAPES: A PUZZLE

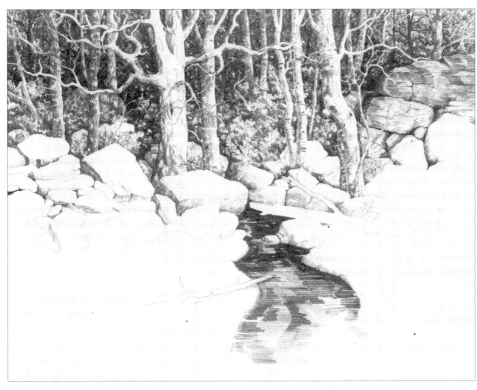

Rocky Woods Stream
Pencil on Strathmore
500 series Bristol, plate
finish, 15" x 20"

An active picture with more interconnected shapes. Below, I've roughly broken the picture into individual shapes—the picture could be broken down in much more detail to show an even greater interaction among its many shapes.

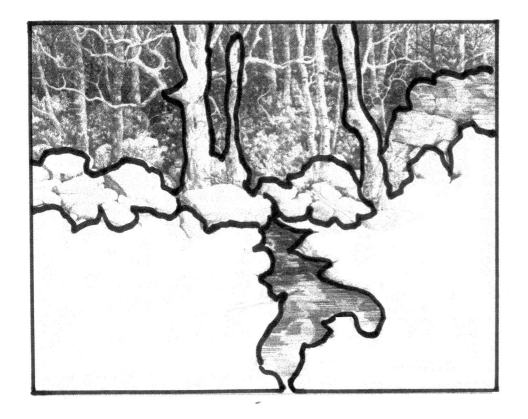

SHAPES: A PUZZLE

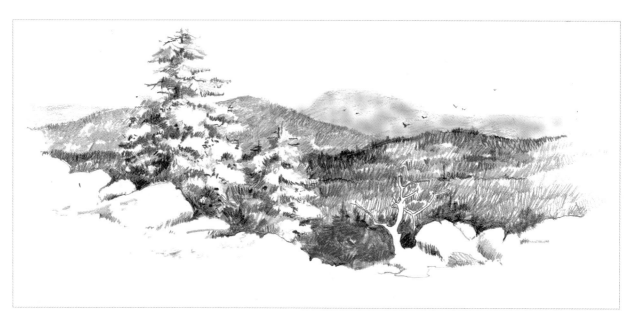

This scene is a mix of quiet and active.
The long horizontal shapes (the hills)
suggest quiet, but the ragged edges of the
trees and rocks liven things up.

Along Skyline Drive
Pencil on Strathmore 400
series Bristol, smooth
finish, 4" x 9 ½"
Collection, Scott and Gerri
Metzger

SHAPES: NEGATIVE

It's natural to think of *positive* shapes—that is, the actual shapes of objects. What's less natural is to see *negative* shapes, the shapes *surrounding* an object. Every drawing has both positive and negative shapes, and both must be well-designed. It's not easy for some people to "see" negative shapes, but if you learn to see them and draw them, you'll certainly improve your art.

In this tree close-up from Chapter Three, there are positive shapes galore—leaves, branches, etc.—but there are also many negative shapes, such as the dark areas surrounding some of the leaves. Those negative shapes are every bit as important as the positive shapes because they have lots of impact on the overall design.

TIP

DONUT!
I know it's a cliché, but seeing negative shapes is seeing "the hole rather than the doughnut." You can train yourself to see this way, but only by consciously reminding yourself to do so. No matter what object you're looking at, try to focus on the shapes behind and around the object.

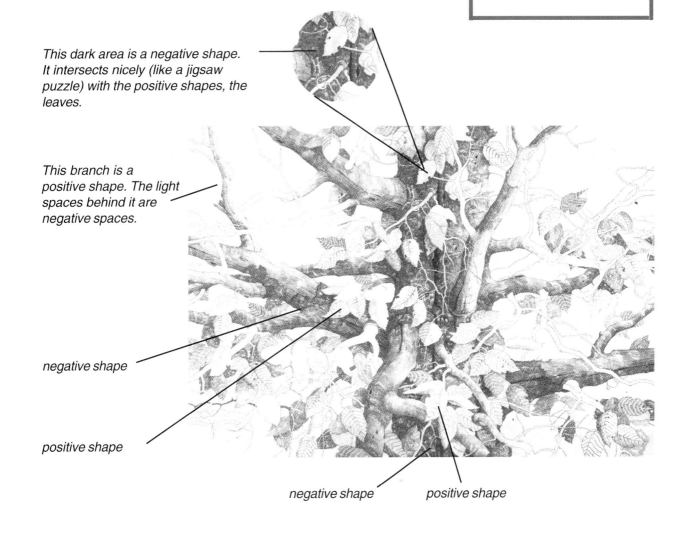

This dark area is a negative shape. It intersects nicely (like a jigsaw puzzle) with the positive shapes, the leaves.

This branch is a positive shape. The light spaces behind it are negative spaces.

negative shape

positive shape

negative shape *positive shape*

SHAPES: NEGATIVE

Pick any subject and try drawing it by drawing only its negative shapes, 1,2, 3 and so on. You can draw an object by ONLY drawing the negative shapes, but the real objective is to draw any way that's comfortable and then check the accuracy of your drawing by looking at the negative shapes and making sure they're accurate.

An illustration of negative drawing with three levels.

Level 1: Flat strokes fill in the negative space behind the leaves. I didn't draw in the leaves first—I used the negative drawing to form them.

Level 2: Now I form a second layer of leaves by darkening further.

Level 3: A third layer of leaves emerges as I darken again. I've begun to draw some detail with a sharp pencil.

VALUES

Value is the lightness or darkness of an area—high value means light and low value means dark. The highest value in a pencil drawing is white, the lowest, black. In between white and black lie an infinite number of grays.

You can draw effectively using as many values as you like, but it's easily possible to overdo things and include so many value nuances that you lose some spark. What I mean is this: A picture with, say, three values—black, white and middle gray—is bound to be fresh-looking because there will be strong value contrasts. But if you add a lot of slightly differing grays, chances are good the picture will have a smoother but less dynamic look.

People have different views about how many values to rely on when doing a sketch or a finished drawing. What makes sense for me is to use no more than five values in a preliminary sketch (often I use just three); when I get to work on a finished drawing, I keep those few values in mind, but allow plenty of variations to creep in.

Why are values so important? Because by placing one value next to another you can create visual excitement. By placing an object with value 1 next to an object with value 5, for instance, you create an area that's almost impossible to ignore—like the white circle at left surrounded by black: Conversely, if you keep values close together, you can make an area more subtle, like this:

1 *low value*

2

3

4

5 *high value*

The vertical strip at far right illustrates an interesting and useful characteristic of values: The perceived value of an area is greatly influenced by the values nearby (Momma, make sure your kids keep good company). The values of the small squares inside the larger squares are all exactly the same—honest! Clearly, you can make an area look darker by putting it near a bright object and vice versa. To make a drawing sing, play values against one another.

VALUES: BALANCE

Too heavy on the left.

Values need to be balanced in a picture just as shapes need to be balanced. Often you'll find your picture feels "too heavy" in one area or another. Sometimes, you won't notice an imbalance until you look at your picture in a mirror or look at it upside-down.

The simple example at left shows a picture that's too value-heavy on the left. Moving strong value to the center doesn't help because now we have *too much* balance, too much symmetry. The third attempt is also too symmetrically balanced. The fourth picture is reasonably balanced by placing a small, but darker, object at the far right.

Too obviously balanced.

Too obviously balanced.

Balanced.

VALUES: ADDING ZEST

Sharp value changes can help wake up an otherwise dull area. Suppose you have a large gray shape in your picture—e.g., the side of a barn—that looks lifeless. One of the easiest ways to enliven the area is to punch holes in it with some well-placed darks. Not only does this add some spice, but it adds a lot of depth, as well, because the dark holes make you feel as though you're looking *inside* the barn, past the outer wall.

Similarly, inserting whites into a drab scene can provide some spark, as in the landscape sketch at bottom right. Although it's often possible to erase to reclaim white areas, it's usually better to plan ahead and leave the whites crisp and clean.

There's such a thing as too much value contrast and too many sharp darks or bright whites. A good rule of thumb is to let a major part of a picture be midtones and lights, and reserve rich darks for smaller, well-placed areas. There are plenty of exceptions to that "rule," but most of the time it's reliable.

Above, a dull barn side enlivened by adding some sharp darks.
Below, a dark landscape freshened by including some whites.

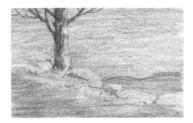

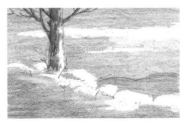

This drawing gets its liveliness from the dark values under and between the roots

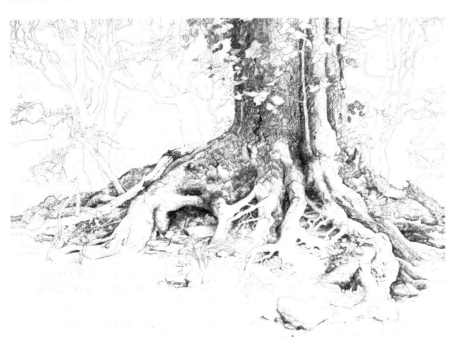

Sycamore Roots
Pencil on Strathmore
illustration board, high finish,
18" x 24"

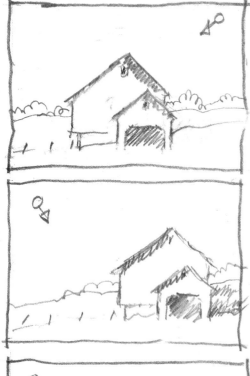

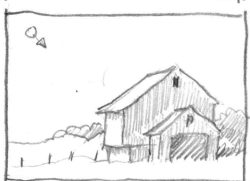

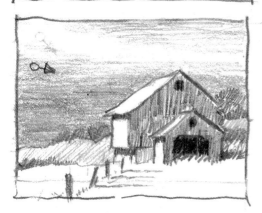

Value sketches (also called thumbnail sketches) let you change your mind without penalty. In this sequence of sketches, I moved things around and even shifted the sun twice! In the end, I raised the buildings to give a little more foreground area where I could emphasize the fence leading into the picture. I lowered the sun to get an end-of-day mood with long cast shadows.

VALUE STUDIES

Unless you're one of those rare people who can visualize values without putting anything down on paper, it's a good idea to make a few quick value sketches before beginning your drawing. The idea is to know where you're going before you begin messing with that expensive drawing paper. If you make value sketching a habit, you'll save a lot of missteps (and paper and time). When laying out your value scheme, here are some guidelines:

1. Keep value sketches small, about the size you see in the accompanying examples—that will make the process quicker.

2. Forget neatness. These are tools, not finished pictures.

3. Use only a few values—three are usually adequate—*black* for the darkest areas, *white* for the brightest and *gray* for the midtones. A single gray should suffice for the midtones. Later, in the actual drawing, you can use a much wider range of grays.

4. Even though you intend to draw in pencil, you might use markers for your value sketches, as I've done in the illustrations on the opposite page. Markers speed things up and they have the additional advantage that each has a definite darkness (unlike a graphite pencil, which can yield varying darknesses depending on the pressure you apply). So you can use a black marker, a gray marker and the white of your paper to get a clearly defined set of values.

5. In many pictures, the larger area will be a range of grays, with whites and blacks reserved for smaller areas. Skillful placement of darks and lights is critical to your picture's success. Look for opportunities to place a dark adjacent to a light for some extra zing. And, as mentioned earlier, a large gray area can be greatly enlivened by some well-placed darks or lights or both.

6. Sometimes, instead of relying on *lines* to separate areas, you can achieve the separation you want simply by making the adjacent areas different in value.

VALUE STUDIES

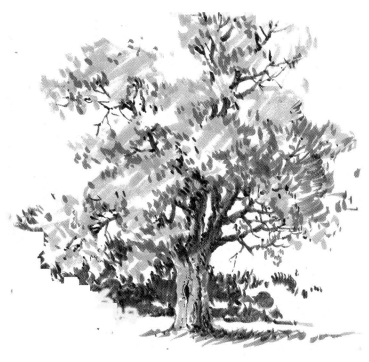

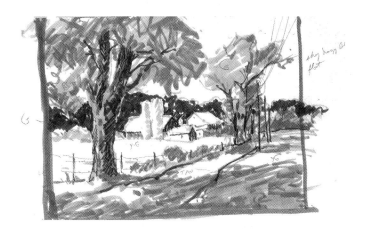

Examples of value sketches using two markers: Staedtler Mars graphic 3000, black and medium gray.

HB close hatching

HB close crosshatching

HB flat, light pressure

6H flat moderate pressure

2B hatching, chisel lead

2B crosshatching, chisel lead

TEXTURES

In our context, texture means the degree of roughness of a surface. Most landscapes include a number of textures, ranging from the rough nature of foliage, buildings, weathered objects, rocks and similar subjects to the smoothness of still water or a shiny apple.

To render rough textures you may be tempted to use rough drawing paper. I prefer to stick with smooth papers and make textures by manipulating the pencil appropriately. The problem with using a rough paper is monotony—all the texture tends to look the same. Having said that, I admit that some artists use textured paper and come up with excellent results.

Texturing can easily be overdone. Make sure the kind of texture and the amount of texture you draw fits the subject. You might texture like crazy on an old man's brow, but not on a baby's cheek!

Smooth textures are best attained either by leaving an area white or by filling it either with flat strokes from a relatively hard lead or with closely spaced, uniform strokes from sharp or chisel leads. Rough textures are easier—either use flat strokes with a soft lead or a variety of open strokes with any pencil lead. When you make rough texture, keep in mind that a great deal of the texture you see on the subject is the result of countless tiny *shadows*. If you were to flood a surface such as linen or brick with plenty of light from all directions, there would be few shadows and, as a result, the surface wouldn't look very textured.

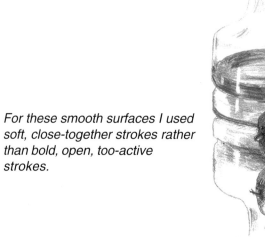

For these smooth surfaces I used soft, close-together strokes rather than bold, open, too-active strokes.

TEXTURES

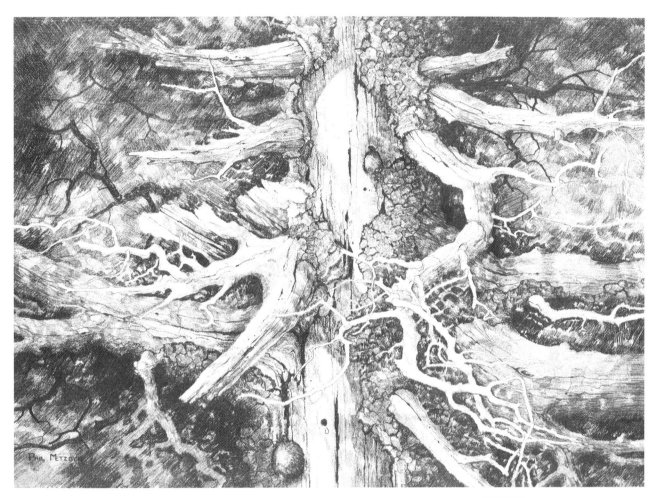

Old Spruce
Pencil on Strathmore illustration
board, regular surface, 18" x 24"

*For the bark texture I drew
many little knobby
protrusions, treating them
like little spheres, each
with its own light and
shadowed sides.*

*For the smoother bare wood, stripped of
bark, I used light strokes in the direction
of the grain of the wood.*

LINE

Horizontal direction suggests quiet.

Oblique direction suggests agitation.

Vertical direction suggests solidity.

Drawing, after all, is about lines—straight, curved, jagged, hatched, crosshatched and so on. About the only pencil mark in this book that is not made up of lines is the flat stroke, and I suppose even that could be considered a fat line.

The impact of a picture is directly related to the nature of its lines. Any drawing by Ingres, for example, consists of delicate, sensuous, flowing lines, while one by van Gogh is alive with strong, dark, sometimes frantic, lines. The nature of your lines can put the stamp of YOU on your drawings.

Of course, I don't mean to say you must go either in the direction of Ingres or the direction of van Gogh. You may well combine different line qualities in a given drawing or from one drawing to the next. I would not advise consciously setting out to adopt a particular kind of line in order to develop your style—let your style come about naturally as you experiment with lines.

DIRECTION

Direction can help set the mood for a painting or drawing. A flat, left-right passage, for example, suggests little action; it's the kind of direction you might use to represent a quiet day. Oblique directions, on the other hand, are much more active; they're what you might choose if you're trying to suggest turmoil, activity, or upset. Verticals, while they may suggest activity, are more likely to impart balance and solidity.

Direction can be used to suggest more than mood—the direction of a cloud bank or a road, for example, might steer the viewer's eye toward something intended as the picture's center of interest. In the example middle left, the oblique direction suggests activity but it also helps direct the eye toward the lighthouse, the center of interest.

CHAPTER EIGHT
PUTTING IT ALL TOGETHER

Now we're ready to get out of the house and do some drawing. Let's see what a typical day's drawing in the field might involve.

CHOOSING A SUBJECT

Let's say, you've decided to draw a farm scene. You and your dog get in the car and drive to a spot you've had in mind, or maybe you select a photo of the scene you took some time ago and stay in your studio to draw. If you can work outdoors, on the spot (*plein air* drawing), I think you'll get a great deal more pleasure from your drawing time than if you stay home and draw from a photo. You can walk around the subject and see details a photo might have missed—and there's a soul-soothing pleasure in being outdoors, just you and the pencil and paper and your subject (and maybe a few bugs and a bull or two).

Your choice of subject is absolutely your own—unless, of course, you're doing a commission. I had a commission once to paint a barn that was magnificently uninspiring. It was red and shaped like a shoe box. And clean. No trash around, nothing to excite me. I decided to invent a very strong, active sky for a little diversion and I hid a lot of the barn behind a tree.

Unless you're choosing a subject simply to learn how to handle it, which is a good thing to do, choose something that at least interests you and maybe even excites you. If a stack of hay in a field excites you, go for it! You do not have to choose something that interests other people unless you've fallen into the ages-old artist trap of having to draw or paint what sells. I'm not making light of that—I've been there. Even so, make sure that *sometimes*, at least, you draw just what *you* want. Chances are good that if you invest enough of yourself in a subject, you'll eventually draw it so well that others will come to appreciate that subject, too.

NARROWING THE FIELD

Okay, you're at the farm. You look around and find there is a lot more there to draw than you had remembered. Can't do everything in one drawing, so let's try to settle on some part of the scene and leave out the rest.

BEST SELLERS!!!

NARROWING THE FIELD

Get out your cardboard viewfinder and scan the scene through the viewfinder's hole looking for a part of the scene that's better than other parts. Take your time doing this because this is really part of the design process. The more carefully you choose the subject, the less messing around you'll have to do to make a good design. Once you've settled on a part of the scene, try to stick with it—but leave enough room on your paper left, right, up and down in case you feel a need to expand the drawing as it develops.

Zoom in on the part of the scene you like best.

MARKING YOUR PLACE

If you're drawing a distant subject, moving around a little won't affect your drawing much. But if you're close to your subject (and especially if you're doing a still life), then shifting your position right, left, up, or down even by a few inches will change what you see. If you want to do an accurate drawing (as opposed to a quick sketch or an impression) stay put. If you think a little shifting makes no difference, try this: Place two objects on the table in front of you—say, two cups a half-inch apart. Now move your head six inches to one side. The cups that had space between them are now probably overlapped.

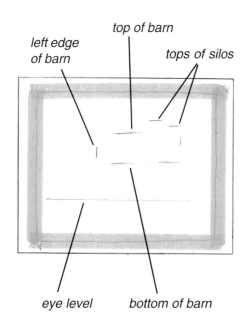

Stay put.

If you're standing and drawing, mark your place with a stick or stone so when you take a break and return you get back to your former position. If you're in the studio doing a still life, why not mark the floor where you're standing—if you're sitting, mark the position of your chair or stool.

DIVIDING YOUR PAPER

First, draw a light horizontal line to remind you where the eye level is; remember that all receding horizontal lines must be consistent with the eye level you choose (see Chapter Six). Then make a few tentative marks on your paper to show the outer limits of your drawing—that's to help insure against running out of paper as your drawing grows.

An alternative method is to go ahead and start drawing somewhere around the center of your paper and work outward from there. Using that method, you'll generally stay within the confines of the paper.

left edge of barn

top of barn

tops of silos

eye level

bottom of barn

SETTING THE LIGHT SOURCE

Before you begin to draw, decide where your light source is to be. This is critical because all the shadows, and therefore the values, in the drawing depend on where the light is coming from. If you're working indoors from a photo or if you're drawing a still life, you should not have to worry about the light changing, but outdoors, of course, it changes throughout the day. At this point, shoot a Polaroid picture or digital photo to capture the light and the resulting shadows or make a value sketch roughly indicating where the shadows are.

Here's an alternative approach: Go ahead and draw without committing to any shadows; then, when you're ready to put in shadows, look at the way they are *right now* (as opposed to the way they were an hour ago when you began drawing).

This matter of capturing the light and shadows at a particular time is important to any competent representational drawing. If you keep waffling and changing your mind as you draw, chances are good you'll end up with an unconvincing drawing.

sun from left front

sun directly overhead

sun from right rear

I usually scribble a little symbol at a corner of the drawing to remind myself where I decided the sun should be.

WORKING ON MORE THAN ONE DRAWING

One way around the problem of a shifting sun is to work for a limited time—say, an hour or two—on a drawing and then switch to another, entirely different drawing. The next day, come back and finish the first drawing at the same time of day you began it. Ditto the second drawing.

TRANSFERRING A DRAWING

It's time to draw, so you dive in. An hour later you're unhappy. You like the outlines and the positions of shapes, but you're afraid erasures and tentative lines have made a mess—or maybe you're not satisfied with the detail you've begun filling in. What to do?

Get a clean sheet of paper and transfer to it the parts of the drawing you're happy with. Then finish on the fresh sheet.

There are a couple of ways to transfer a drawing: (1) If your drawing is on a relatively thin sheet of paper, place it over a clean sheet with transfer paper between the two and trace over the parts you like. (2) If your drawing paper is too thick for the first method, tape a sheet of tracing paper over it and trace off the parts you like. Then transfer from the tracing paper to a new sheet of drawing paper.

You can buy commercial transfer paper, such as Saral brand, but some of them tend to smear too easily. Better to make your own transfer sheet. Smear one side of a thin sheet of paper (newsprint is okay, but a tougher paper would be better) with the flat of a 2B pencil or better, with a black Conté crayon. Smear until the paper is filled in densely.

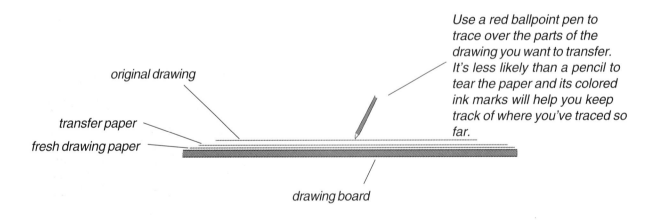

original drawing

transfer paper

fresh drawing paper

Use a red ballpoint pen to trace over the parts of the drawing you want to transfer. It's less likely than a pencil to tear the paper and its colored ink marks will help you keep track of where you've traced so far.

drawing board

MATTING AND FRAMING

Protect your finished drawing by matting and framing it under glass. The graphite will not fade and, provided you use acid-free matting and backing—as well as acid-free drawing paper—your picture will resist yellowing for a very long time. If you use a wood frame, some acid may eventually leach into the drawing paper from the wood, but probably not much. If you want better protection, coat the wood frame's inner surfaces with acrylic gesso or paint to seal off the acids.

WORKING FROM PHOTOS

We can't always work on location, so it's important to build a file of photos to use as raw material. I suggest you be reasonably organized about this. I don't mean you should arrange all your photos in albums—in fact that could be cumbersome and expensive. I use shoe boxes (actually, they're boxes you buy at a photo store that *look* like shoe boxes) with labeled cardboard dividers. There are sections for "trees" (of course), "trees close-up," "barns," "people," winter" and so on.

Don't feel as though you have to slavishly copy a photo—just use the parts you like. Often, as you'll see in PART II of the book, I combine objects from a number of photos. If you begin with one or more photos and end up with a drawing that looks like none of them, no problem. All that counts is that you're happy with the drawing. Here is a typical way of using a photo.

TIP

It's best to work from your own photos to avoid ethical and legal complications. If you copy a picture from a magazine or calendar, that picture may be copyrighted and you may be in trouble if you exhibit your copy without written permission from the copyright holder.

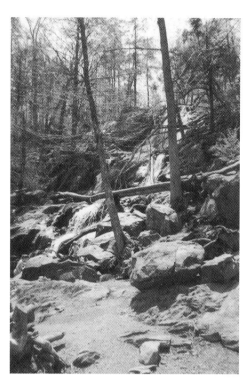

I begin with this photo . . .

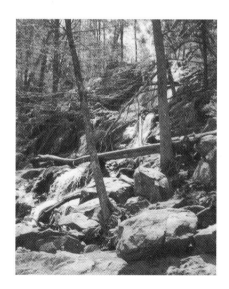

. . . but I'm interested in only this much of the scene.

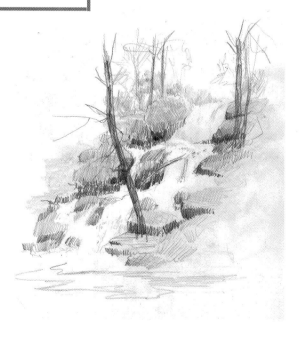

At left is my first quick sketch on scrap paper.

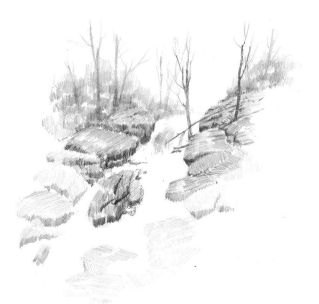

I begin with light strokes, focusing on the water and surrounding rocks. I'm not after every rock or tree in the photo—I choose the shapes I want.

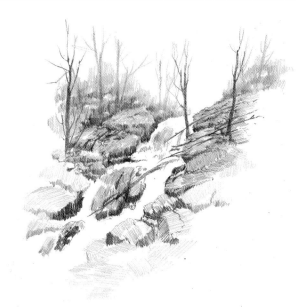

Satisfied with the main shapes, I use darker strokes to strengthen the picture.

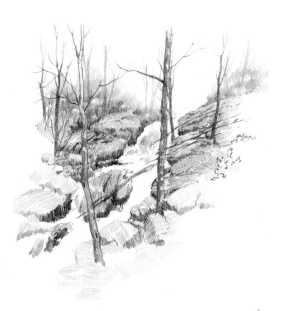

I decide to include the two main foreground trees, but the big, horizontal fallen log forms an eye-catching letter "H," so I leave it out.

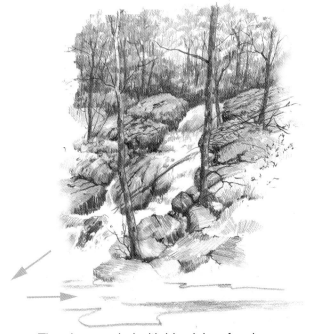

The photo ended with big slabs of rock at the bottom, but I substitute a simple pool of water flowing off to the right to balance the leftward thrust of the waterfall.

PART II

DEMONSTRATIONS

In this section we'll draw some scenes using a mix of the ideas discussed in PART I. My intent is to show you the steps in my thinking as I develop each drawing, all the way from initial concept to the finished picture. I view copying as an excellent way to learn drawing (and painting) techniques, so I invite you to copy any or all the drawings you see here. To help get you started, I've included an outline of each drawing—as large as the book's pages will allow—at the end of each exercise.

As you'll see, I usually begin a drawing by sketching in the major shapes using very faint lines. Because it's difficult for the book-printing process to pick up such faint lines, I've exaggerated them and made them dark enough for printing. Just keep in mind that you probably won't want those initial outlines too visible in your drawing—they're only there to guide the rest of the drawing process.

As a warm-up we'll first draw a simple still life. Besides being fun and instructive, a still life has the advantage of convenience—you can always manage a still life no matter what the weather or time of day and no matter what restrictions you have on your mobility.

CHAPTER NINE
A SIMPLE STILL LIFE

Here's a photo of an apple-and-pear still life. It's a simple enough subject, but it has some subtleties in shapes and values that are critical to drawing it successfully.

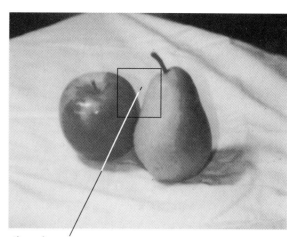

Compare this negative shape in the still life to the shape in my drawing.

The first problem is getting the shapes right. In this first stab, I've exaggerated my missteps for purposes of illustration.

 Both the apple and the pear are out of whack. The way I try to correct these shapes is by looking hard at the *negative* shapes rather than the shapes of the objects themselves.

Here are my shape corrections. The dotted lines represent the original sketch.

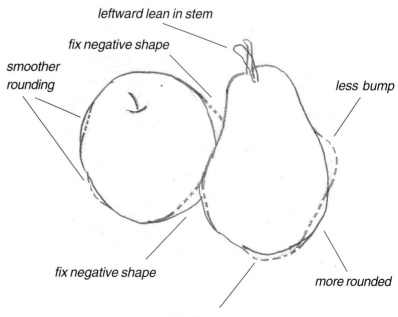

leftward lean in stem

fix negative shape

smoother rounding

less bump

fix negative shape

more rounded

cut off a little of bottom

*strokes follow shape
of object*

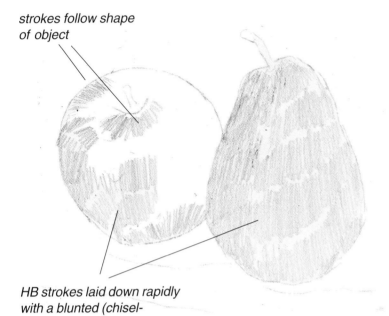

*HB strokes laid down rapidly
with a blunted (chisel-
shaped) HB*

4

I lay in the two shapes entirely with a chisel-shaped HB. This layer will represent the lightest areas of the fruit (except for a few highlights to be picked out later). I make the strokes generally follow the shapes of the objects. The apple is shown not yet completely laid in so you can more clearly see the directions of the strokes put down so far.

2B blunt strokes closely placed

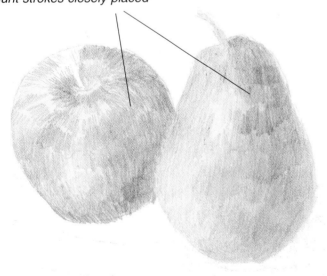

5

Next, using a chisel-shaped 2B, I begin giving more form to the fruit, darkening the shadowed sides. I use varying amounts of pressure against the paper, easing up and using lighter pressure as my strokes approach the lighter sides of the objects. I try for gradual transitions, no sudden jumps in value, no hard edges.

6

I use a chisel 2B to gradually darken shadowed areas and stems. I turn the paper to make it easier to draw strokes that follow the curves of the objects.

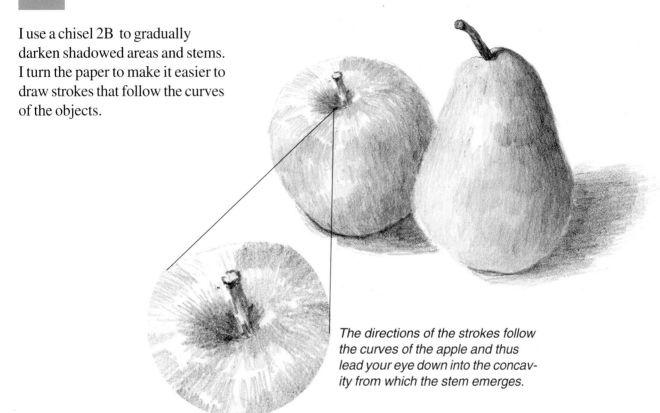

The directions of the strokes follow the curves of the apple and thus lead your eye down into the concavity from which the stem emerges.

7

I use a slightly chisel-shaped 4B to further darken both the shadowed sides of the objects and their cast shadows. Notice the cast shadows are lighter and fuzzier near their edges—this is partly because of light diffusion and partly because of multiple light sources in the room.

As a last step, I use an eraser to pick out the highlights.

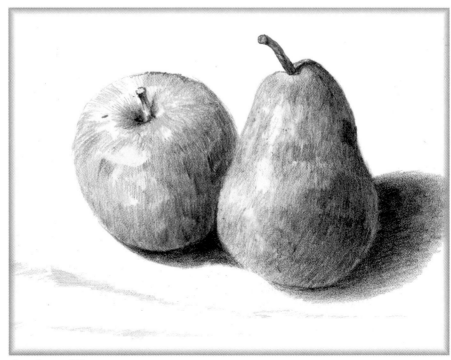

Apple and Pear
Pencil on Strathmore Bristol, smooth finish, 3 ½" x 4 ¾"

Here is a contour drawing you may use to render this subject. It would be more instructive, though, and more fun, to set up your own similar still life and use it as your subject.

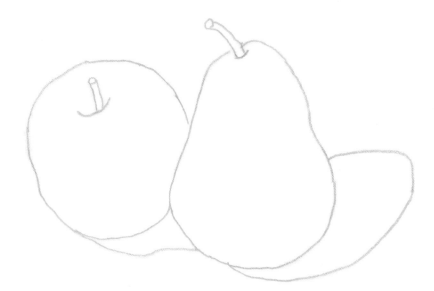

CHAPTER TEN
FARM BUILDINGS

1

This is a farm in Maryland that survives surrounded by urban development—there are apartment buildings in the background, behind the bare trees. I shot a bunch of photos and thought this snowy one was a good composition, needing few changes.

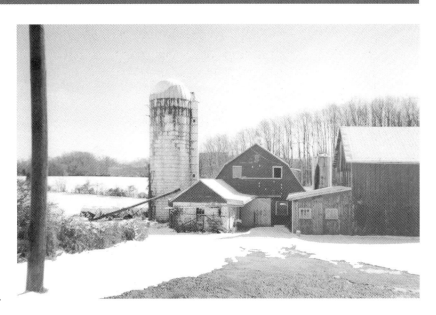

2

There's a nice variety of shapes in the buildings and I like the way they're positioned relative to each other—some facing the front of the picture, others facing the sides. If they were all neatly lined up, I would turn at least one of them. The power pole is obtrusive and uninteresting, so out it goes. I'll stick a couple of hills behind the buildings to help suggest a bit more distance.

TIP

As you roam with your camera (an indispensable tool), you're really designing every time you choose a scene through the camera's viewfinder. You can do your preliminary drawings directly from your photos—you can even trace a photo. Cheating? No, provided you copy your own photos, not other people's.

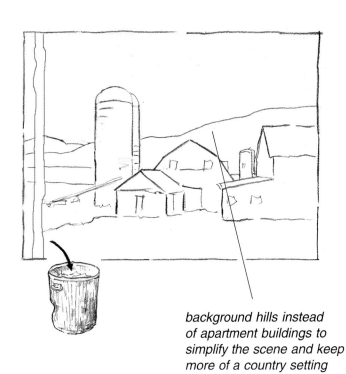

background hills instead of apartment buildings to simplify the scene and keep more of a country setting

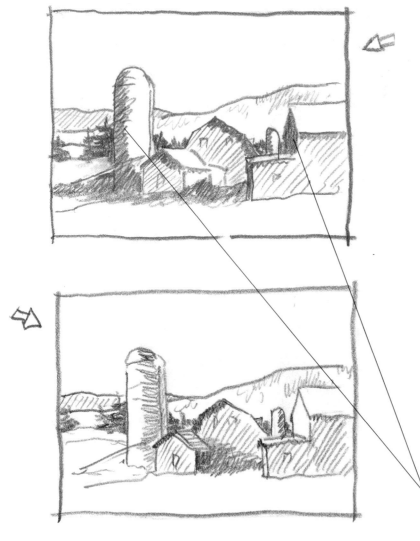

3

Now let's see what value scheme might work best.

I'll reposition the sun to suit me. I usually prefer a light source to be either at the right or the left, not in front of or behind the subject, because right and left give you more dramatic shadow possibilities.

In the first sketch the light comes directly from the right. The parts of the building away from the light and the areas under roof overhangs are dark. The areas getting direct sun are brightest and the building faces that are parallel to the picture plane (that is, the faces you're seeing straight-on) are neither bright nor dark—they're getting a raking light from the sun.

In the second sketch I try the sun at the left. Workable, but I like the first sketch better because the dark on the side of the silo and the dark face of the right-hand building neatly embrace the rest of the buildings

So I'll go with the sun at the right and add a few touches: (1) A fence to help lead the eye into the picture toward the center of interest (the buildings); (2) dirt showing through the snow where vehicles move to and from the barn; (3) a few dark accents to enliven the mostly gray faces of the barns.

The dark evergreens in the background provide some good value contrasts. They also help to tie the cluster of buildings to the left side of the picture. Without them, the buildings might appear to float without anchor.

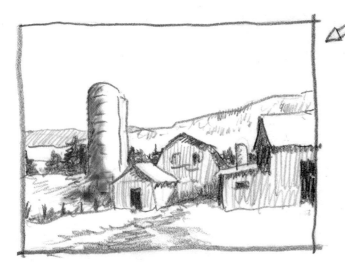

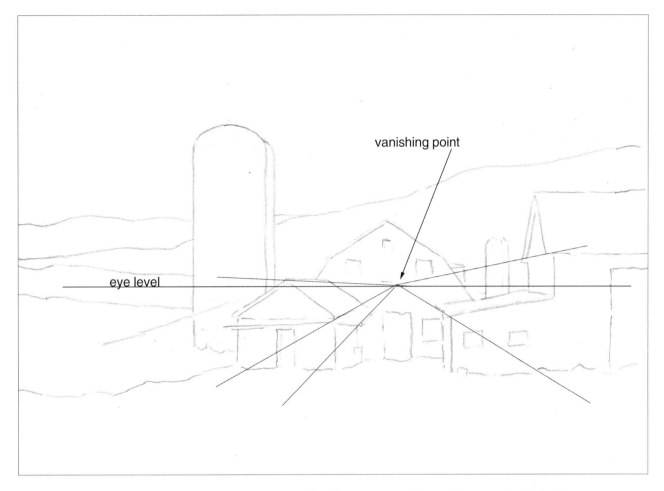

vanishing point

eye level

4

Here's the first step in the actual drawing, a light outline of the main shapes.

The actual drawing is 8" x 11", but here we're limited by the size of the book. If you decide to copy this drawing and want to work 8" x 11" (or any other size), you can use the gridding method explained earlier to get the size you want, or you may copy the outline at the end of this chapter.

The linear perspective in this scene is straightforward. Eye level is about where shown; if some of my perspective lines don't feel quite right, I'll fix them as I go along. As is often the case in an old-farm scene, some structures are often at an angle to others, rather than lined up neatly. Also, there are usually drooping roof overhangs, cockeyed doors, and so on, which only add to the charm of such places.

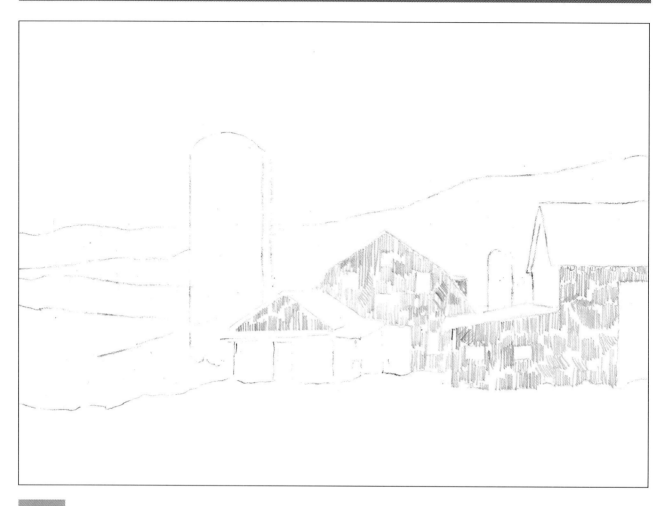

5

It's up to you where to begin filling in. Sometimes I like to work up the background first, but more often I dive into the fun stuff right away—that is, the center of interest—and then work out from there in all directions.

Here I use chisel 2H hatching to suggest the boards in the buildings. To suggest vertical boards I use mostly vertical strokes, but here and there, to avoid monotony, I use some diagonal strokes. Rather than fill in uniformly, I work in patches to add some visual interest and help keep the areas lively. Where I want to preserve a fairly even edge, I use an index card as a mask.

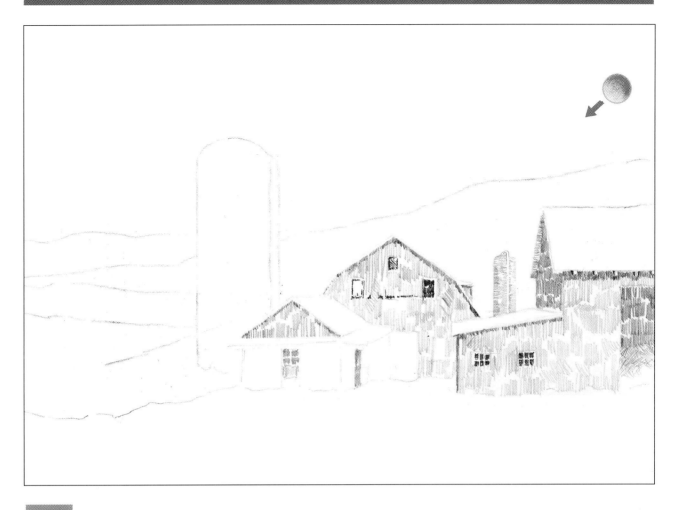

6

Now I begin to introduce some value contrasts using HB chisel strokes. The sun is at the upper right, and areas away from the light source are dark. Also, windows and open doorways may be dark. Adding dark accents to a gray midtone area helps to enliven that area.

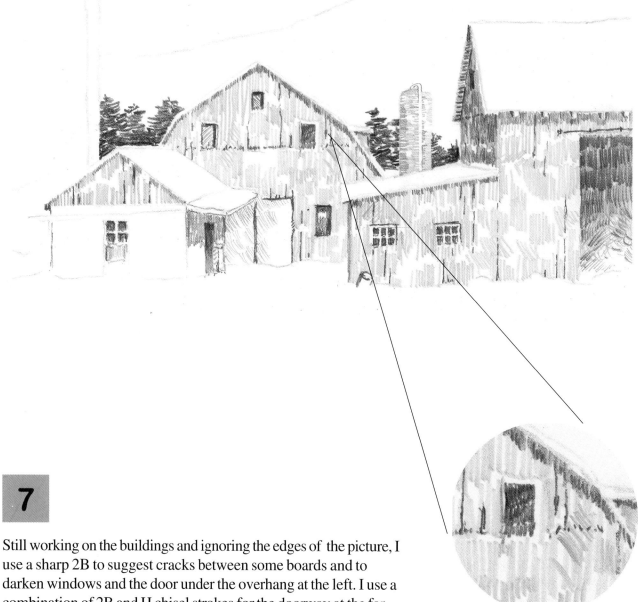

7

Still working on the buildings and ignoring the edges of the picture, I use a sharp 2B to suggest cracks between some boards and to darken windows and the door under the overhang at the left. I use a combination of 2B and H chisel strokes for the doorway at the far right. This area is darkest at the top, where there is little light, and lighter toward the bottom where some sunlight gets in. Diagonal strokes near the bottom suggest hay or straw.

I use the 2B to darken the left face of the right-hand barn and also to begin planting evergreens behind the buildings. The evergreens help make the barns stand out better because they provide a good value contrast.

At right is a close-up of a section of the center barn showing the raggedness of my strokes. These strokes are, in a way, like the paint strokes in Impressionist paintings. They're loose enough to keep the picture from being tight and photographic, but from a little distance they blend together enough to suggest the rigid nature of the subject.

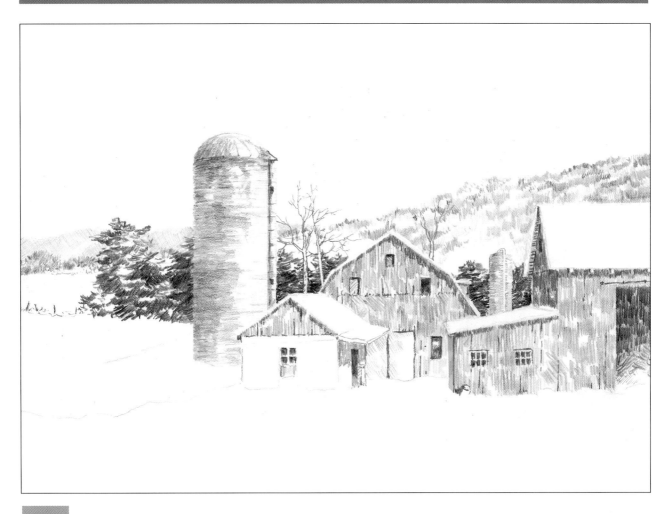

8

I show roundness in the silo by using horizontal strokes, mostly 2H and HB, some chisel, some flat, lighter on the surface nearest the light source. Next, to help frame the buildings and make them more prominent, I darken the evergreens behind the buildings, using chisel 2B and 4B.

Time to put in some distant background. I crosshatch the most distant hill with a sharp 4H and use chisel 2H and HB for the nearer hill, where I use vertical hatching to suggest scrub growth on a snowy hillside.

Next I use a sharp 4B to darken the accents (doors, windows, cracks) in the buildings. The buildings now seem a little too pale, so I do a little more hatching with a 2B chisel.

To preserve edges, I make frequent use of an index card as a mask. I mask most of the roof edges this way, as well as the sides of the silo.

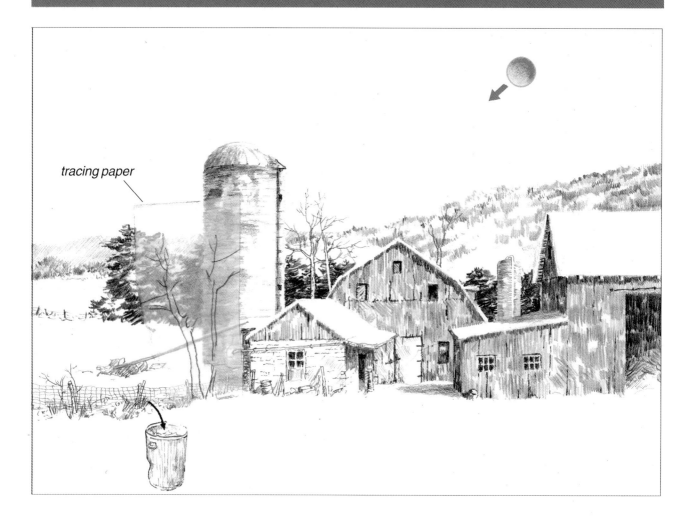

tracing paper

9

The sun is at the upper right, quite high, so the shadows cast on the ground are relatively short. I lay these in with a 2B flat. Then I draw in just a little detail to represent the whitewashed cinder-block shed at the left. Next I add the wire fence at the left because I think the picture needs something there to connect the barn grouping with the left edge of the picture.

Now I'm trying to decide whether and where to add a couple of bare trees in front of the silo. I want them because I think the big silo shape needs to be broken up a bit—otherwise, it seems a little boring. But I don't know just where to plant the trees, so I quickly sketch them on a piece of tracing paper and move the paper around to find the best position for the trees.

Now I take another look at the fence. Ugh! Too fussy and not in a good location. I erase it with the Pink Pearl and use tracing paper to fiddle with other, more suitable, locations.

TIP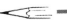

If you have to erase a big area, such as the fence in this picture, it's important to be working on a tough paper that will take the heavy erasing without shredding. Most Bristol papers I've used are suitable. In this scene, I erased the fence by scrubbing heavily with a Pink Pearl eraser and the paper survived nicely.

Farmyard
Pencil on Strathmore series 500
Bristol, plate finish, 8" x 11"

10

I get rid of the fussy fence and draw in a new one that directs the eye into the picture and breaks up the long foreground rectangle so the foreground shapes are more interesting. I decide the picture doesn't need the foreground road I originally planned.

I add a few details, including the trees in front of the silo, the hay conveyor (the long oblique object at the left behind the new trees), some boards and general junk alongside the edges of the buildings, and a bit more evergreen at the left to help attach the scene to the left edge of the picture. And finally, some birds in the sky.

CHAPTER ELEVEN
CITY MONTAGE

1

A montage is a combination of a number of separate pictures or parts of pictures, all related to one another through some common theme. In this montage demonstration, the theme is a set of landmarks near the center of the town of Gaithersburg, Maryland. Visible from the intersection of Summit and Diamond Avenues are the buildings, traffic signs and signals shown in these photos.

I first painted this montage in watercolor as a commission for the town's Kiwanis Club. The painting was large (30" x 40") and there was plenty of space to play with fading and overlapping objects without their becoming too jammed together. In the smaller drawing we're about to do, it will be necessary to simplify objects a lot to avoid having a confusing mess.

2

The first job is to choose a center of interest for the montage, a central object around which the other objects can be grouped. It seems to me the pole with the street signs and traffic signals is a natural—it's the thing that defines this intersection. I place it a little off-center so it doesn't divide the montage in half. Now, where shall I place the buildings?

3

My way of making such decisions is to do a set of quickie sketches on separate pieces of paper and shuffle them about until I'm happy with their arrangement. At left are six separate sketches that I move around.

The two buildings that have the most detail are the railroad station and the drug store; so, for balance, I place them on opposite sides of the pole. I try the other pieces in various positions. I've made all the buildings about the same size, and that won't do, so I sketch the mill and the post office smaller. That helps, and now the arrangement feels comfortable.

4

The railroad is such an important part of this old town center that I think the tracks need to be shown, so I add them at the center of the picture, but resolve to try to keep them from becoming too busy. Done right, the tracks should help to bind the pieces of the montage together. I add a couple of distant power poles because I like the calligraphic detail they lend the picture. After slightly shifting and reshuffling the pieces, I end up with this montage outline.

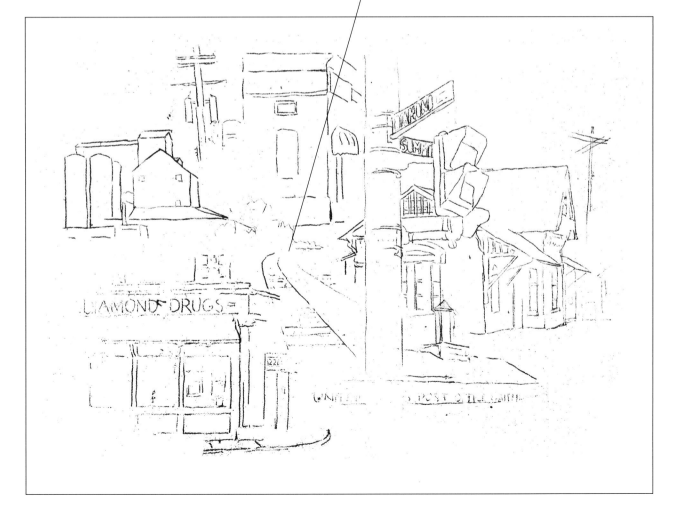

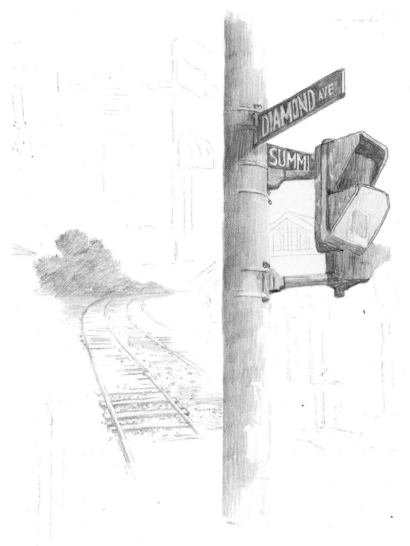

5

I begin at the center, with the pole and the tracks, the combination around which I hope to build this montage. I use an HB and a 2B, either sharp or slightly chiseled, and make mostly open strokes very close together—so nearly blended that, from a little distance, they look about the same as flat strokes. Later I'll use an eraser to lighten some areas where I want a transparent, see-through effect.

What about some of the ideas I've emphasized in PART I, such as light source and eye level—do they matter in a montage? The unequivocal answer is *maybe*. If you think of the pieces of the scene as all being viewed on the same day at the same time, then you might choose (as I have) to keep the light consistent—but you don't have to. In this case I think a single light source helps by adding coherence to the montage.

I've said in PART I that you're only allowed one eye level per picture, yet here I'm using several different eye levels. Obviously, this is not a single scene, so there's no reason to stick to a single eye level. But notice (this will become clearer as the drawing develops further) that the eye levels for the various parts of the montage are not *wildly* different. In fact, all the eye levels stay well within the picture area. That feels comfortable because it helps promote the idea that you're seeing all these buildings from one central spot, the intersection of Summit and Diamond.

HB hatched strokes
close together

The words on the signs are made by
lightly penciling their outlines and then
darkening the spaces around them.

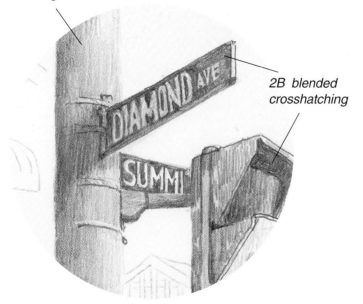

2B blended
crosshatching

6

The tracks and pole are not quite finished, but they're far enough along to act as a nucleus around which I can begin to build the rest of the montage.

I continue by drawing parts of all the surrounding pieces rather than complete one piece at a time. I call this "explosion" drawing—you establish a center and work outward from there in all directions (you can work the same way in painting).

I erase here and there to introduce some "see-through" areas. While certainly not mandatory, these transparencies help to knit the pieces together and maybe add a little air of fantasy.

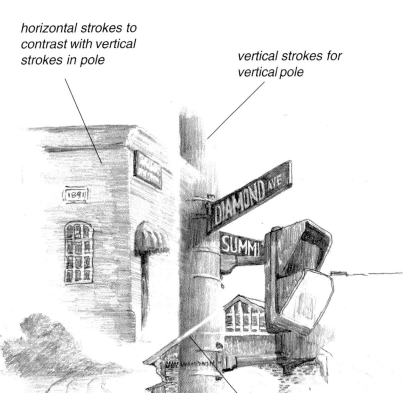

horizontal strokes to contrast with vertical strokes in pole

vertical strokes for vertical pole

see-through sections made by erasing through an erasing shield

7

I fill in roughly all the remaining parts of the picture to get a sense of whether the parts are relating well. At this stage I see three areas needing attention: (1) The mill needs to be more firmly connected to the rest of the montage; (2) lots of details need sharpening; and (3) the right side of the picture seems stronger, "heavier" than the left. So far I've used HB and 2B pencils; for the final details I'll use some sharp 4B strokes.

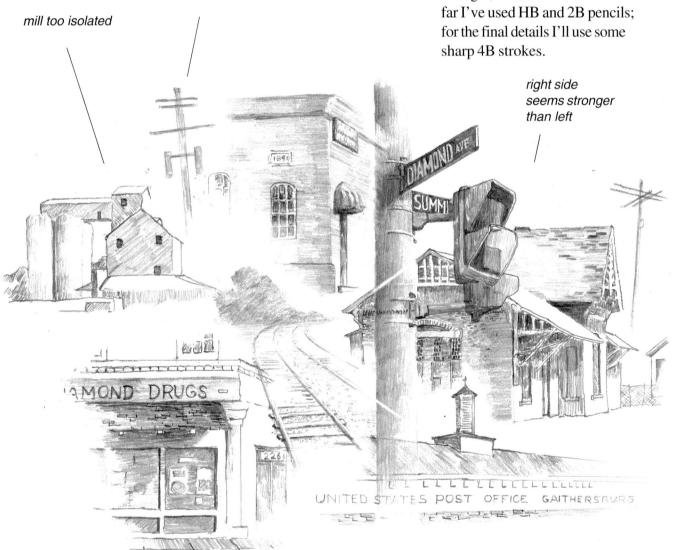

stronger detail needed

mill too isolated

right side seems stronger than left

8

I drew this montage 9" x 12" because that is the maximum size my scanner would accept. Ideally, a picture with this much detail (and, in fact, I left out a lot) deserves a larger format. If I were to do a similar subject, free from mechanical restraints, I would draw it at least twice as large.

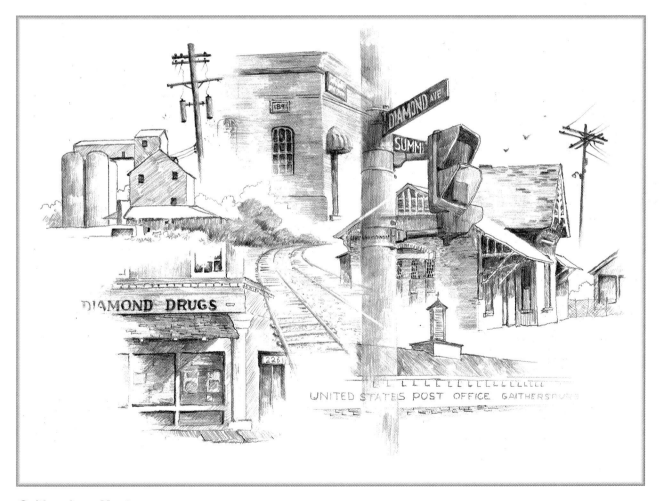

Gaithersburg Montage
Pencil on Strathmore 400 series
Bristol, smooth finish, 9" x 12"

CHAPTER
TWELVE
BARE TREES

1

In this photo, the big foreground tree, an oak, is what catches my eye. I'm something of a tree nut, and I especially like big, bare, textured specimens.

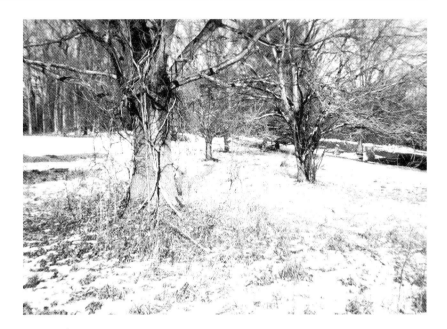

2

The photo is pretty good as it stands, but I want to zero in more closely on the forward tree. I look through a viewfinder and consider this horizontal format that includes a strong secondary tree at the right.

cardboard viewfinder

3

I like this vertical format better because I can zoom in on the one tree and play down all the background stuff.

These simple sketches are important because they represent the basic design for the picture as far as shapes and values are concerned.

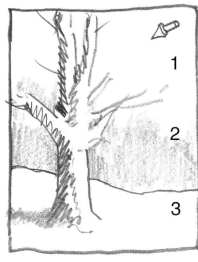

4

I make a small, quick sketch to see just where to place the tree on the drawing paper—I put it roughly one-third of the way across the sheet, a reasonably safe design decision. Similarly, I divide the background vertically into thirds (see Chapter Seven, SHAPES: LOCATIONS). Then I decide where to place the sun. I choose to make the right side of the tree light and let it burst into the big right-hand side of the picture—it's as though the tree is emerging from the shadows at left into the light at right.

5

Satisfied with the basic design, I make a faint outline of the important shapes. As always, I know I'll make changes to this outline as the drawing develops.

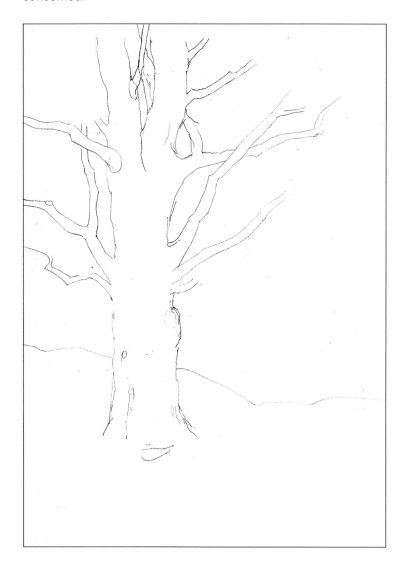

6

Sometimes I begin by shading large areas to get an early feel for overall values. Today I'm eager to dig into the texture of the tree, so I pick an interesting spot and start there.

 With a sharp HB, I outline some of the vines that grow up this tree. Then, using slightly chiseled points, I hatch the bark area, first with H, then with HB in the next darker areas and finally with 2B in the darkest parts of the bark. I'm filling in the negative spaces around the vines, leaving the vines white. I use a sharp 4B for the black knotholes.

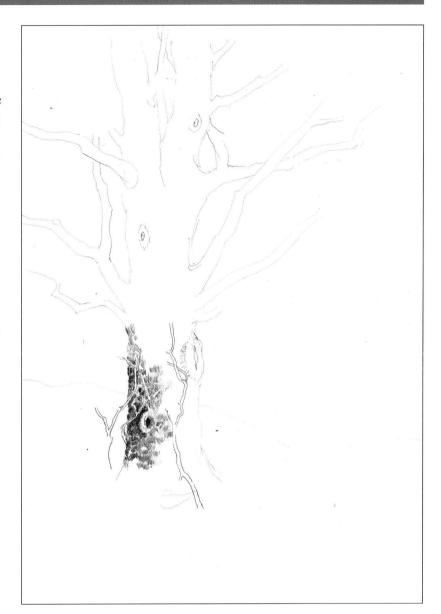

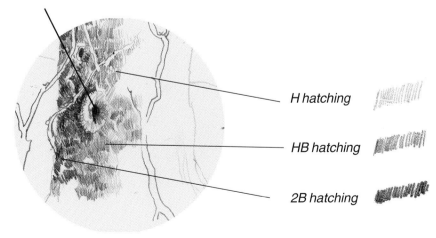

4B solid darks

H hatching

HB hatching

2B hatching

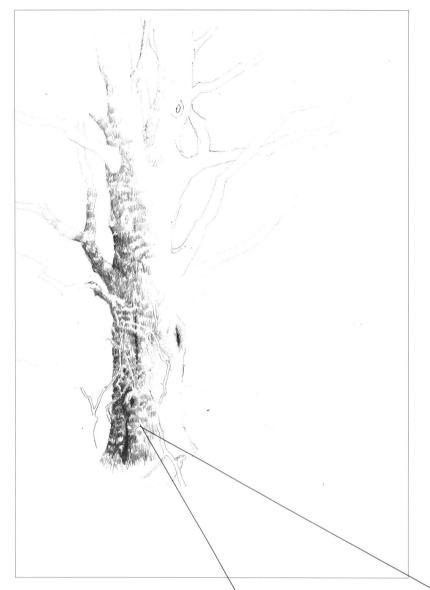

7

I continue to texture the darker side of the trunk, leaving the sunlit side alone for a while. I keep my eye on this dark/light relationship and try to avoid bringing the dark too far around the trunk. At the base of the tree I use some brisk vertical strokes to suggest grasses against the trunk. I keep most of the hatching marks vertical to help suggest this tree's bark, which has mostly vertical texture (unlike birches or beeches, which show a lot of horizontal ring-like texture).

Most of my hatching strokes are continuous—that is, made without often lifting the pencil from the paper. I'm still using H, HB and 2B strokes except for the dark 4B holes and crevices.

This inward-sloping surface is in shadow.

Sunlight catches this surface.

If you want your picture to be convincing, be a keen observer and pay attention to details such as the knotholes and crevices in this tree. A knothole isn't just a hole—it's a place where there once was a branch. The trunk surface around the knothole may take unusual forms, such as the concave dish shape you see here.

The left side of the crevice catches light, but the right side of the crevice curves inward into shadow.

8

I lightly texture the sunlit side of the tree (H chisel) and add a couple of branches. I'm beginning to think about the background, which I had initially planned to fill in fairly completely with pale woods. I like, so far, the boldness of the tree against its stark background and I may leave it that way. I use the flat of a 2B pencil to rough in a background treeline, just dark enough to separate sky from ground.

TIP

If you're not sure you'll keep an area, such as the distant treeline, use strokes that will be easy to remove cleanly. I used flat 2B strokes. Firm open strokes or strokes made with a harder lead would be more difficult to erase.

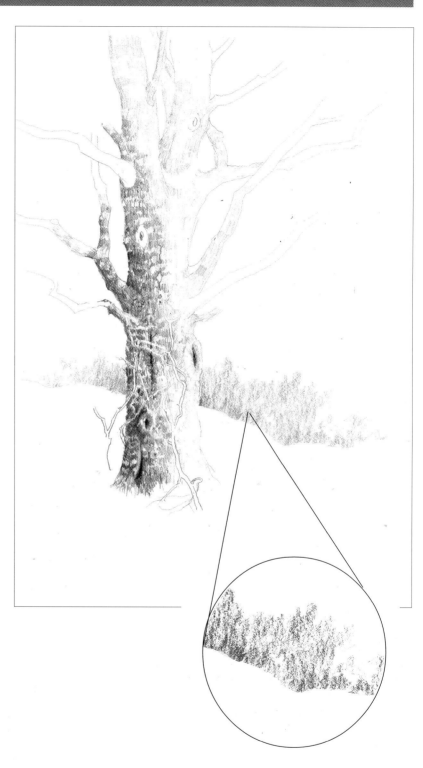

You know the TV character called Courage, the Cowardly Dog? He's a real wimp about doing what takes guts, but his timid approach always comes out right in the end. I can't decide whether or not to leave the background this simple, so I make a cowardly decision to delay any more messing with the background until later.

9

With HB hatching I strengthen the right side of the tree, making sure I don't get too dark and lose the sunlit effect. I add a few branches and leave a couple of white areas for snow that has settled in the crotches (a) where the trunk divides and (b) between the trunk and a branch.

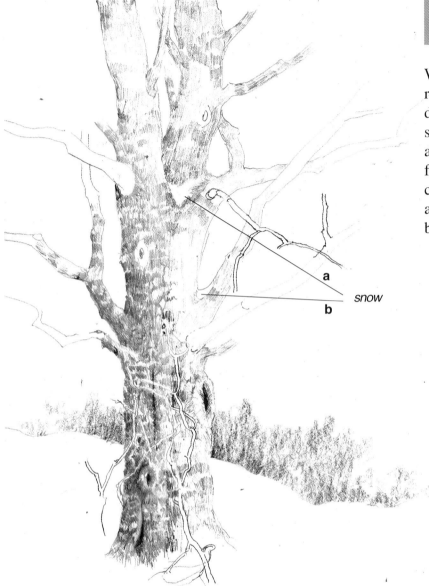

a

snow

b

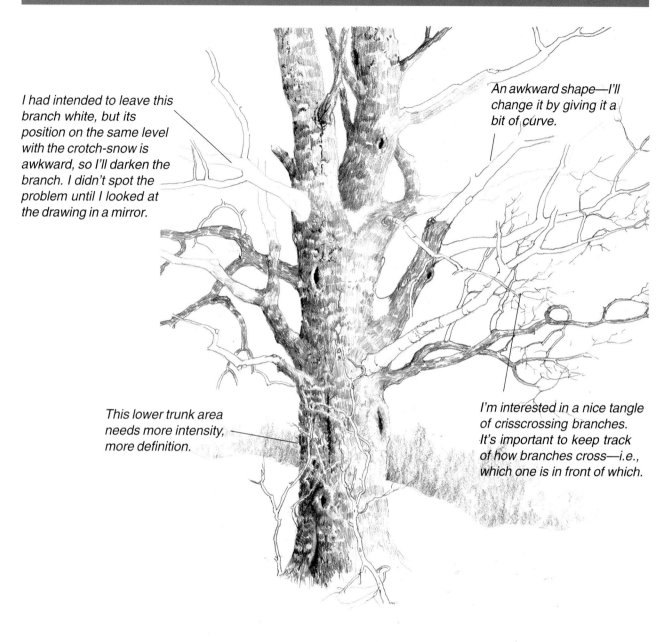

I had intended to leave this branch white, but its position on the same level with the crotch-snow is awkward, so I'll darken the branch. I didn't spot the problem until I looked at the drawing in a mirror.

An awkward shape—I'll change it by giving it a bit of curve.

This lower trunk area needs more intensity, more definition.

I'm interested in a nice tangle of crisscrossing branches. It's important to keep track of how branches cross—i.e., which one is in front of which.

10

It's time to expand the tree and see how well it fills the image area. Using sharp HB, 2B and 4B pencils, I add texture (hatching strokes) to the trunk. I add branches, change the size of some, and begin texturing them. A few dead, bleached branches will be left bare and barkless. I like that effect because those bare branches provide a visual relief from the mass of heavily textured areas. I look hard at the total mass of the branches to try to decide whether their mass is appropriate for the mass of the trunk. Usually it looks odd to have a massive trunk supporting spindly branches. So I keep adding branches, first to the right, then to the left, always looking for balance. At this stage, and during the rest of the drawing process, I'm pretty much ignoring the real tree and treating the picture as a design project, taking whatever liberties I wish, as long as I'm happy with the result.

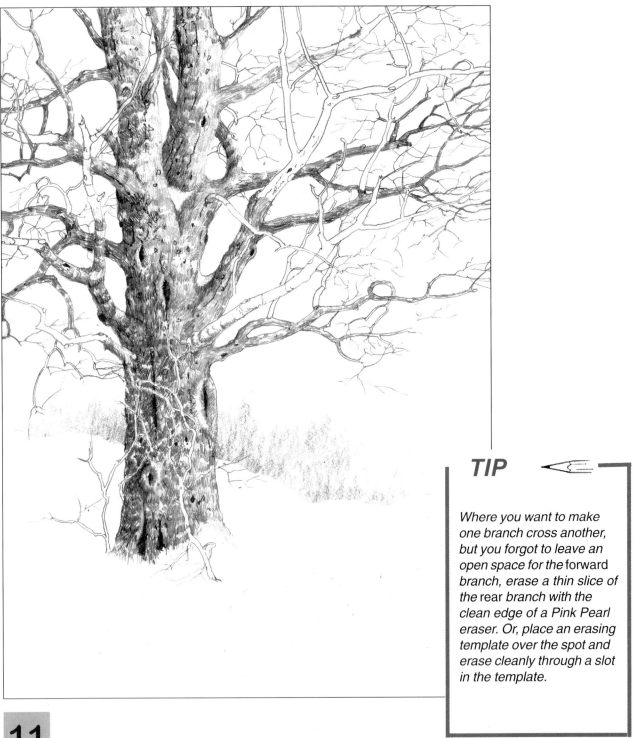

TIP

Where you want to make one branch cross another, but you forgot to leave an open space for the forward *branch, erase a thin slice of the* rear *branch with the clean edge of a Pink Pearl eraser. Or, place an erasing template over the spot and erase cleanly through a slot in the template.*

11

The tree is nearly finished. I try for a convincing tangle of crisscrossing branches and plenty of texture, including small holes and crevices. I keep my eye on which branches cross in front of or behind other branches—this requires patience in following each branch to its completion. (Of course, a few minor "errors" will never be noticed!). What remains is to decide on a suitable background and to "plant" the tree firmly into the ground by adding some grasses, twigs and cast shadows around the base of the trunk. The background still eludes me.

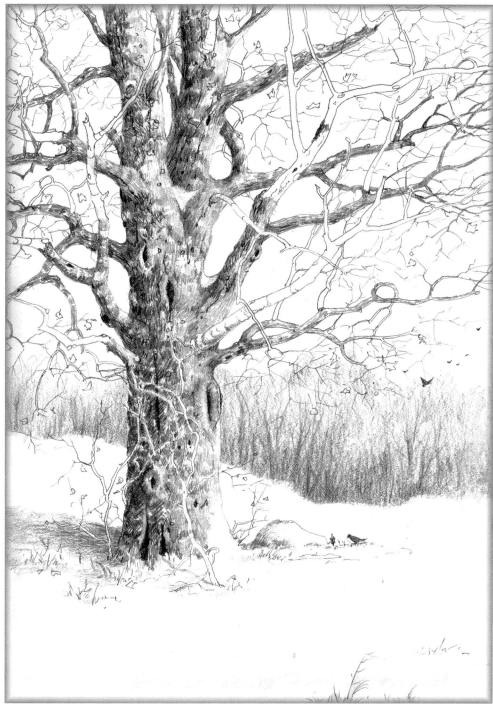

12

Red Oak
Pencil on Strathmore series 500 Bristol, plate finish, 12" x 9"

I decide to darken and enlarge the background so it doesn't look so weak. I add enough ground clutter to anchor the tree. I notice that, because of the tree's bulk, the picture feels a little unbalanced toward the left. For balance, I add a few strong dark crows at the right. The grasses along the bottom edge of the drawing are there only to signal where the bottom of the picture is. Without a mat or frame, and with only white at the bottom, there would be no clue where I intend the bottom edge to be.

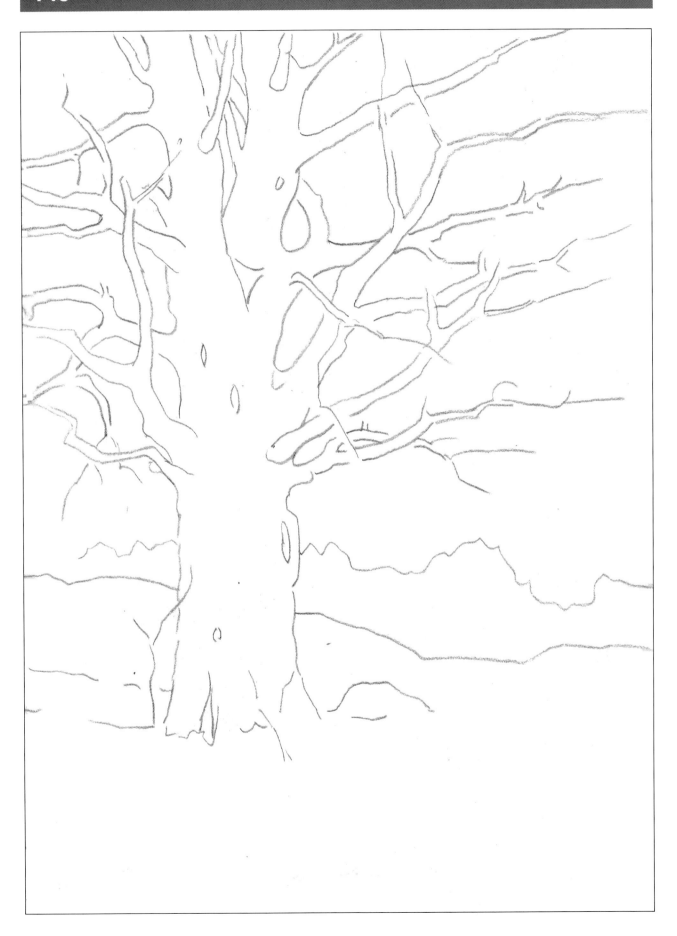

CHAPTER THIRTEEN
WOODS AND STREAM

1

In this case we'll get right to the value sketch. There is no photo of this scene because the scene doesn't exist—it's one I imagined, based on lots of trips into the woods. I painted the scene in watercolor, based on this value sketch. Now I'll do a pencil drawing using the same sketch.

Let's begin by looking at some key elements of the design.

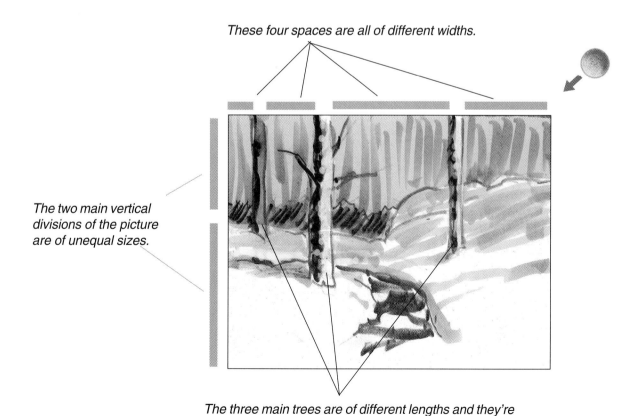

These four spaces are all of different widths.

The two main vertical divisions of the picture are of unequal sizes.

The three main trees are of different lengths and they're placed in three different planes in the picture—near, farther back, and still farther back.

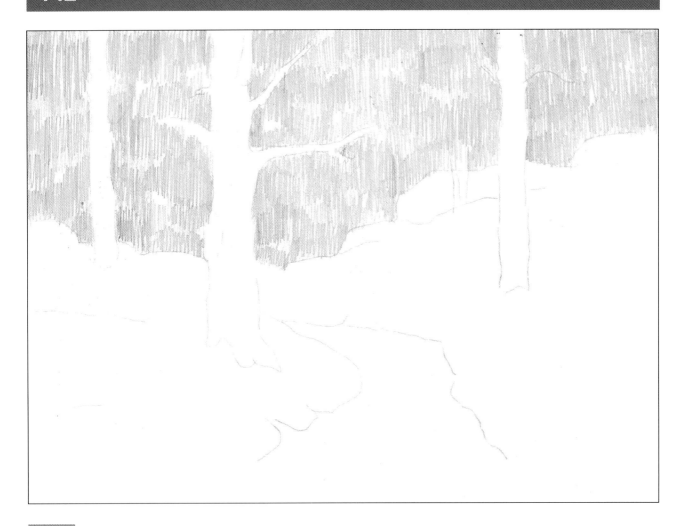

2

I fill in the woodsy background with a chisel HB, using big patches of hatched strokes. This represents the most distant area in the scene. Now I'll work my way forward in stages (I call this process "staging," whether in a drawing or a painting).

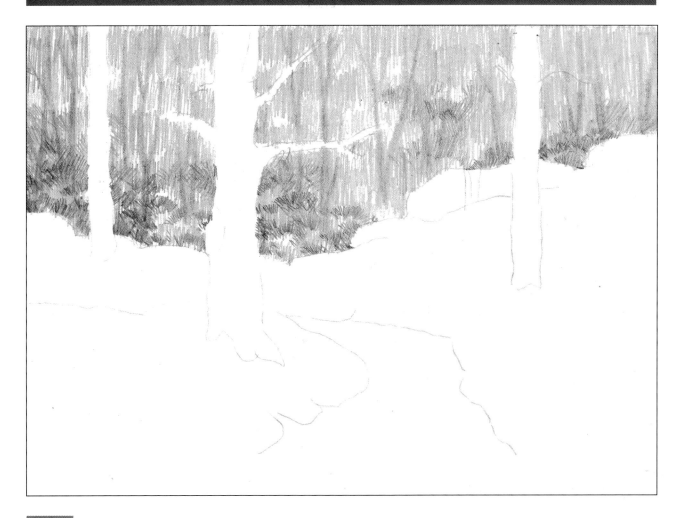

3

For the second stage I use an HB to faintly suggest trees in the distance and the closer underbrush. For the underbrush I use hatching and crosshatching, seeking a suggestion of bushes partially covered by snow. I also faintly suggest some masses of higher foliage, possibly some distant evergreens or oaks still holding onto their leaves.

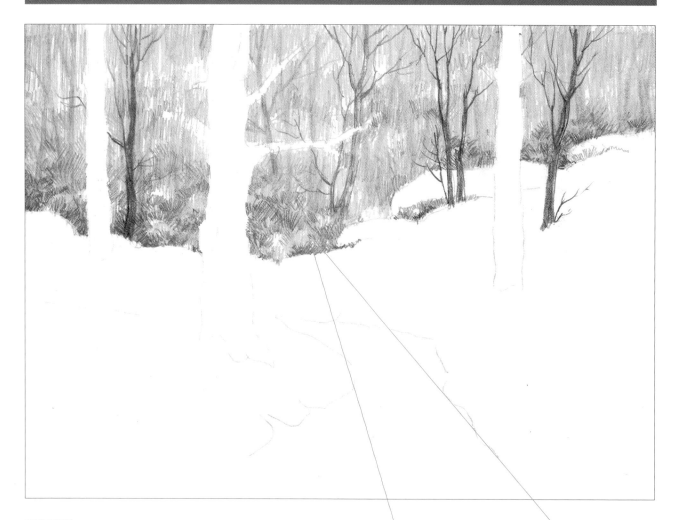

4

The next stage is the darker, more defined trees and darker underbrush, rendered mostly with a sharp 2B. I also use the 2B to darken some of the earlier, more distant, layer.

index card

I use an index card with various curves cut into its edges to mask areas such as these and get relatively crisp edges.

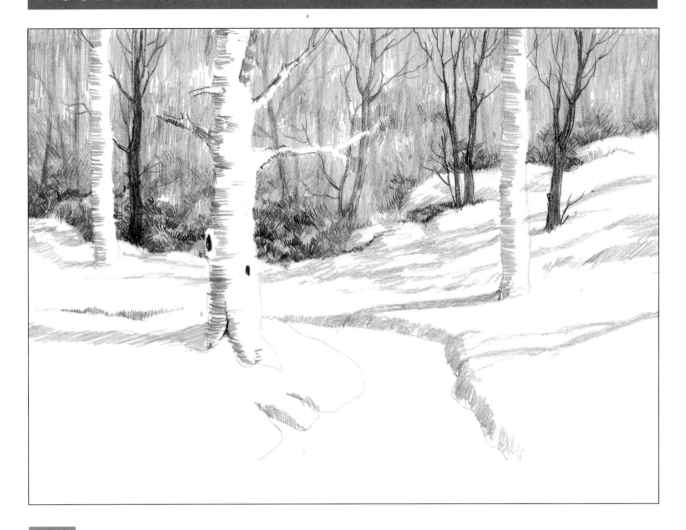

5

With a chisel 2B I draw cast shadows extending from the right toward the left. Some of the shadows are cast by trees outside the picture area. Still using 2B, I indicate, with vertical hatching strokes, the shadowed edge of the bank leading down to the brook. All the shadows follow the contours of the snow-covered ground.

I begin drawing the three main trees using horizontal strokes to suggest the horizontal banding often found in the bark of these trees (American beeches). I leave their sunlit sides white for now.

I notice the darker trees behind the beeches seem spindly, so I fatten them a bit with 2B strokes. I also darken some of the background underbrush to create a better value contrast with the snowy area.

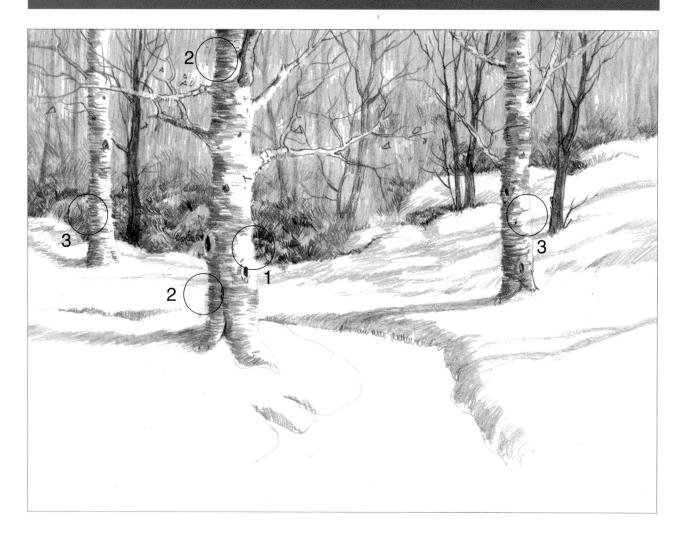

6

Using HB strokes, I add to the height of the stream bank. With 2B, I strengthen the beech trees. To form some of the beech branches I first erase parts of the background using the fine slots in an erasing shield.

As I work on the trees I adjust values in several ways to get some variety: (1) I leave some *light* edges on the trees to contrast with the darker background; (2) I make some edges of the trees *dark* to contrast with the lighter background; and (3) I create some *lost* edges by making tree values and background values the same or nearly the same.

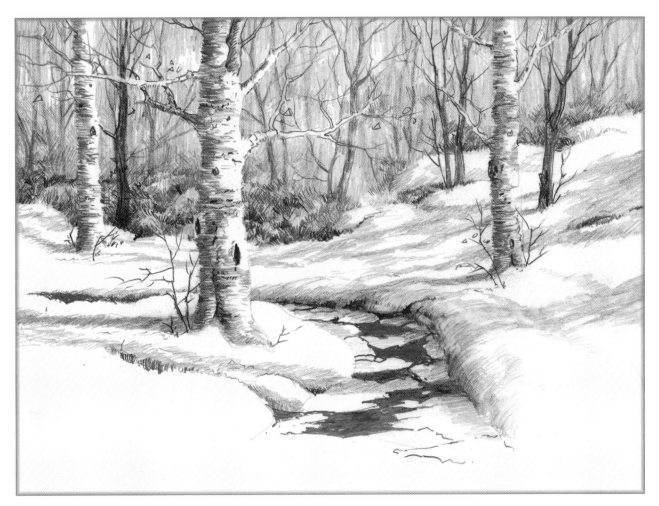

Woods and Stream
Pencil on Strathmore Bristol,
plate finish, 5" x 6 ¾"

7

I finish by broadening and reshaping some cast shadows with an HB and filling in the dark water with a chisel 4B. Then I use sharp 4B and 2B pencils to darken details all over the picture—it's important that small darks elsewhere in the picture balance the large darks in the water.

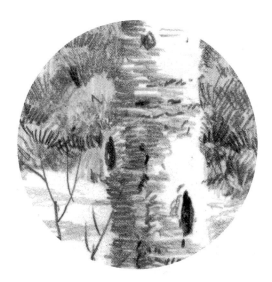

Here is a closer look at the strokes that form the main tree and the background.

CHAPTER
FOURTEEN
OLD HOUSE

1

This interesting old house lies along Interstate 95 near the Virginia-North Carolina border. I'm attracted by its shapes and its textures.

I plan to keep the large foreground tree, but it must be moved because it's too close to the chimney—the two shapes side by side are too competitive. If I move the tree, however, I'm not sure what should fill in the space behind it. The second photo answers that question.

This photo tells me what's behind the big tree in the upper photo.

2

This is my first stab at the design. There are some obvious problems: (1) The house is too centered, even though the big tree helps pull things off-center to the right; (2) the little shack behind the house at the left is too slender; (3) the fence may be too rigid and, in fact, unnecessary.

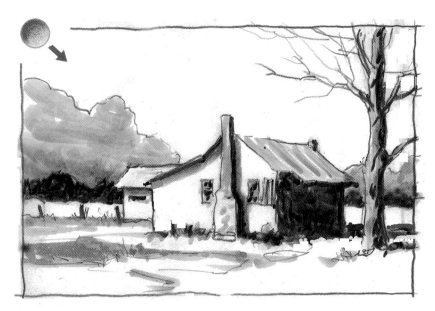

I leave the sun at the left, as in the photos. I show more of the shack at the left and move the main building to the right, closer to the tree. I think the fence in the foreground is too obtrusive, so I get rid of it and add a smaller fence farther back. I use markers to work out values.

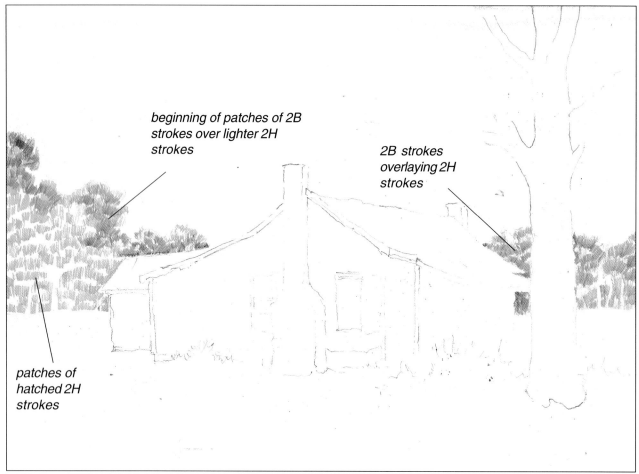

beginning of patches of 2B strokes over lighter 2H strokes

2B strokes overlaying 2H strokes

patches of hatched 2H strokes

4 To begin the drawing, I lightly sketch the main shapes. Using a chisel 2H, I lay in the background tree foliage with patches of hatched strokes. Then I overlay those strokes with darker patches of hatched, sometimes crosshatched, 2B strokes. I'm looking for a fairly dark, patchy, not-too-detailed backdrop for the house. Notice, the background trees are in full leaf even though the foreground tree has lost its leaves.

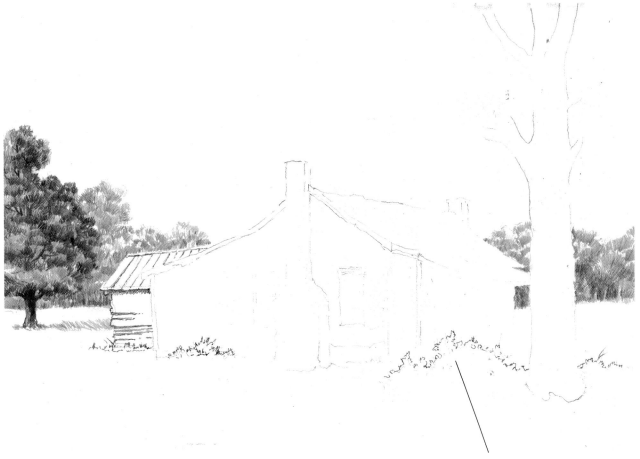

This clump of weeds will later help break up the big dark area of the shadowed side of the house.

5

I finish hatching the background, but at the left it looks too plain, so I decide to plant a tree there. With a 4B, I darken the new tree enough to separate it from the background trees. I make the right side of the new tree (the side away from the sun) darker than the left side.

Now I begin work on the shack, indicating the ribbed metal roof and rough log siding at the left. I also outline some bushes and weeds close to the house. The larger clump at the right will help cheer up the dark, shadowed side of the house (coming later).

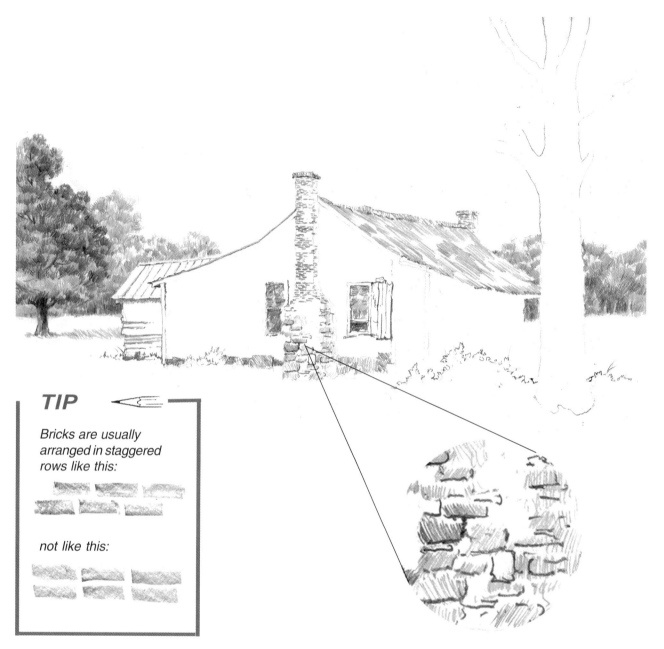

TIP

Bricks are usually arranged in staggered rows like this:

not like this:

The stones are of different sizes, shapes and textures.

6

Using short, horizontal 2B chisel strokes, I draw some bricks, but leave most to the viewer's imagination. I draw the stone part of the chimney using a variety of strokes to suggest the stones. Again, I don't draw every stone.

 I work on the windows and the battered shutter alongside one of the windows, trying for a loose rendering rather than a neat, sharp-edged treatment, keeping in mind this is a dilapidated house. I use broad (chisel) 2B strokes to suggest the metal roof and begin drawing the house foundation and the junk around it.

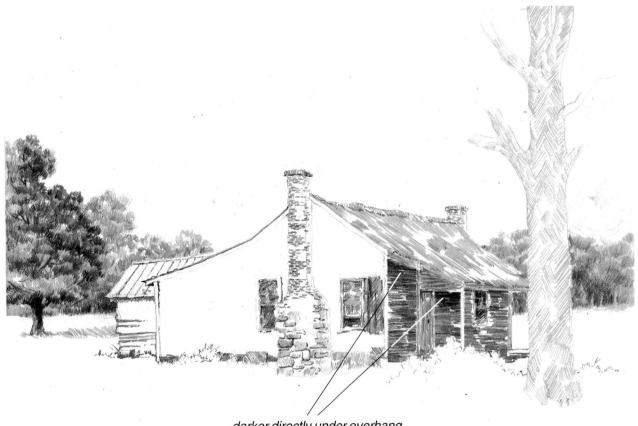

darker directly under overhang

7

With a chisel 2H I lay in the tree trunk. Still using the 2H, mostly with horizontal strokes that follow the direction of the siding, I lay in the shadowed side of the house. Then I go over that entire side with a chisel 2B, leaving many flecks of white to keep the area lively. Up high under the roof overhang the shadow is darkest, so I strengthen those areas with a 4B. I also use the 4B to suggest a window and door.

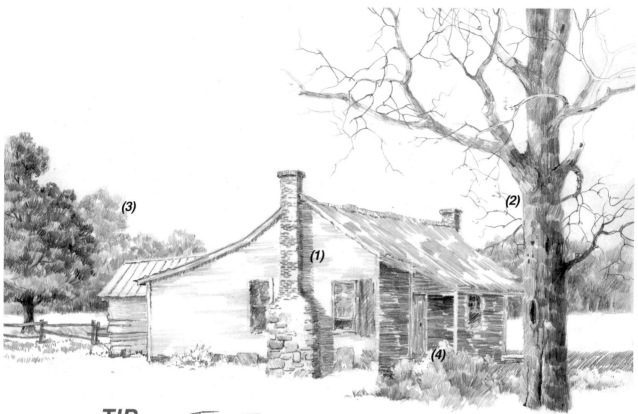

TIP

For a softer, more relaxed look, avoid outlining too many edges. Rather than outlining, you can place one value against another. Examples are: (1) the cast shadow from the chimney; (2) the edges of the tree trunk; (3) the edges of the trees in the background; (4) the edges of the clump of weeds.

To get such edges, it's very helpful to use an index card as a mask, as described in Chapter One.

8

Using H, 2B and 4B, I draw the shrubbery in front of the dark side of the house. I texture the bare tree with patches of 2B and 4B strokes and use 4B for cracks and knotholes. I use sharp H and 2B for the twiggy tree branches. I decide the picture needs more action at the far left, so I add a fence, one with a little more pizazz than the one in my original thumbnail sketch. With chisel 2B strokes I draw the cast shadows of the chimney and the house. I add some faint texture to the sunlit side of the house, using a chisel H.

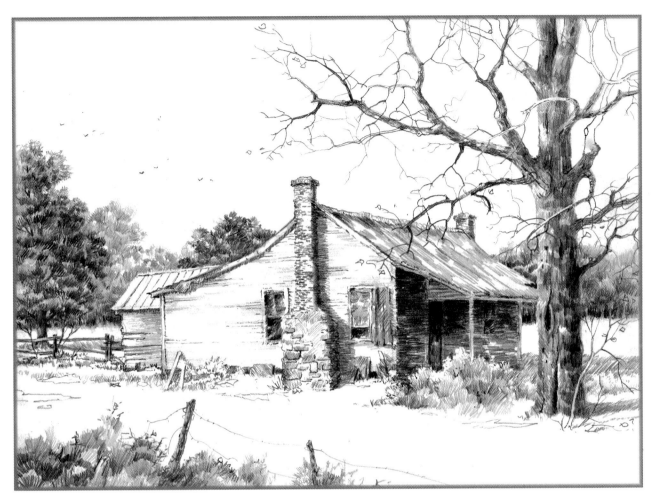

Albert's Place
Pencil on Strathmore Bristol, plate finish, 8 ½" x 10 ½"
Collection, Leah Henrici, Gaithersburg, MD

9

I enliven the foreground by adding more shrubbery, along with a couple of simple fence posts that help direct the eye toward the house. I patiently work all over the picture, adding many details and strengthening small areas, mostly with sharp 2B and 4B leads. As I add details, I'm careful to leave untouched white areas, such as the sky, the foreground and the narrow strip of middle ground. Those sections are important as visual relaxation areas (areas not busy with detail) and they provide pleasurable contrast with the darker areas.

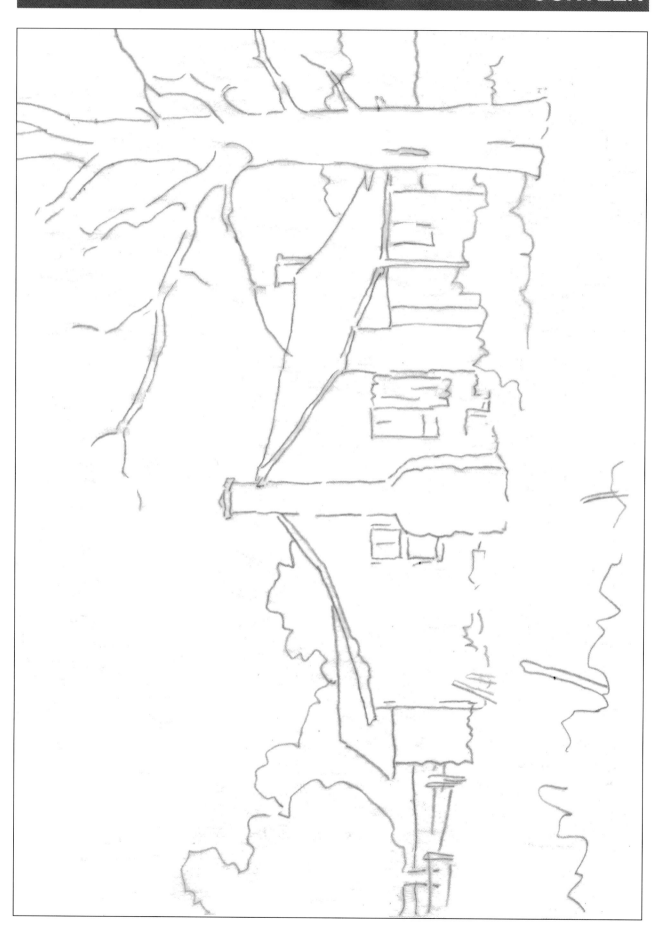

CHAPTER FIFTEEN
PEOPLE

1

I'd like to combine these two scenes but you can't just plop a figure into a scene any old way and expect it to be convincing. There are at least three important considerations: (1) Scale; (2) position; and (3) believability.

Scale: When inserting a figure into a scene, compare the figure's size with that of other objects (such as the trees in this case) and make sure the relative sizes seem reasonable.

Position: Look for a decent balance—for instance, in this scene putting the figure at the lower right should nicely balance the mass of trees at the upper left.

Believability: The outdoor scene shows a lot of bare trees (aside from the evergreens), so this is probably either fall or winter. It wouldn't do to have the figure strolling along in a bikini. Coat and gloves seem reasonable.
 The sun in the landscape photo is at the right (you can see the light on the right sides of the tree trunks), but the sun on the figure is at the left. When I put the two photos together, I'll need to decide on a single, consistent light source.

deer

I could include the deer in the picture, but if I did that I'd have to treat the dog differently. There's no way a Beagle would be quietly strolling if there were a deer in sight! I'll keep the scene quiet and simple—no deer, so Charlie and Momma can relax.

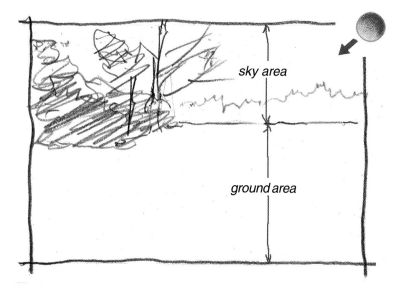

First I lay out the main sections of the landscape part of the drawing. To avoid symmetry, I make the division between sky and ground something other than fifty-fifty—I choose to make the ground area larger than the sky area, giving me more room to maneuver when I begin placing the figures.

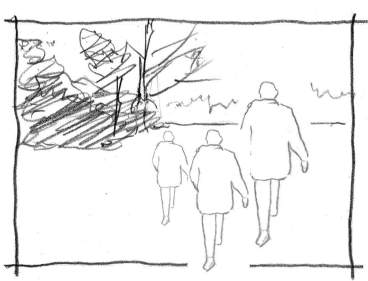

Now I flip the photo of the woman and the dog to get the sunlight on their right side. I try them out in several different sizes to see which size feels right. I'd like them to be close to the viewer, in the near foreground, so the middle sketch looks about right. The right-hand one looks like a giant and the smallest one seems too distant.

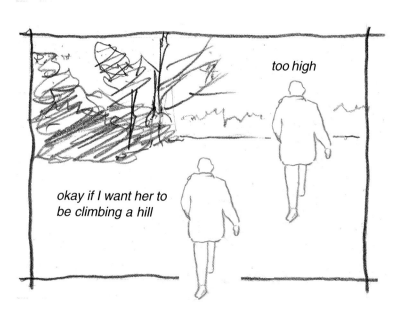

How high or low should the figure be? If I place her low, below the viewer's eye level, she'll be walking uphill; if I place her too high, she might seem to be floating above the ground.

5

I decide to place the figure on flat ground with her eye level the same as the eye level of the picture.

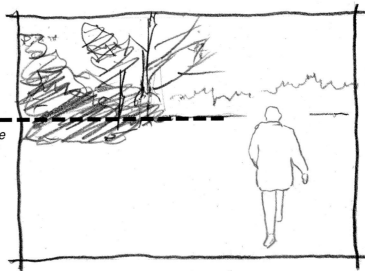

eye level of the picture and of the woman

6

Here's my value sketch—nothing complicated. There are three values, white, black and gray. When I get toward the end of the picture I'll probably add some light-valued areas to break up the big white foreground.

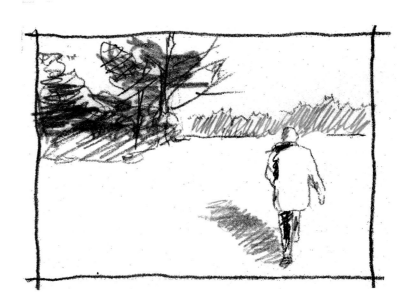

The sketch at right shows how several people, all the same height, would appear in a scene on flat ground. Provided they're all standing on the same flat surface, all their eyes would be on the same level. If they were walking along a straight path, the path would "disappear" at a vanishing point on the eye level.

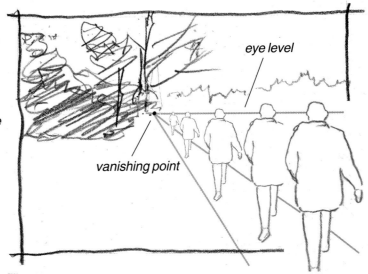

eye level

vanishing point

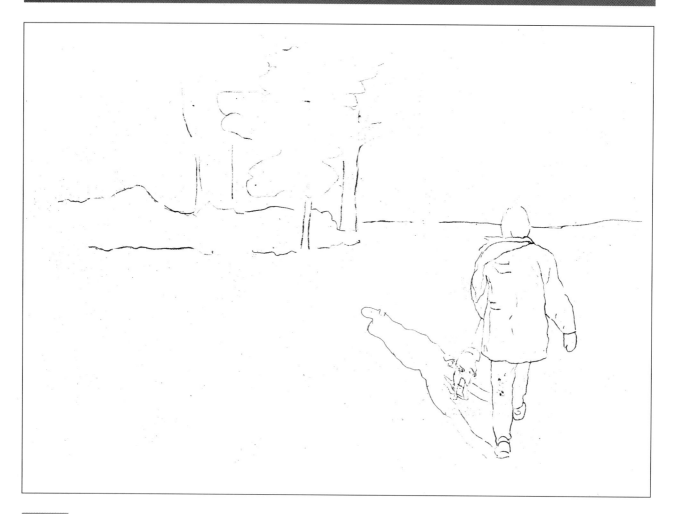

7

After establishing the basic design on scrap paper, I transfer it to my drawing paper. As usual, I outline lightly and in just enough detail to get me started. Too much detail at this stage would deny me the freedom to improvise as I go along.

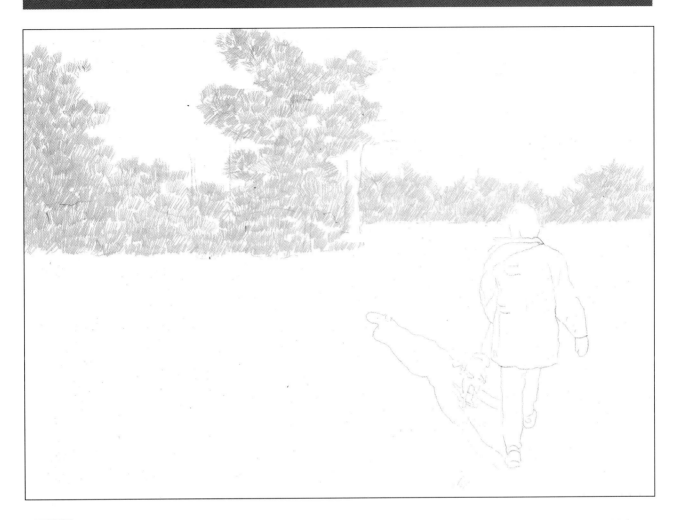

8

Hatching with a chisel 2H, I lay in fairly densely all the tree and brush area. This is what painters would consider an underpainting, a layer that serves as a foundation to build on.

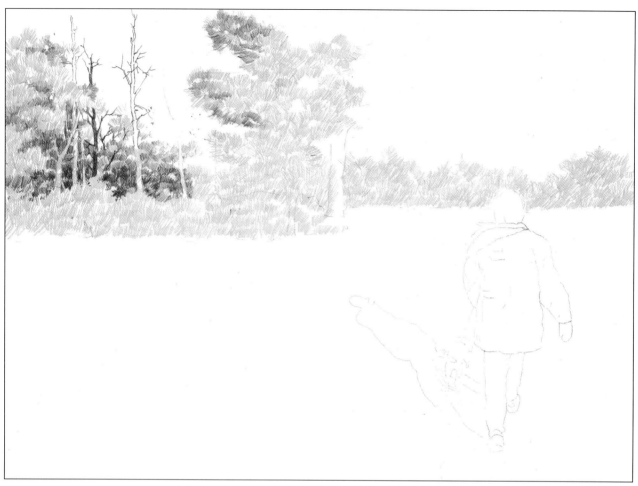

9

Using a sharp 2B, I begin texturing and darkening the background foliage and forming tree trunks and limbs. Much of this work involves "negative drawing"—that is, drawing the spaces around things rather than the things themselves. For example, the light tree trunks are negatively drawn—they are simply left light, and they show up because of the dark alongside them.

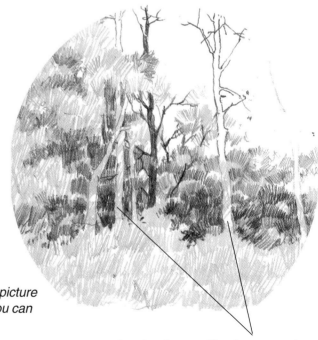

Here is a portion of the picture shown actual size so you can see individual strokes.

tree trunks resulting from negative drawing

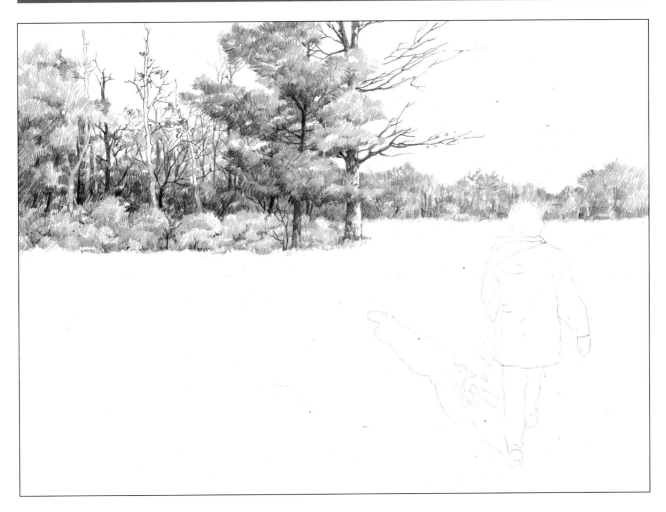

10

Using 2H, HB, 2B and 4B, I work my way across the picture, nearly finishing the upper part of the landscape.

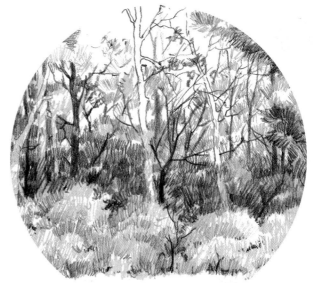

I use pale 2H and HB strokes to keep the front area of shrubbery lighter than the background woods.

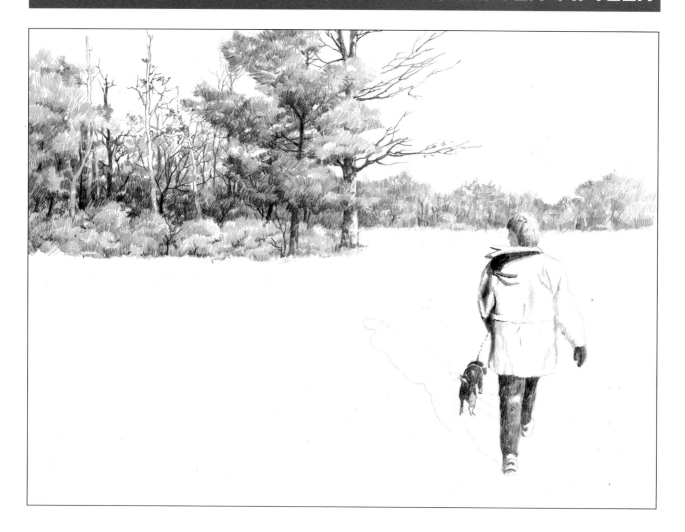

11

I draw the woman and dog, trying for simple patterns of lights and darks to contrast with all the detail in the landscape. I turn the figure's head slightly left (rather than straight ahead as in the photograph) to help connect the figure with the cluster of woods at the left. You may notice that when you look at her, your gaze follows hers, toward the woods.

For the next and final step I have to decide what to do about all that foreground. I like the stark white, but I think there's too much of it. I'll let this be a snowy field, but draw some grasses poking up through the snow in appropriate places to break up the white and help connect the woods and the figures.

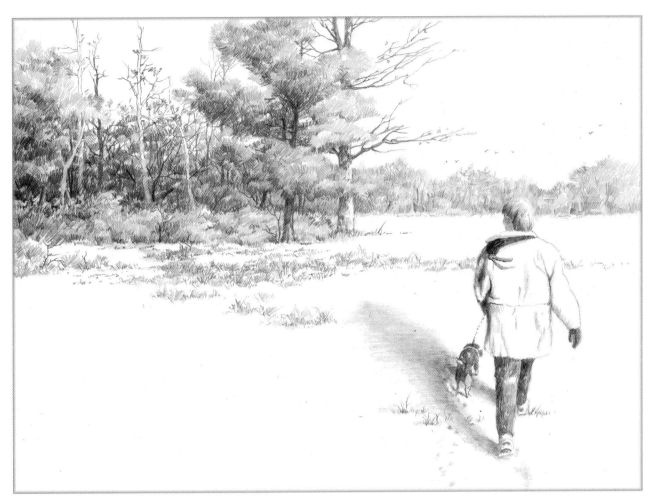

Walking Charlie
Pencil on Strathmore Bristol, plate
finish, 8 ½" x 11"

12

I try various patterns of weeds, erasing a couple of times and trying again, until I'm satisfied I've broken up the white area enough. The weeds also provide a visual connection between the woods and the figure.

I lay in the shadow at first as dark and rigid as it appears in the photograph. That doesn't work, so I fuzz the edges of the shadow with light H strokes and use a kneaded eraser to dab out some of the darkness until the shadow feels more natural. I make sure the shadow is darkest near the figures.

Finally, I work all over the picture, trying to get a better balance—for instance, I darken the woods at the far left to help balance the figure at the far right. The figure, even though it's quite simple, is a strong element because it's isolated, surrounded by all that white space.

CHAPTER
SIXTEEN
ANIMALS

1

I like both the photo of my Beagle
and that of these weeds and snow. I
think placing the dog at the lower
right, where his form can balance
the weeds at the upper left, should
be about right.

2

Here is my sketch using three
values—black, gray and white.
Notice that if you exclude his
shadow and don't let any of the
weeds touch him, the dog will seem
isolated from the rest of the picture,
so the shadow and the touching
weeds are important to the design.

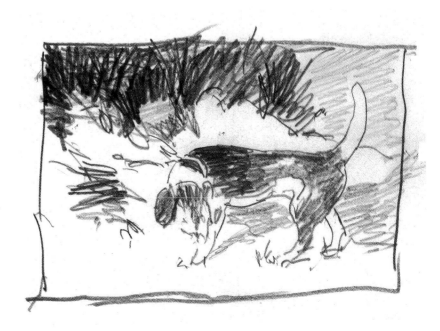

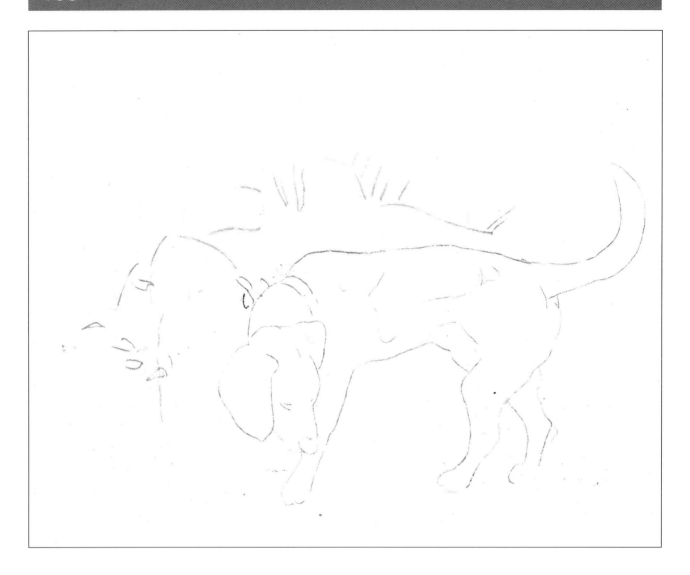

3

I sketch the dog lightly and as accurately as I can, but I only suggest the boundaries of the bunches of weeds. I want to be free to play with the weeds as I draw them, but I don't have that same luxury with the dog.

As in most of my beginning sketches, I keep the initial outline faint, just dark enough for me to see as I begin rendering the form—that way, I can keep soft (not outlined) edges where I want them. The illustration above is shown darker than I really drew it, only because, as I've mentioned earlier, the book-printing process won't pick up lines that are too faint.

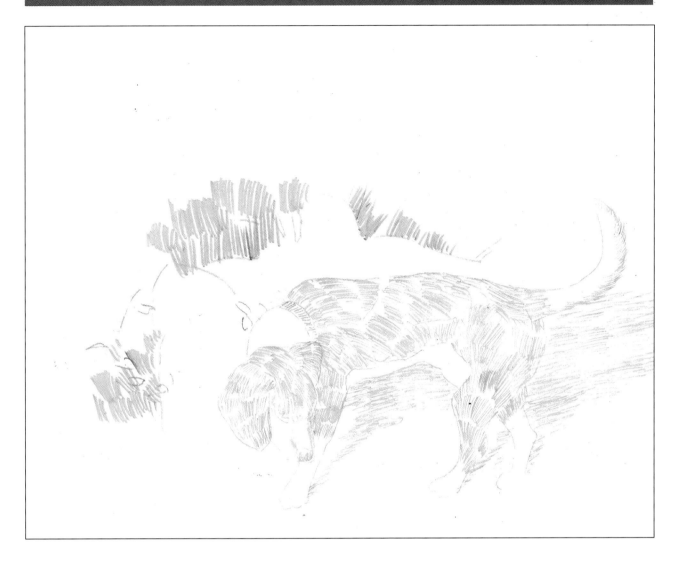

4

With a chisel H pencil I lay in all parts of the dog that are not to be white; *I make all strokes pretty much follow the direction of the dog's hairs*. I also indicate his shadow. Using the same pencil, but blunter and with more pressure, I indicate where the main masses of weeds are to be.

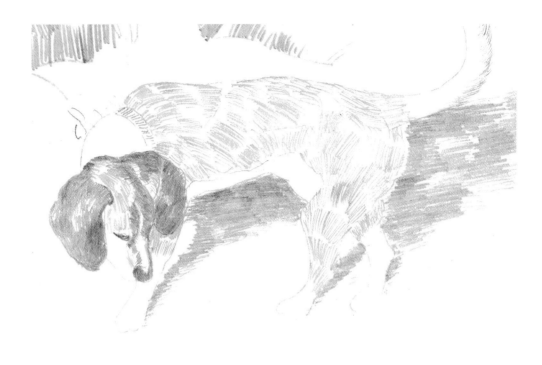

5

The weeds will be relatively easy, so I concentrate on the dog first—he'll be a little tougher. I begin by using a chisel HB to make soft, continuous strokes, gradually filling in the darker areas.

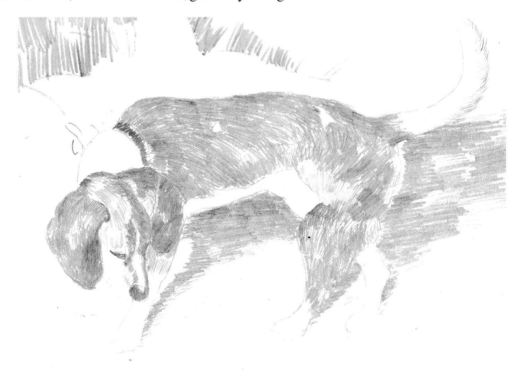

6

Still using a chisel HB, I render the dog fairly completely, but without yet establishing his darkest parts.

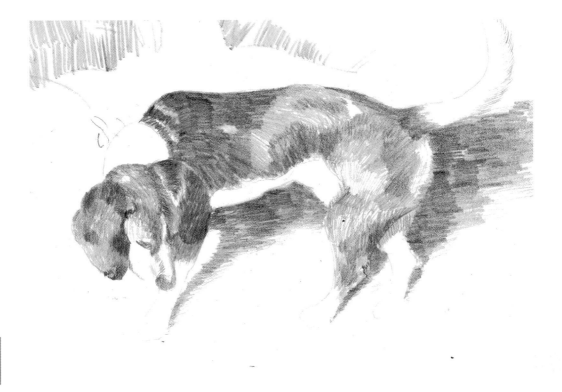

7

Now using a chisel 2B pencil, I give the dog more solidity by darkening appropriate areas, including his shadow. I'll do some final darkening at the end of the job, when I can compare the dog to the finished weeds.

*negative drawing
(grass stem)*

*positive drawing (grass
stem, leaves)*

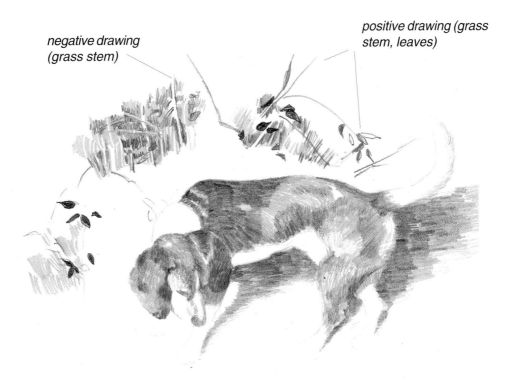

8

Using HB and 2B pencils, I begin making grasses and weeds. I draw some of them positively, some negatively. I use the photograph for clues and then draw things where I think they'll look good in the picture.

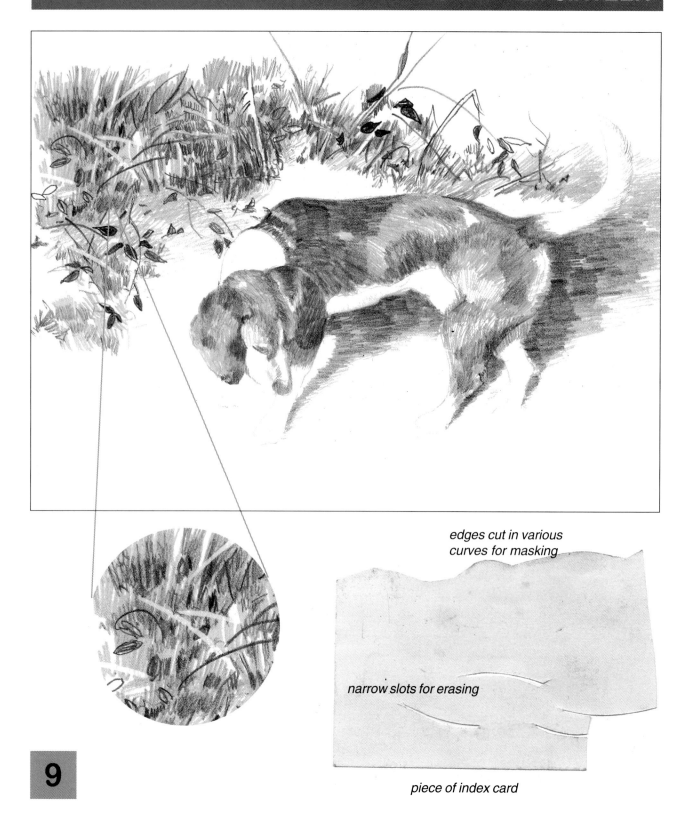

edges cut in various
curves for masking

narrow slots for erasing

piece of index card

9

I use a combination of hatching and crosshatching with H and 2B pencils to suggest the clutter of weeds and grasses. I draw some light stems negatively, but others I *erase* using a homemade erasing shield (an index card into which I've cut some slots—my regular erasing shield does not have slots narrow enough for my needs in this drawing).

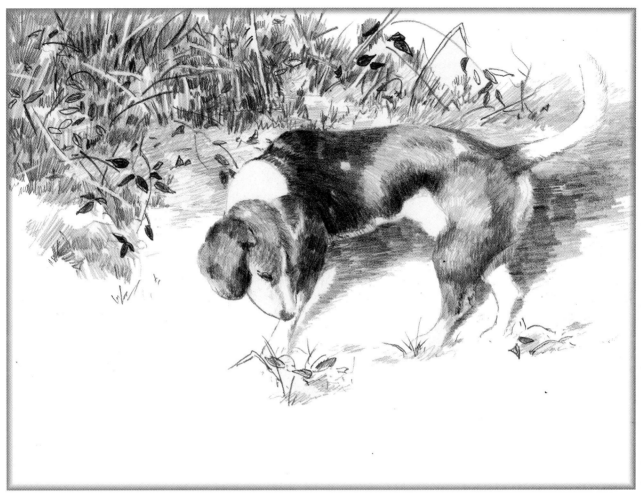

Charlie
Pencil on Strathmore Bristol, plate finish, 4 ½" x 6 ¾"
Collection, Shirley Porter, Rockville, MD

10

I extend the weeds a bit outward to better balance the dog. I touch up the dog in many areas, especially in the darkest areas (4B pencil). His right ear is a little too long, so I erase a bit of it. I use an HB to slightly shade the snow area above the dog so he won't stand out quite so starkly against the snow. I add a few weeds near Charlie's feet to help anchor him to the ground—otherwise, he might appear to float above the snow.

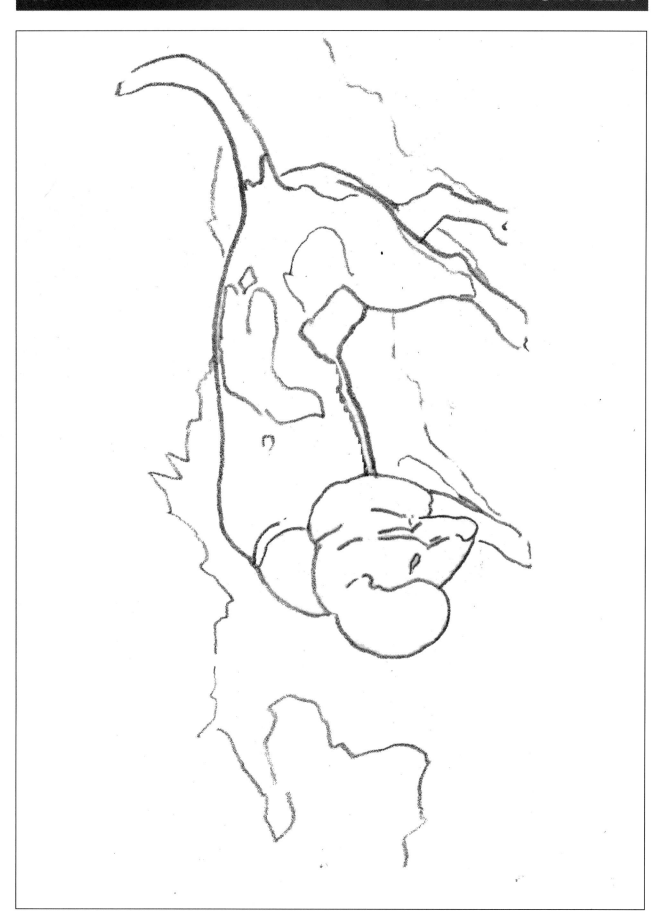

CHAPTER SEVENTEEN
OPEN LANDSCAPE

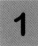

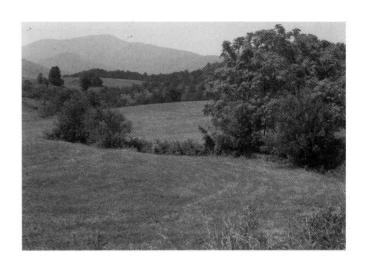

I have in mind drawing the landscape pretty much as it appears in this photograph, but I make a quick sketch and see that there are problems: (1) The tree on the right is an uninteresting blob; (2) the tree is the same height as the distant mountain, causing too much symmetry; (3) the foreground and the sky in my sketch seem too nearly equal in size and shape.

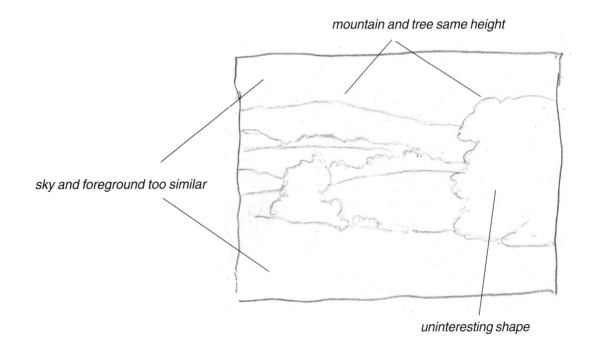

mountain and tree same height

sky and foreground too similar

uninteresting shape

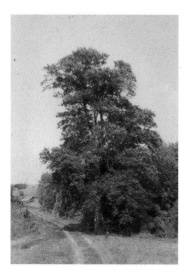

2

I find this taller tree in my box of photos. Its broken shape is better and its height allows me to let it thrust up into the sky. As I add the tree and make the sky bigger to accommodate the tree, I solve the problem I mentioned earlier—the equal sizes of sky and foreground. But now I have a lot more sky to deal with.

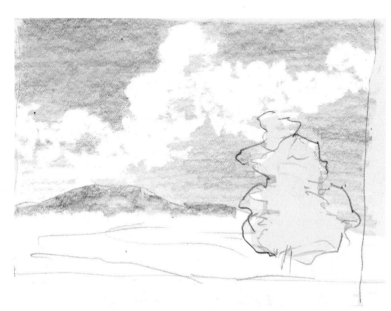

3

I think the sky is too large an area to be left all white, with no action at all, so I decide to experiment. I make the sky in the sketch gray with the flat of a 2B pencil and then "lift" (erase) clouds from the gray using a plastic eraser. I like the effect and decide to go ahead with it in my drawing.

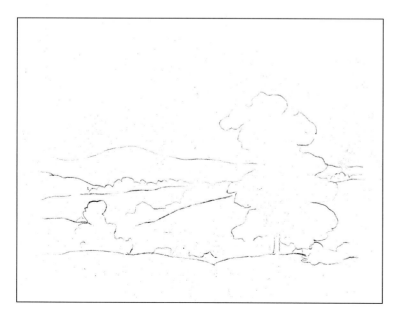

4

Here is the final outline drawing, shown less than full size to conserve space.

I have not drawn in any cloud formations because I want only soft edges in the clouds. That will occur later when I form the clouds by lifting them from a darkened sky.

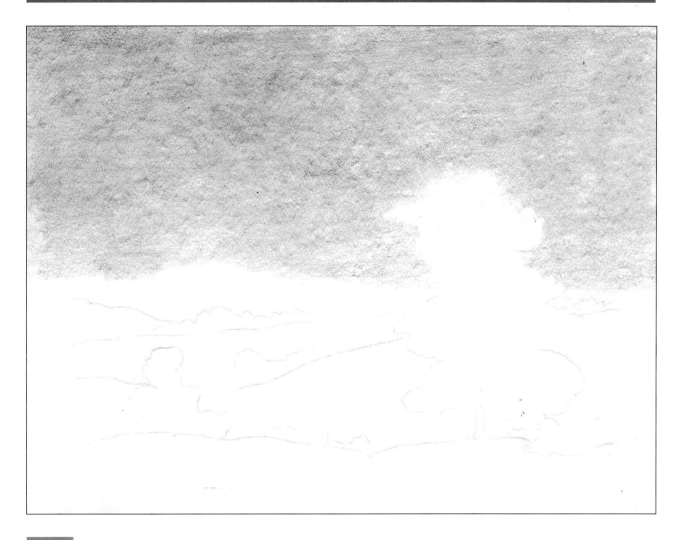

5

I begin by carefully laying in a flat value for the sky using first HB and then 2B pencils held flat against the paper. It's possible to make a mess of this (by not getting the sky smooth enough), so it's a good idea to start here. If I make a mess and have to discard the drawing and start over, I will not have wasted work done on the trees and fields. I use paper with a plate finish to help achieve a smooth sky.

TIP

When using flat strokes:

(1) Rub the lead briefly against scrap paper after each sharpening to remove any coarse grains of graphite that may cling to the lead as a result of the grinding of the sharpener.

(2) Use light pressure to avoid dark edges to your strokes. Gently increase pressure to get a gradual darkening of the area you're working on.

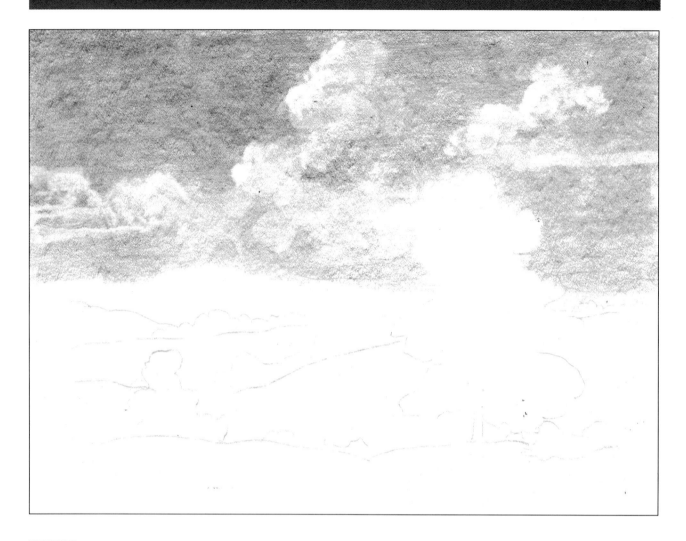

6

I begin forming clouds by erasing, dabbing with a kneaded eraser and pressing more firmly with a plastic eraser. I'll leave the clouds as shown here, only partly formed—it's difficult to see at this stage just how far to carry them. Later, when the rest of the landscape is developed, I'll be able to better judge how much further to carry the cloud rendering.

TIP

Lifting graphite to make clouds is easy—so easy you might get carried away! Go slowly. You can always lift a little more later on.

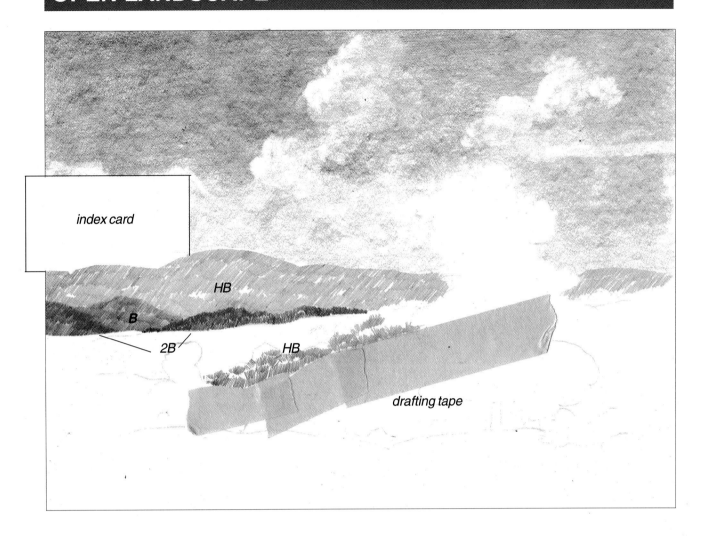

index card

HB

B

2B

HB

drafting tape

7

I draw the most distant sections first and work my way forward, one stage at a time. However, I leave the fields white temporarily because, until I establish the treelines, I'm not certain how dark I should make the fields.

To get crisp edges, I cut curves along the edges of an index card and then use the card as a mask. I use such a mask, for example, to draw the distant mountain—in that case, I place the card-mask against the sky while I draw the mountain using hatched HB strokes. The mask helps me avoid having stray strokes intrude into the sky area. In other areas I use drafting tape as a mask, twisting or cutting it into the shapes I need (as shown above).

TIP

If the area you want to mask is plain white paper, you may use either an index card or tape as a mask. But if the area to be masked already has graphite on it (like the sky in this example), do not use tape because removing the tape would also remove some graphite.

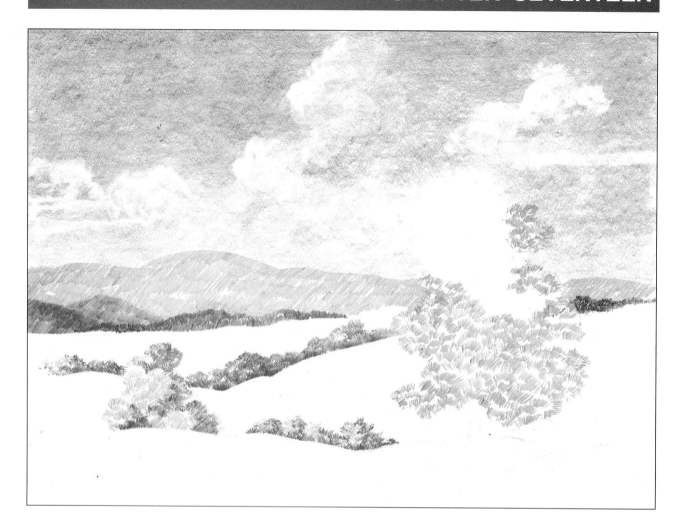

8

Leaving the fields white, I begin drawing the rows of trees and bushes, first hatching with an H or an HB and then hatching and crosshatching with a 2B. The sun is at the left, so the lighter hatch marks (facing left) will represent the sunlit portions of the foliage.

I begin laying in the big tree in the same way, using H hatching as a starter.

TIP

The rows of trees and bushes may be too small in height, compared to the white areas. It's easier to add to them later than to start them too large and then have to erase.

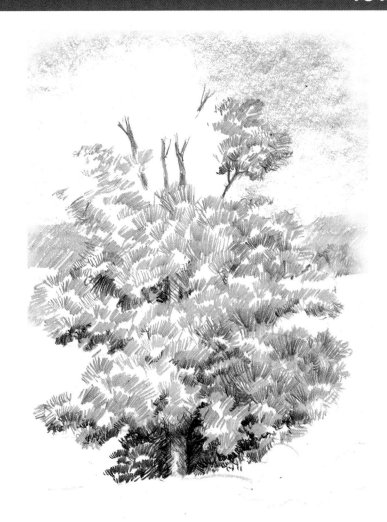

TIP

PAINTERLY DRAWING

*Try for a good balance
between detail and broad
treatment in the foliage. I
could draw in such minute
detail that I get a near-
photographic look, but I
prefer a rendering in which
many individual, fairly bold,
strokes are visible. In
painting, this approach
would be called "painterly."*

9

Time to get serious about the main tree. I continue filling out its form
with H and HB hatched strokes. Over those strokes I hatch and
crosshatch B and 2B strokes, trying for a convincing suggestion of
foliage textures. Remembering that the light is coming from the
upper left, I gradually darken the right side of the tree as well as the
undersides of foliage masses. With more pressure, I use a slightly
chisel-shaped 2B to draw the darker 'holes" in the foliage. I hatch
the lower trunk area with light chisel HB strokes and then draw the
trunk negatively-that is, by darkening the spaces around the tr unk.
Higher, where the trunks and branches are seen against the light sky,
I draw them positively with HB strokes.

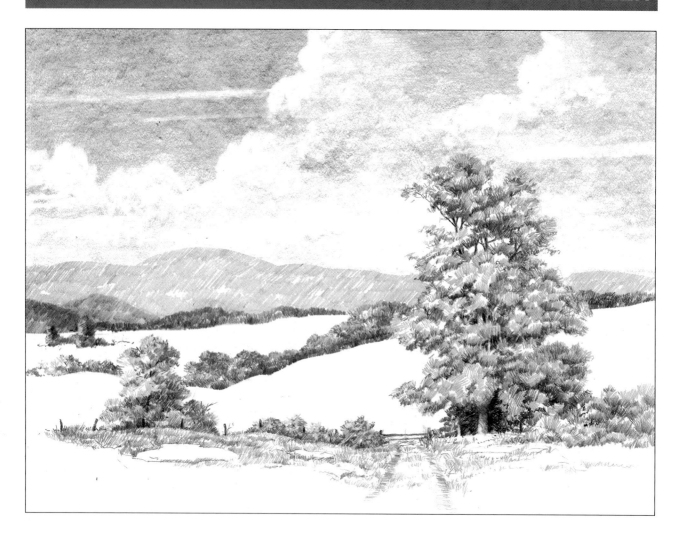

10

I complete the tree and begin work on the foreground, using HB and 2B strokes to suggest grasses and a few rocks. I erase more graphite from the sky to enlarge and whiten the clouds—I also erase a couple of horizontal streaks to help enliven the sky.

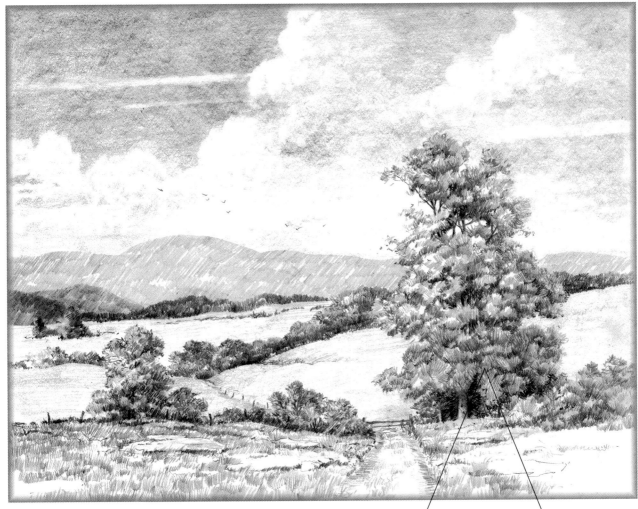

Sky and Fields
Pencil on Strathmore Bristol, plate
finish, 8" x 10"

11

Once the foreground is done, the
fields seem too bright (they look
snow-covered), so I tone them
down with the flat of an H pencil. I
add little touches all over, adjusting
values and shapes.

*Here is an area shown full-
size so you can see the
strokes.*

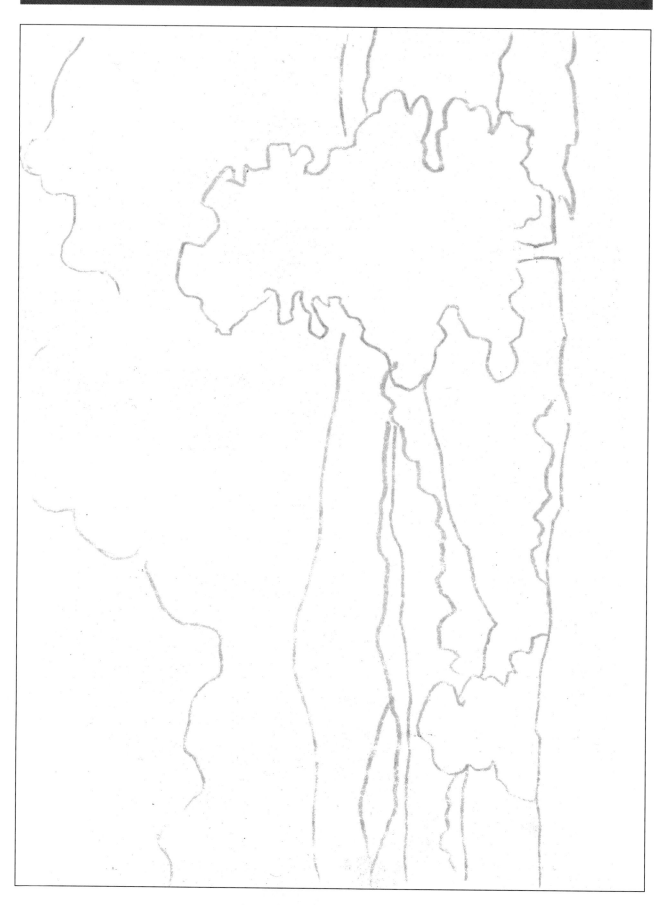

CHAPTER EIGHTEEN
TREE CLOSE-UP

1

I've used this old photo as the starting place for several paintings. What I like about such a subject is its attractive variety of textures.

2

I rarely draw or paint a scene just as it is—I take whatever liberties are necessary to come up with a better design. Don't believe anyone who says you can't improve on nature!

 What drew me to this subject in the first place was the textured tree trunk and the tangle of branches— I'd like them to show up starkly against the background, so I decide to leave the background white.

 My first stab at a value sketch has the sunlight coming from the left, as in the photo. I try moving the sun to the right and like that position better. Why? Because in the first sketch, the dark side of the main trunk seems to be dividing the picture down the middle. The second sketch moves that dark strip farther left, so now I have an L-shaped design (generally a comfortable design choice) rather than a design sliced down the middle.

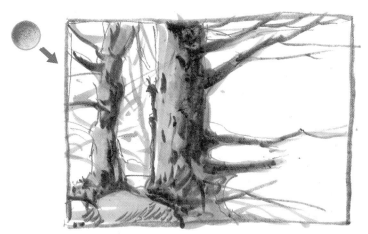

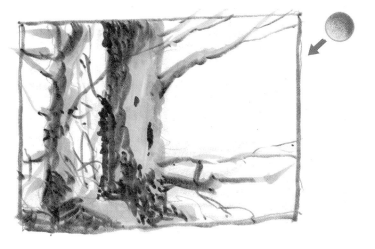

This arrangement is reasonably balanced, but it's too symmetrical because of the heavy dark down the middle.

This L-shaped design feels better. It's still balanced, but not symmetrical.

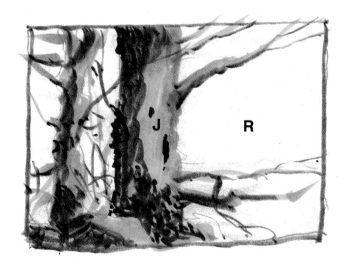

Another reason I like this design better than the other is that the big white area (R) and the sunlit part of the main trunk (J) kiss each other gently—they're not aggressively separated by that dark vertical strip. While it's good to have places where dark values and light values adjoin, it's generally best for those contrasts to occur in places other than the center of the picture.

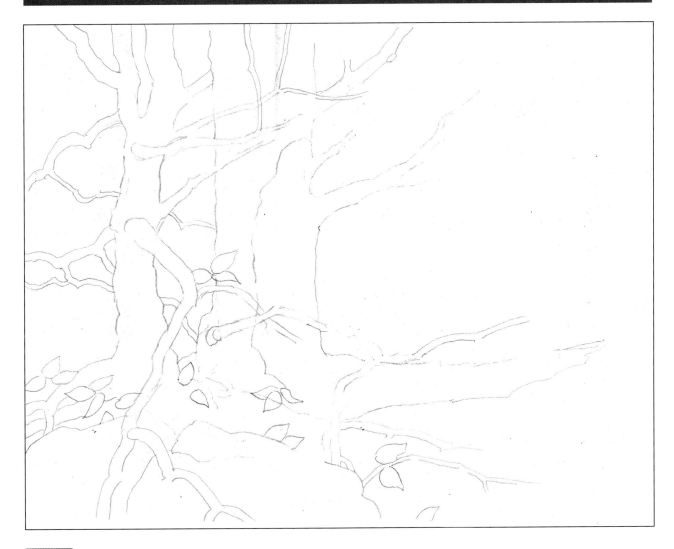

3

Above is my outline drawing. The actual scene in the photo has much more detail, but I don't include it all because I like to add (and invent) detail as I go along. Notice there is a whole section at the far left in the photo that I'm not including because I want to simplify the left and focus more on the main trunk and the smaller trunk next to it. I add a couple of rock shapes in the lower left-hand corner to provide some relief from all the tangled branches and twigs in that corner of the photo. I also add some leaves to the drawing, using their ovoid shapes to break the monotony of all those linear twigs and branches.

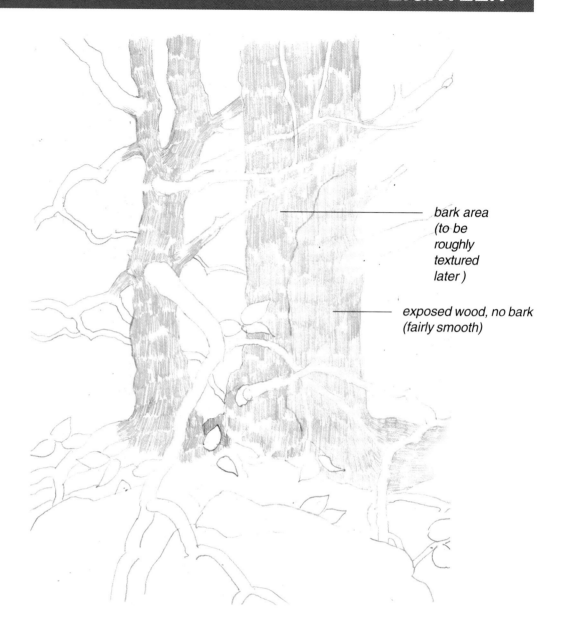

bark area
(to be
roughly
textured
later)

exposed wood, no bark
(fairly smooth)

4

I begin texturing the two trunks. First I apply vertical hatching with a 6H chisel pencil over the entire area. This is essentially an "underpainting," done rapidly as a base for more intense strokes to follow. On the part of the big trunk representing smooth wood from which the bark has peeled away, I use a little lighter pressure than elsewhere.

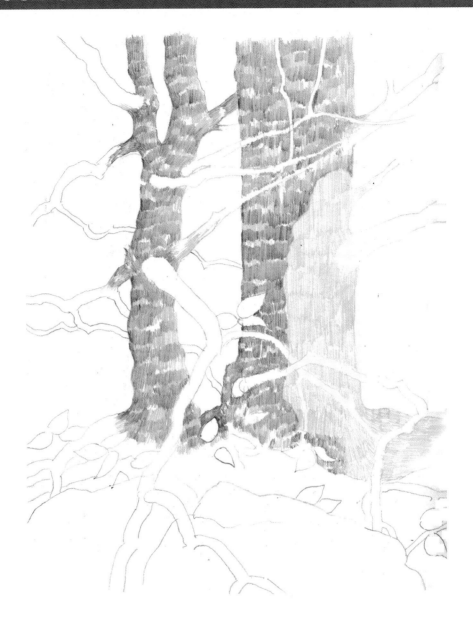

5

I draw a second layer of chisel HB hatching over the first layer in the bark area. I try to work fast enough so I don't fuss over any particular area, but instead let things develop as freely as possible. I'm aware that I'm concentrating on the trunks and ignoring all the rest of the drawing, and this may disturb some readers. If you feel more comfortable working all over the drawing, there is no reason not to do so. My own inclination is to bore in on an important area and get it looking interesting as early as possible (otherwise, I might get bored and chuck the whole project!). Proceed in any way that keeps you excited and involved in the drawing.

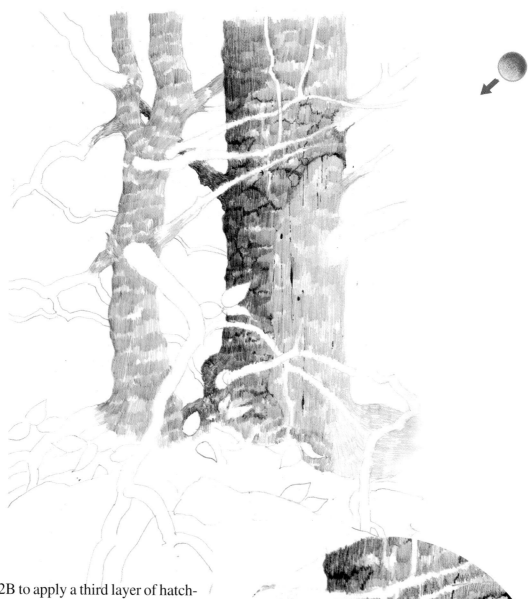

6

Now I use a 2B to apply a third layer of hatching, using more pressure and denser strokes at the left (the shadowed side of the tree) and getting lighter as I go around to the right side of the tree. As I work over the bark area, I begin to add knobby shapes and branches to break up the severe vertical left edge of the main trunk.

Next I use a sharp 4B to add dark cracks, crevices, holes—whatever I can think of to give the bark more texture and dimension. I do most of these strokes quickly with jerky motions, striving for a ragged effect. Then I add more HB hatching to strengthen the smooth wood area on the right side of the main trunk and use a sharp 2B to add some cracks.

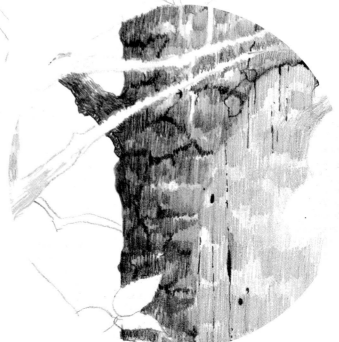

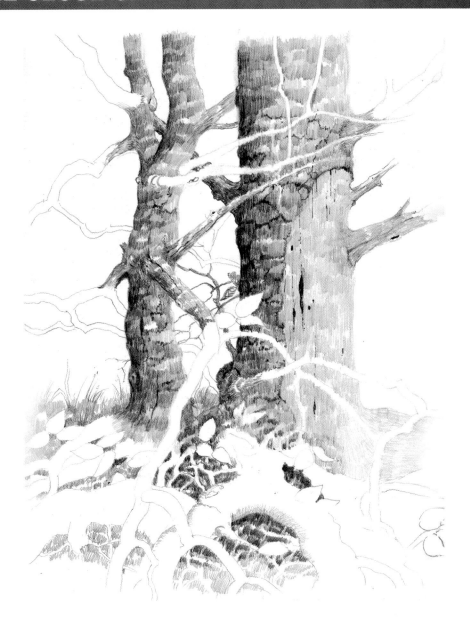

7

I've been glancing at the lower left corner of the drawing while working on the other parts. As I mentioned earlier, I planned to stick a couple of large rocks in the left corner. Now I'm having other thoughts. Back in Chapter Seven I showed you a drawing of some sycamore roots. I think I'll steal some of those roots for this tree (which happens to be an old hickory) and see if that doesn't work better than rocks. If not, I can always erase and go back to my original idea.

I've always been intrigued by such passages in nature—not only do those little dark holes seem mysterious (what lives in there—hobbits, maybe?), but they are a great excuse for some deep darks to enliven a drawing.

I feel my way along, using an HB to lightly sketch in the roots. Then I darken the holes among the roots with HB and 4B hatching.

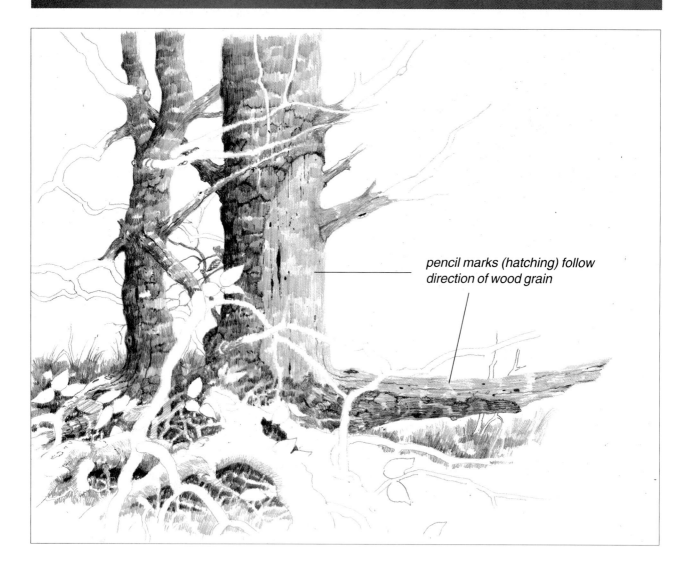

*pencil marks (hatching) follow
direction of wood grain*

8

Time to leave the left corner and begin developing the right. I hatch all over the protruding lower branch with chisel-shaped 6H followed by HB and finally, 2B, just as I did in the early stages of the upright trunks. In this case, however, my hatching is horizontal, following the direction of the object. Generally, it's a good idea to make your hatching follow the directions or contours of the subjects. The hatch marks in this case actually represent the grain of the wood.

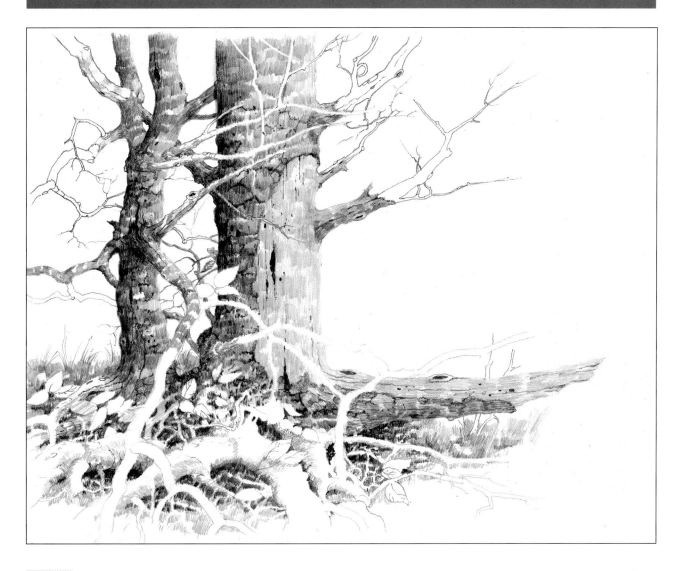

9

Using HB, 2B and 4B pencils, I develop the ground area, forming roots, rootlets, leaves and grasses as I go. I keep looking at the original photo for clues; I rely also on the roots drawing in Chapter Seven. More important, I count on my familiarity with this subject to help me imagine and invent details as I draw.

Had I never seen an old tree with exposed roots and scraggly branches and leaves, how could I hope to do justice to a drawing of such a subject? If you want to draw (or paint) a subject competently and confidently, get to know it intimately. Look carefully at the subject every chance you get, studying it from every conceivable angle, photographing it and, of course, drawing it over and over.

What remains now is to refine the drawing by (1) adding more branches to enhance the subject's raggedy look, (2) adjusting values for better value contrast, (3) reducing some value contrasts where they are too distracting, (4) sharpening some of the twiggy branches and (5) inspecting the picture in a mirror to look for design problems.

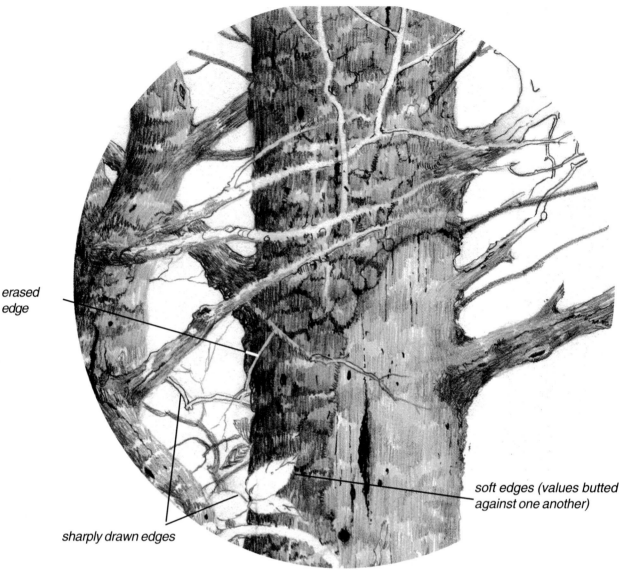

*erased
edge*

sharply drawn edges

*soft edges (values butted
against one another)*

10

Here are full-size details of the finished draw-
ing. To provide variety, I form some edges
softly by butting two areas of differing values
against each other and I make other edges by
using a sharp pencil. Still other edges are made
by erasing, usually with the aid of an erasing
shield.

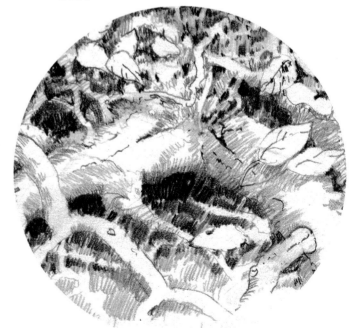

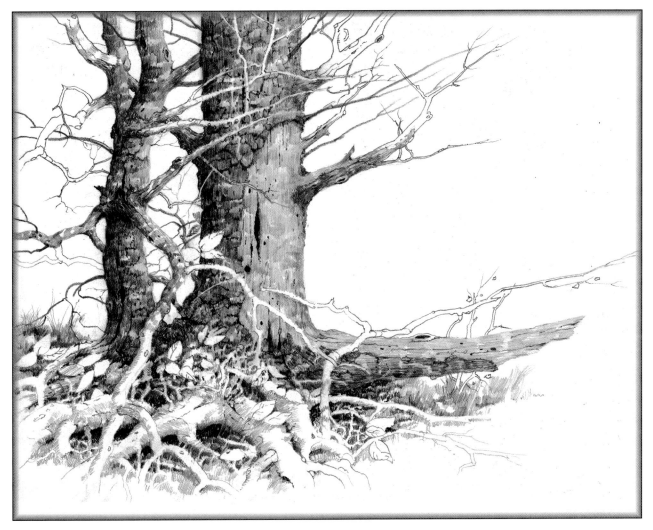

Old Hickory
Pencil on Strathmore Bristol, plate finish, 11" x 14"
Collection, Marah Heidebrecht, Montgomery Village, MD

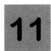

I decide to vignette the bottom of the drawing, allowing the bleached roots to fade off into the white of the paper. What I like about vignetting is the airiness it may give a picture. That's an arbitrary personal decision—you might well prefer to "finish" the drawing all the way to its borders.

DRAWING BOOKS BY OTHER AUTHORS

Albert, Greg and Rachel Wolf
Basic Drawing Techniques
Cincinnati: North Light Books, 1991

Brown, Michael David
Washington DC and *Viewpoints*
Rockville, MD: Winterberry Publishing, 1995

Calle, Paul
The Pencil
Cincinnati: North Light Books, 1985

Camhy, Sherry Wallerstein
Art of the Pencil
New York: Watson-Guptill, 1997

Dodson, Bert
Keys to Drawing
Cincinnati: North Light Books, 1990

Friend, Trudy
Drawing Problems and Solutions
Cincinnati: North Light Books, 2001

Graves, Maitland
The Art of Color and Design
New York: McGraw-Hill Book Company, 1951

Guptill, Arthur L.
Rendering in Pen and Ink
New York: Watson-Guptill, 1976

Kautzky, Theodore
Pencil Pictures
New York: Reinhold, 1947

Lewis, David (editor)
Pencil Drawing Techniques
New York: Watson-Guptill, 1984

Nice, Claudia
Sketching Your Favorite Subjects in Pen & Ink
Cincinnati: North Light Books, 1993

Petrie, Ferdinand
Drawing Landscapes in Pencil
New York: Watson-Guptill, 1979

Porter, Shirley
Drawing and Painting Birds
Cincinnati: North Light Books, 2000

Simmons, Gary
The Technical Pen: Techniques for Artists
New York: Watson-Guptill, 1992

Watson, Ernest W.
The Art of Pencil Drawing
New York: Watson-Guptill, 1968

Watson, Ernest W.
Pencil Drawing
New York: Watson-Guptill, 1937

The very best book you'll find on drawing and painting birds! Birds are a tough subject (they rarely sit still for you), but this book by AWS member Shirley Porter shows you how to capture them.
ISBN
0-89134-919-7

BOOKS BY PHIL METZGER

Perspective Without Pain
Cincinnati: North Light Books, 1988

Enliven Your Paintings with Light
Cincinnati: North Light Books, 1993

*The North Light Artist's Guide to
Materials and Techniques*
Cincinnati: North Light Books, 1996

Realistic Collage Art
Collaboration with Michael David Brown
Cincinnati: North Light Books, 1998

Perspective Secrets
Cincinnati: North Light Books, 1999

How to Master Pencil Drawing
Rockville: LC Publications, 1991

*How You Can Sell Your Art or Craft For
More Than You Ever Dreamed Possible*
Rockville: LC Publications, 1993

*The Artist's Illustrated Encyclopedia:
techniques, materials and terms*
Cincinnati: North Light Books, 2001

TO ORDER BOOKS:

Some of the books listed are sold out
or out of print. Those whose covers
are shown here and on the preceding
page are readily available. Alongside
the illustrations are international
standard book numbers (ISBN),
which may be used when ordering.
These books are generally available
at book stores, including Barnes &
Noble and Borders. They are always
available direct from the publisher:

North Light Books, Cincinnati, OH
1-800-289-0963

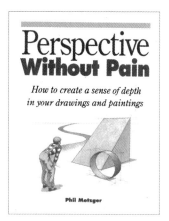

Everything about perspective for the artist, from the basics to special problems such as curves and stairs. North Light lists this book as a "best-seller."
ISBN
0-89134-446-2

A chapter for each painting and drawing medium—oil, alkyd, watercolor, acrylic, pastel, egg tempera, gouache, colored pencil, pencil, ink, mixed media and more. The perfect book to get you started in any medium.
ISBN
1-58180-253-6

Everything a watercolorist needs to know about all the perspective techniques.
ISBN
0-89134-880-8

Nearly 500 pages beautifully illustrated by 80 artists. Over a thousand entries covering every subject a practicing artist needs to know. This one belongs on every artist's bookshelf.
ISBN
1-58180-023-1

acid-free paper
Paper that is naturally free of acidic materials or has had its acidity neutralized by adding alkaline substances to it.

angle of incidence
The angle at which a beam of light strikes a reflecting surface.

angle of reflection
The angle at which a beam of light bounces away from a reflecting surface.

atmospheric perspective
The illusion of distance achieved by making distant objects paler and cooler in color than close objects.

B
Black, a designation for pencil leads (B, 2B, 4B, etc.).

balance
Bringing visual satisfaction to a picture by using an effective mix of design elements.

blended stroke drawing
Rendering an area using strokes that leave no bits of white paper showing.

board, drawing
Any stiff material such as hardboard, wood, Plexiglas, or cardboard, used to support drawing paper.

bridge
A device for keeping hands from smudging a drawing in progress.

bristol (or Bristol)
Paper formed by pasting together, under pressure, two or more sheets, or plies. Long ago, European papermaking mills sent their fine papers to Bristol, England, for pasting. Sometimes the term is used also for a strong, but single-ply, paper.

buffering
The addition of an alkaline substance, such as calcium carbonate, to papers during manufacture to neutralize acidity and provide protection from exposure to acidic environments.

center of interest
An area of a picture intended to be its focus.

charcoal
Carbon obtained by heating wood in the absence of air.

chisel stroke
A stroke made by a lead blunted at an angle.

cold-press finish
A slightly textured paper surface.

continuous hatching or crosshatching
Strokes made rapidly in hatching or crosshatching fashion, but without often lifting the pencil from the paper.

contour drawing
Outline drawing.

core
The graphite in a pencil; also called the "lead."

crosshatching
A set of parallel lines laid at an angle over another set of parallel lines.

deckle edge
The irregular edge of some drawing papers. *See* handmade paper.

design
The arrangement of the parts, or elements, of a picture.

design elements The ingredients that make up a picture: shapes, values, colors, lines, textures, directions.

directional stroke
Any stroke that follows the surface shape of an object.

dominance
For any given design element (such as *shapes)*, giving one form of that element (such as *rectangles*) more importance than other forms of that element (such as circles).

drafting tape
A paper tape used for masking; less tacky than masking tape.

drawing through
Drawing the hidden edges of an object.

drawing pencil
Usually means a wood-clad pencil with a graphite core.

drawing
Any depiction of a subject using any combination of marks from pencils, pens, or other tools.

easel
A structure that holds a drawing or painting in progress, either vertically or at an angle.

ellipse
A circle seen in perspective.

eraser
Any substance, such as rubber, used to lift pencil marks.

extender, pencil
A device for gripping the end of a short pencil to allow using the pencil down to the last inch.

eye level
The level defined by an imaginary horizontal plane passing through the viewer's eyes when the viewer is looking straight ahead: horizon.

fixative
A varnish used to protect paintings and drawings, especially charcoal or pastel. Not routinely used on pencil drawings.

fixative, workable
A dilute fixative.

flat stroke
A stroke made by holding the side of a lead parallel to the paper surface.

foreshortening
A technique of suggesting depth by shortening receding lines.

French easel
A transportable folding easel.

gm/m²
Grams per square meter, a standard way of designating the weight (and therefore the thickness) of papers.

gridding
Dividing a picture (such as a photo) into uniform rectangles to assist in reproducing that picture either larger or smaller on a new surface that also has been divided into rectangles, proportional to the rectangles in the original picture.

H
Hard, a designation for pencil leads (H, 2H, 4H, etc.).

handmade paper
Paper made a sheet at a time by pouring pulp (a watery mix of fibers and chemicals) over a wire mesh mould surrounded by a wooden frame called a deckle.

hardboard
A dense, rigid board made from compacted wood fibers.

hatching
A set of parallel lines, usually closely spaced.

high finish
Smooth paper surface.

highlight
The brightest part of a lit area.

Homosote
A thick, fairly lightweight, gray board with a hard surface but a spongy core.

horizon
Eye level.

hot-press finish
A smooth paper surface.

illustration board
Drawing paper glued to a stiff cardboard backing.

jaws, perspective
Two strips of cardboard or other material hinged at one end, used for measuring angles.

kneadable (or kneaded) eraser
A soft, rubbery substance used to erase with minimal danger of spoiling the paper's surface.

laid paper
Paper with a pattern of ribbed lines (see wove paper).

lead
The core of a pencil; it contains graphite and clay, but no lead.

lifting
Removing graphite, paint, etc. from a surface. In pencil drawing, use of an eraser is an example of lifting.

machine-made paper
Paper made on a high-speed device; unlike handmade and mouldmade papers, these have uniform surface textures.

mahlstick (or maulstick)
Any rod used to brace a hand to keep it away from the drawing surface while working.

mask
Any material (tape, cardboard, etc.) used to protect an area of a picture from pencil marks, paint, etc.

masking tape
A paper tape used for fastening paper to a supporting board; also used for masking. (See drafting tape.)

Masonite
Popular brand of hardboard.

mat
A cardboard border usually placed around a drawing, separating the drawing from the frame.

matte
A soft, nonglossy finish.

modeling
The use of shadow and curved lines to describe form and suggest depth.

mouldmade paper
Paper made by machine to simulate the look and texture of handmade paper.

negative drawing
Drawing the spaces around an object, rather than the object.

newsprint
Inexpensive paper made from wood pulp; not suitable for permanent work.

one-point perspective
Linear perspective in which receding horizontal lines meet at a single vanishing point on the eye level.

open stroke drawing
Rendering an area by placing individual strokes (either hatched or crosshatched), leaving tiny bits of white paper showing between strokes.

outline drawing
Drawing only shapes without any filling-in; contour drawing.

overlap
A perspective technique that suggests depth by placing one object in front of another.

pencil, graphite
Any pencil with a graphite core.

pencil, mechanical
A metal or plastic holder containing a replaceable graphite core.

pencil, carpenter's
A graphite pencil with a large, flat core.

perspective
Drawing techniques that give an appearance of depth.

perspective, aerial
Atmospheric perspective.

perspective, atmospheric
The illusion of distance achieved by making distant objects paler and cooler in color than close objects.

perspective, linear
Drawing technique that creates a sense of depth by making parallel lines meet at vanishing points.

perspective, one-point
Linear perspective in which receding horizontal lines meet at a single vanishing point on the eye level.

perspective, three-point
Linear perspective that takes into account parallel lines that are not horizontal and that meet at a vanishing point not on the eye level.

perspective, two-point
Linear perspective in which receding horizontal lines meet at either of two vanishing points, both on the eye level.

pH
A measure of the acidity or alkalinity of a paper or other material on a scale of 1 to 14, 1 being most acidic and 14 being most alkaline. Neutral is 7.

picture plane
The physical, flat surface of a picture. If you consider this page a picture, the flat surface of this page is the picture plane.

plate finish
A very smooth, hard paper surface.

plumb line
An imaginary vertical line used to see how different parts of a subject line up vertically.

ply
One layer of a paper or board. A paper or board having *only* one layer is called single-ply; one having two layers is called double-ply, and so on.

pulp
The fluid mass of fibers and other materials used to make paper.

quire
Twenty-five sheets.

rag
Fabric (usually cotton) used as the source of fibers in the manufacture of quality papers. The best papers are 100% rag.

ream
Five hundred sheets, or twenty quires.

receding line
An edge that lies not in the picture plane, but at an angle to it.

reflected light
Light that bounces from one surface and reaches another.

refraction
Light that veers from a straight course as it travels at an angle from one substance, such as water, through another substance of different density, such as air.

rice paper
Paper typically made from such fibers as mulberry (but not from rice), popular among Oriental artists.

rough
A significantly textured surface; also, a loose, quick sketch or a trial drawing made in preparation for a final drawing.

rule of thirds
Placing a center of interest a third of the distance across the paper is usually a good design decision.

sandpaper
Gritty material glued to a paper backing; may be used to shape a pencil point.

scribble stroke
A stroke, usually curved and erratic, made by holding the pencil loosely. Used for such subjects as foliage and hair.

shadow
A relative absence of light in an area because something is blocking the light source.

shadow, cast
Shadow on a surface because an object is blocking light from reaching that surface.

shadow, core
The dark band of shadow adjacent to the light area on a rounded object.

shadow, crest
Core shadow.

sharpener
Any device used to renew a pencil point.

shield, erasing
Flat material, such as plastic, metal, or paper, with openings of various sizes and shapes; used to restrict erasing to the area visible through one of the openings.

size or sizing
Material added to paper either at its pulp stage or later, on the finished surface, to alter the paper's absorbency.

sketch
A preliminary drawing, usually done rapidly, for the purpose of capturing the essence of an object or scene.

sketchbook
Any bound set of papers used to record images.

smooth finish
Untextured paper surface; also called plate or high.

stippling
The use of small dots rather than lines to express a scene.

stomp
Stump.

stump
A tightly wound cylinder of paper or other material, pointed at both ends, used for blending strokes.

support
Any surface used for painting or drawing.

sweet spot
Any of the four spots at the center of the four quadrants of a rectangle, often considered a good location for a center of interest.

symmetry
Sameness of design elements on both sides of a vertical or horizontal axis.

template, erasing
Erasing shield.

texture
The tactile nature of a surface.

three-point perspective
Linear perspective that takes into account parallel lines that are not horizontal and that meet at a vanishing point not on the eye level.

tone
Value.

tortillon or tortillion
A tightly wound cylinder of paper or other material, pointed at one end, used for blending strokes (or for lifting charcoal).

tracing paper
Translucent paper used for copying an underlying image.

transfer paper
Paper with graphite on one side, used to trace a drawing from one sheet to another.

two-point perspective
Linear perspective in which receding horizontal lines meet at either of two vanishing points on the eye level.

value
The degree of lightness or darkness of a stroke or an area. High value means light, low value means dark.

vanishing point
A point on the horizon, or eye level, at which parallel receding lines seem to meet. See *receding line.*

vellum
The fine-grained skin of a calf, kid, or lamb, used for writing or in bookbinding.

vellum finish
In drawing papers, a slightly textured surface.

viewfinder
A piece of cardboard with a rectangular hole, through which an artist looks to help isolate and select a portion of a scene for drawing.

visible corrections
Corrective lines that are left as part of the finished sketch or drawing.

watercolor board
Watercolor paper glued to cardboard, often used as a drawing surface.

wood pulp
Watery mixture of wood fibers, water and chemicals used in making paper.

wood-clad pencil
Common graphite pencil made of wood with a core of graphite.

wove paper
Paper with a smooth, unlined finish (see laid paper).